SPIRIT of PLACE

CONTEMPORARY LANDSCAPE PAINTING & THE AMERICAN TRADITION

JOHN ARTHUR

BULFINCH PRESS

LITTLE, BROWN AND COMPANY

BOSTON TORONTO LONDON

DEDICATION

THIS BOOK IS DEDICATED TO THREE MEN WHO EDUCATED ME,
SHAPED MY ATTITUDES, AND SET ME ON MY COURSE IN THE ARTS:

ALEXANDRE HOGUE, A PAINTER WITH THE TEMPERAMENT OF AN OLD
TESTAMENT PROPHET, A CONCERNED ECOLOGIST, AND A DEEPLY COMMITTED
TEACHER. HE TAUGHT ME TO HOLD PASSIONATELY TO MY CONVICTIONS.

BRUCE GOFF, THE LAST OF THE GREAT ROMANTIC ARCHITECTS. HE TAUGHT ME THAT
ALL OF THE ARTS ARE INTERRELATED, THAT THEY OFTEN SHARE THE SAME IMPULSES AND STEM
FROM THE SAME SOURCES, AND INSISTED THAT ONE MUST REMAIN TRUE TO HIS INSTINCTS.

CHARLES PENDEXTER, A SCHOLAR, TRAVELER, AND COLLECTOR. HE TAUGHT ME
THE IMPORTANCE OF KNOWING THE HISTORICAL AND CULTURAL RELATIONSHIP OF THE
ARTIST TO HIS TIME, AND THAT THERE IS NO SUBSTITUTE FOR DIRECT EXPERIENCE.

FIRST EDITION

Library of Congress Cataloging-in-Publication Data

Arthur, John, 1939–
 Spirit of place: contemporary landscape painting and the American
tradition / John Arthur.
 p. cm.
 Bibliography: p.
 ISBN 0-8212-1707-0
 1. Landscape painting, American. 2. Landscape painting—20th
century—United States. I. Title.
 ND1351.6.A78 1989
 758' . 1'0973—dc19
 89-30353
 CIP

Bulfinch Press is an imprint and trademark of Little, Brown and Company (Inc.).
Published simultaneously in Canada by Little, Brown & Company (Canada) Limited.

PRINTED IN ITALY by A. Pizzi S.p.A. Milano

CONTENTS

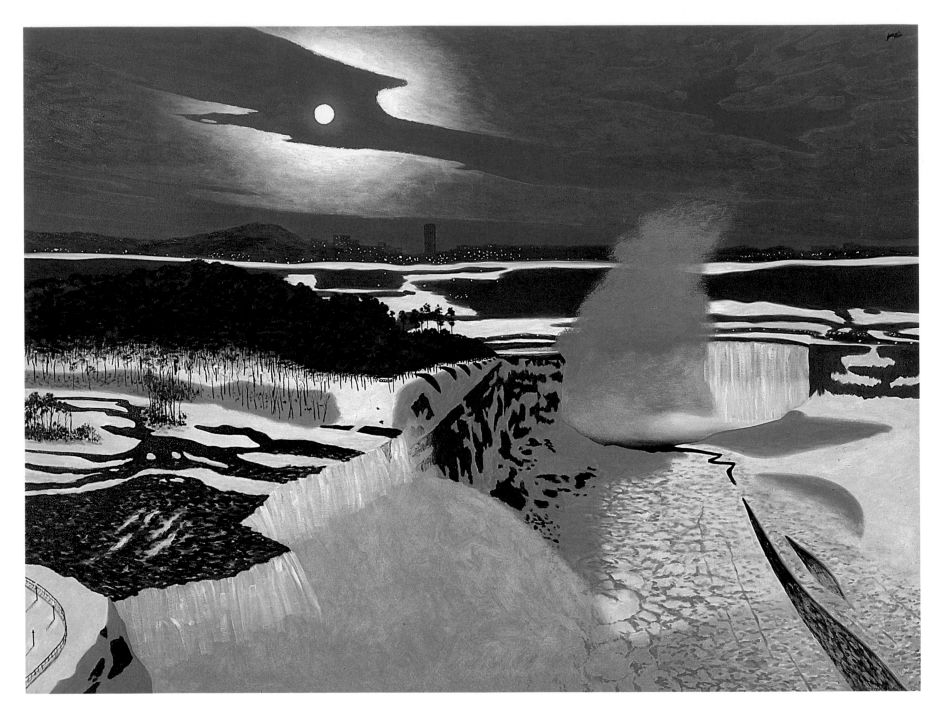

Bill Sullivan
Niagara Honeymoon, 1986
Oil on canvas, 42 x 70 inches
Courtesy of Gil Einstein Gallery, New York

ACKNOWLEDGMENTS

My earliest memories of childhood are interwoven with images of the landscape. They are as expansive as the infinity of that flat, southwestern horizon on a bright day, as small as the slow unfurling of the white blossoms of the jimsonweed on a hot summer evening, and as magical as a distant thunderstorm lighting up the night sky. These moments mix in my memory with a grainy, water-stained reproduction of Winslow Homer's *Fox Hunt*, animated by my imagination and the oily, dancing light from a kerosene lamp on the wall of my uncle's farmhouse. Various Maxfield Parrish calendars flicker throughout my faint remembrance of that period during the dark days of World War II, as does an old platter with a scene of an English cottage garden surrounded by a garland of roses.

Until I left home for college, the sandbars and lazy waters of the Cimarron River were never far away, and even today, at the eastern edge of the continent, there are certain Farm Security Administration photographs that carry me back to that past, that landscape of my childhood, and conjure up the ghosts of the people who inhabited it. Such is the power of images.

This book is about artists who have experienced a similar pull toward the natural world and have shared an attraction to its many facets, whether remembered, transformed, or imagined. For this account I have relied heavily on the artists themselves, rather than on secondary and interpretive sources. In almost every case, their assistance has been far beyond the call of duty. James Weeks, Paul Wonner, and Elmer Bischoff were especially helpful in shaping my understanding of the fifties and sixties, that mythic period of Bay Area painting. Neil Welliver, Michael Mazur, Peter Milton, and Joseph Raffael have shared with me their experiences at Yale under Josef Albers; and Nell Blaine, Wolf Kahn, and Jane Freilicher provided me with information about Hans Hofmann's school in New York and Provincetown. Over the years, George Nick and I have discussed Edwin Dickinson, one of this country's greatest painters and teachers, and Alfred Leslie has filled my head with his personal accounts of the Abstract Expressionists and the writers and poets of that seminal time. Jack Beal and I have talked into the night more times than either of us can remember. I have watched Richard Estes' paintings develop over many months, discussing them at length with him, and

we have spent leisurely moments talking of Art Nouveau and Art Deco, sharing our enthusiasm for Gaudi, Tiffany, and Bugatti, and shopping for William Morris wallpaper. My close friendship and correspondence with Daniel Lang spans more than twenty-five years. Keith Jacobshagen's letters have always been a warm experience. These are old friendships and shared loyalties.

For almost three decades Alexandre Hogue, through his attitude, action, and art, has symbolized for me the highly independent landscape painters of the Southwest, whose instincts differ so sharply from those of East Coast artists and who have remained quite detached from the prevailing winds of the art world. Hogue is the oldest of the contemporary artists represented here. Among the younger ones are Juan Gonzalez, James Winn, Tom Uttech, and David Bates; they have shown me that new possibilities have been opened during the last decade, and indicate the sublime prospects for landscape painting in the decades to come.

The visual character of Japanese screen paintings, scrolls, and above all, ukiyo-e has had a profound and lasting influence on American landscape painting, but the

character of that work, which so subtly fuses nature, art, and culture, has remained elusive to Westerners. Masahiko Shibata of Brain Trust, Inc., and Midori Shiraishi, through her wonderful, eloquent letters, have enhanced my understanding of the arts and attitudes of the extravagant, refined, and mysterious culture of Japan.

Rackstraw Downes has responded to my questions about Fairfield Porter; Helen Dickinson Baldwin has been most helpful in furnishing information on her father, Edwin Dickinson; and James Ryan, the historic site manager of Olana, has supplied copies of letters and other materials on Frederic Edwin Church and Olana. In addition to providing solid information in his book, biographer Coy Ludwig has answered some of my queries on Maxfield Parrish. Carol Troyen and Linda Thomas of the Museum of Fine Arts, Boston; Dr. Susanne Neuburger of the Museum of Modern Art, Vienna; Marilee Meyer of Robert W. Skinner, Inc.; and Robert Frash have helped me with various details concerning the book.

I would like to extend my ongoing gratitude to the numerous galleries that have assisted me, generously furnishing transparencies, photographs, and other materials. Without the support of Brooke Alexander, Inc., New York; Alpha Gallery, Boston; Associated American Artists, New York; Babcock Galleries, New York; Grace Borgenicht Gallery, New York; Capricorn Galleries, Bethesda; Charles Cowles Gallery, New York; Maxwell Davidson Gallery, New York; Tibor de Nagy Gallery, New York; Gil Einstein Gallery, New York; Fischbach Gallery, New York; Xavier Fourcade Gallery, New York; Sherry French Gallery, New York; Frumkin/Adams Gallery, New York; Graham Modern, New York; Jane Haslem Gallery, Washington, D.C.; Hirschl & Adler Modern, New York; Nancy Hoffman Gallery, New York; Barbara Krakow Gallery, Boston; Marlborough Gallery, New York; Barbara Mathes Gallery, New York; Victoria Monroe Gallery, New York; O. K. Harris Works of Art, New York; Oil and Steel Gallery, Long Island City; Pace Editions, New York; Gerald Peters Gallery, Santa Fe and Dallas; Roger Ramsay Gallery, Chicago; Schmidt-Bingham Gallery, New York; Robert Schoelkopf Gallery, New York; Allan Stone Gallery, New York; Struve Gallery, Chicago; Tatistcheff Gallery, New York; Edward Thorp Gallery, New York; Vose Galleries, Boston; and Winn Corporation, Seattle, this book would not have been possible. Also, I would like to thank the various museums that have allowed me to include works from their collections.

Many of the paintings reproduced are in corporate collections, and I am grateful to David K. Stevenson of Arthur Andersen & Co., Boston; Sara J. Miller of the Boston Company, Boston; Frank F. Oppedisano of General Electric, Stratford, Connecticut; Larry Winn of The Winn Corporation, Seattle, Washington; Charles E. Hilburn of Gulf States Paper Corporation, Tuscaloosa, Alabama; and Janice Orsman and Lawrence R. Levine of Chemical Bank, New York, for furnishing me with transparencies and photographs of various pieces.

I have relied heavily on the knowledge and skills of my editor, Betty Childs, in organizing and shaping this book; only another writer would understand my special debt to her. In addition, I would like to thank Dorothy Oehmler Williams, who has ably assisted in every phase from manuscript to book; the copyeditor, Peggy Leith Anderson; Rick Horton, whose classical design has greatly enhanced both the character of the art and tone I have tried to achieve for the book; and Christina Holz, who has seen the book through production.

In closing, I would like to acknowledge the major role my wife, Karen, has played, for she has once again assumed the full responsibility of managing home and hearth for the long duration of this project.

J.A.

PROLOGUE

In the spring of 1971 I accepted a position as gallery director at Boston University, and that fall I moved to New England. Like many others, I had long been attracted to this area, so rich in historical and cultural connotations, so active in shaping the politics, literature, and art of this country, and so adamant in preserving its values.

That same year, by coincidence, Alfred Leslie took an appointment as artist in residence at Amherst College, in central Massachusetts. He had requested a studio large enough to hold a Jeep, which he needed for one of the paintings in his monumental narrative cycle, *The Killing of Frank O'Hara*; the college agreed to furnish it. Also, this quintessential New York artist intended to paint a contemporary version of the oxbow in the Connecticut River near Amherst, a popular nineteenth-century motif, best known today through the magnificent painting by Thomas Cole at the Metropolitan.

Alfred and I had met briefly at a crowded, boisterous party in a New York loft in 1960, and had renewed our acquaintance in Illinois in 1969. By that time, Leslie and many of the contemporary Realists were quite well known. On various occasions I had met Wayne Thiebaud, Fairfield Porter, Philip Pearlstein, Jack Beal, Gabriel Laderman, Red Grooms, and James McGarrell. Richard

Diebenkorn was already a mythic giant in American art, and Richard Estes had emerged, an enigmatic figure whose earliest work hinted at a brilliant renewal of *vedute* painting. But it was from Leslie, in Illinois, that I first heard the term "post-modern," which would come to be associated primarily with architecture.

In 1968 I had lectured on contemporary Realism at a major Midwestern university, a session that concluded in a heated debate with a Harvard-trained art historian who adamantly argued that figuration was no longer a viable form for contemporary expression. He also questioned the merit of nineteenth-century American landscape painting, which he considered a very poor cousin of European art. Although I did not know it, a decade earlier, Barbara Novak had argued, with great tenacity, that nineteenth-century American art could provide a significant area of study for her doctorate at Harvard; she won her point, and the study led eventually to her landmark book *Nature and Culture*, first published in 1980.

Too often historians, curators, and critics make the grave mistake of assuming a narrow and judgmental role as arbiters of taste, and vainly attempt to dictate a proper course for art to follow. In general, they best serve as ledgerkeepers of the historical data, rather than as interpreters of the past, judges of the present, or seers of the future — a point

repeatedly confirmed by their faulty judgments. For example, some of these scholars were among those applauding loudest and longest at Frank Stella's interpretation of the art of Caravaggio (in a performance worthy of Professor Irwin Corey), in spite of Stella's failure to acknowledge subject and content as a paramount feature in those turbulent Mannerist paintings. Caravaggio killed a man for a far lesser offense.

Our view of the past is always and inevitably shaped by the prevailing winds of the present; but the true scope and aesthetic range of art can be easily flattened by the historian's narrow, linear thinking, as demonstrated by both the emphasis on European art and the omission of many great American painters, such as Church, in the widely used *History of Art* by H. W. Janson.

For a more recent example of such blinkered vision, consider Joseph S. Czestochowski's generally very fine book *The American Landscape Tradition*, which makes an illogical concluding shift from Charles Burchfield and Milton Avery to the abstractions of Clifford Still and Mark Rothko, while failing to acknowledge the existence of a single contemporary landscape painter. Although it is a fairly recent

publication (1982), and the author must surely have been aware of the work of Fairfield Porter, Richard Diebenkorn, and Neil Welliver, for example, Czestochowski gives no indication of the actual continuation of the American landscape tradition. Similarly, the beautiful exhibition at the Whitney Museum and the related book, *Reflections of Nature: Flowers in American Art* by Ella M. Foshay (1984), make a dizzy, incomprehensible descent from the fabulous paintings of Severin Roesen, Martin Johnson Heade, Maria Oakey Dewing, John La Farge, and Georgia O'Keeffe to the work of Jennifer Bartlett, currently popular but inappropriate in this context, while ignoring less trendy works more obviously linked to that tradition, such as those of Paul Wonner, Carolyn Brady, Janet Fish, and Juan Gonzalez. The Bicentennial exhibition The Natural Paradise, curated by Kynaston McShine for the Museum of Modern Art, attempted to span an impossible aesthetic chasm between Luminism and Abstract Expressionism. Quite simply, there is no logical bridge between the highly indigenous light of the Luminists and Abstract Expressionism, with its European roots. The catalogue, however, completely failed to acknowledge that during that period there were highly viable alternatives to abstraction that *were* linked to the Luminist tradition.

That each of the arts is to a degree a reflection of its milieu is undeniable, but more important, the most lasting art is an individual expression that ultimately transcends its period. The artist wears the convention of the time like an exterior shell that shelters his interior vision; and art is at its best when it is direct and specific and narrow in its response. Above all, it must communicate by reflecting the spirit of its epoch and must commemorate its own content.

In 1972, when I organized the exhibition The American Landscape at Boston University, there was no reflection in it of the national discontent brought on by the tragic Vietnam War. Such a response was best expressed by other means. Later, at the time I was organizing the U.S. Department of the Interior's Bicentennial exhibition, America 1976, we were still embittered by that most unpopular war, and the nation was preoccupied by Watergate and its aftermath. This situation was disturbing to all of the participants in the exhibit, but that mood was not directly reflected in the paintings they produced. As I write this book, ethics in government and the corporate sector has become a national disgrace. But as with the paintings commissioned for the Bicentennial exhibition, those aspects of our national experience, quite simply, are not what the works in this book address. Instead, they should be viewed as a reaffirmation of values and feelings that have been neglected in our time. Obviously, there is now a renewal of indigenous, regional expression and an emphasis on our coexistence with nature, a

relationship fraught with ecological disasters and rapidly increasing agrarian problems. Somewhat surprising are the younger landscape painters' spiritual and religious feelings toward their subjects, a characteristic that has been sadly de-emphasized in our callous and jaded time.

This book is an examination of current attitudes reflected through landscape painting; it explores the bond of the contemporary artists to the American landscape tradition, and searches for a continuation of our indigenous, nationalist traits, which have remained straightforward, romantic, and optimistic. It is an examination of one facet of contemporary art, one that remains, however, as vital and credible in our time as it was in the past. It is art that venerates the past rather than reacting against it. That it is popular with a broad audience does not diminish its significance.

The shape and content of this book were dictated by the work and the artists, rather than based on preconceived notions on my part. The abbreviated historical review of the American art that has most influenced the contemporary artists discussed here was constructed by working from the present to the past. Church, Heade, Ryder, Inness, Homer, and the artists from the first half of the twentieth century were chosen as exemplars and spiritual forebears because of their particular expressive emphasis and their continued influence on the contemporaries. I was surprised by the strong correlation

between the early twentieth-century landscape painters and the American Arts and Crafts movement, which has been underemphasized; by the continuing influence of Japanese art; and by the spiritual connotations of the landscape so deeply felt by so many of the younger painters. Every artist constructs his own heritage, and the clear connection of the more recent landscape artists to the Luminists and Northern European landscape painters has emphatically emerged.

In preparing the first two chapters of the book, I relied on various monographs and articles but gave precedence to statements by the artists and to early accounts. As for the present-day artists, far too much misinformation has been propagated through well-circulated surveys, monographs, and periodicals. Because of this, I decided to rely on the artists themselves for background information. A two-page questionnaire was assembled and sent to almost all of those included. All but three responded, and often with an abundance of material. Many of the quotations appearing in this book and almost all of the background information come directly from the questionnaires. Also, I have relied on my own previous interviews and conversations with these artists. When in doubt, in need of elaboration or clarification, I have simply phoned them. The direct contact with the artists has considerably changed the complexion of the text.

In the winter of 1972, Alfred Leslie and I transported his monumental painting of the oxbow, still tacky, in a rented truck to the Boston University Art Gallery for the exhibition The American Landscape. Although Realism was a firmly fixed aspect in contemporary painting, a question frequently asked at that time was if there were enough good contemporary landscapes to fill the gallery. Now, more than a decade later, one of the major problems I have grappled with in working on this book is that to keep it to reasonable size, so many noteworthy artists have ultimately had to be excluded. Therefore, at best, it should be regarded as an indicator rather than a comprehensive survey of contemporary landscape paintings and graphics.

In the end, this is a look at an aspect of contemporary art from a different position, with a decidedly different emphasis. It is an examination of art's more tranquil aspects, a search for the poetic, the metaphoric, the mysterious, and an acknowledgment of the return to a more romantic vision. Perhaps it is an attempt on my part to partially fill that deep-seated, almost forgotten longing for a sense of comfort, graciousness, and solace, which is so often absent in our modern, harried life.

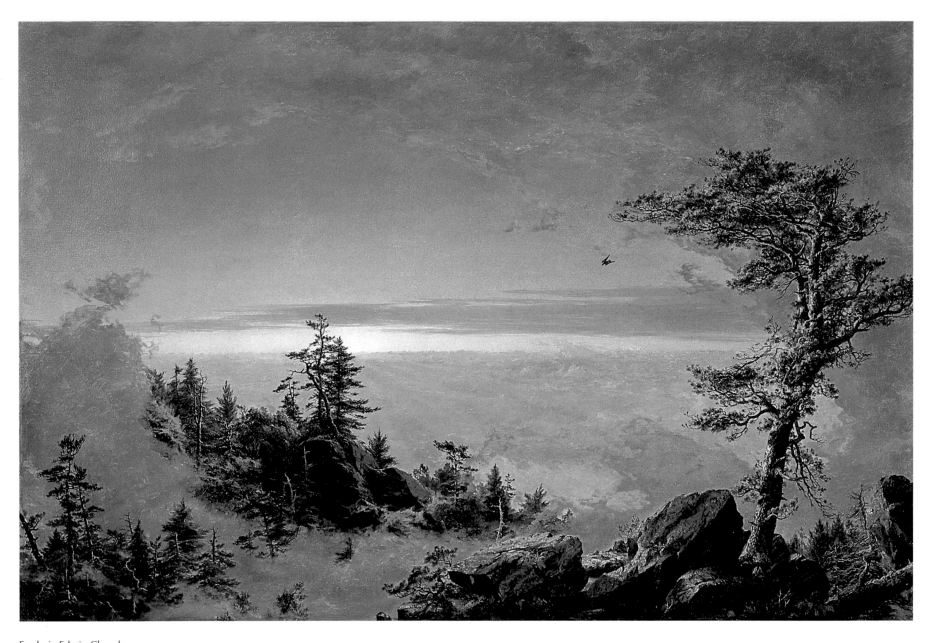

Frederic Edwin Church
Above the Clouds at Sunrise, 1849
Oil on canvas, 27 x 40 inches
Warner Collection of Gulf States Paper Corporation, Tuscaloosa, Alabama

CHAPTER ONE

AMERICAN LIGHT:
The Shaping of a National Tradition

In the woods, is perpetual youth. Within these plantations of God, a decorum and sanctity reign, a perennial festival is dressed, and the guest sees not how he should tire of them in a thousand years. In the woods, we return to reason and faith. There I feel that nothing can befal me in life, — no disgrace, no calamity (leaving me my eyes) which nature cannot repair. Standing on the bare ground, — my head bathed by the blithe air, and uplifted into infinite space, — all mean egotism vanishes. I become a transparent eyeball. I am nothing. I see all. The currents of the Universal Being circulate through me; I am part or particle of God.

Ralph Waldo Emerson, Nature[1]

If there is a shrine for American art, a place that symbolizes the most poetic and spiritual characteristics of our country in the nineteenth century, it is Olana, that lofty, amber-windowed castle designed and built by Frederic Edwin Church at the close of the century. Olana is the embodiment of the painter, a reflection of his unique stature in American art, and of the inquisitive, romantic spirit that tempered the time. Its obsessively detailed blend of Gothic, Persian, and Aesthetic movement elements reflects Church's pilgrim nature, and its rooms are filled with the souvenirs of a romantic and immensely successful voyager. The lawn slopes gently down from the southern porch,

and spreads into a vast panorama of the Hudson River and the Catskills, with all the connotations that region conjures up, from the art of Thomas Cole and the Hudson River painters to the legends of James Fenimore Cooper and Washington Irving.

If there is an icon that symbolizes the mood of America just past the cusp of the nineteenth century, it is *Twilight in the Wilderness*, painted by Frederic Church in 1860. That tranquil but melancholic look at the ghosts of our past, that grand emblem of Transcendentalism, was produced at almost the precise point when such thoughts were being shattered forever by rapidly advancing attitudes of scientific determinism. It was finished in a year of thunder, before the country was split by civil war. This painting marked a point of no return, for the world had changed too much, and would change much more before the century closed. But if it designated a loss of innocence, it did so with grace and grand style. Church was a showman who could make an exhibition of one spectacular painting that people would stand in line to see, providing them with a glimpse of extraordinary, mysterious, and primeval worlds for a small admission fee. He was a cultured and dignified Barnum, an explorer with the facility to accurately record what he saw with paint, and a virtuoso who could expand his small, plein-air oil sketches, drawings, and on-site notations into vividly colored, melodramatic, monumental landscapes with which no photographer of

the period could hope to compete. His only serious rival was Albert Bierstadt, with his sensational paintings of the American West.

Church's earlier *Above the Clouds at Sunrise*, painted in 1849, stands in sharp contrast to the melancholy *Twilight in the Wilderness*, for it is euphoric in its symbolic anticipation of the sweet mysteries of the New World. The two paintings are a visual prologue and epilogue for Manifest Destiny, and poetic representations of our natural manse. The sun is widely regarded as a symbol of knowledge and immortality, and in *Above the Clouds at Sunrise*, with its rising skeins of lavender and rose mists, and a sea of clouds that stretches to infinity, the brilliant light of the sun begins its ascent. This sun will evaporate those dark, primitive mysteries, and reveal all through the great clarity of its emerging light.

Both paintings are reflections of the prevailing attitudes of their time. Alexander von Humboldt's belief that the divine was manifest in nature and that beauty and truth were one permeated American painting at the middle of the nineteenth century, and Church could perfectly distill such thinking in his art. The public response to *Niagara*, *Heart of the Andes*, and *Icebergs* was almost unparalleled in America, and Church's paintings were greeted with the same enthusiasm in Europe. He was admired by Ruskin, toasted by Gérôme as the founder of New World painting, and considered by many as the successor to Turner.

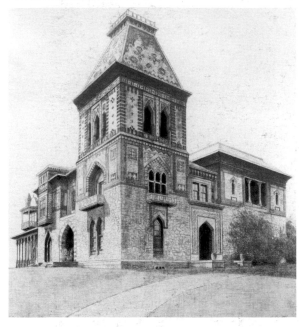

As a plein-air painter and colorist, Church had few equals in America or Europe, and it was fortuitous that among the social and scientific developments that spilled over into the arts of that period were technical advances that had a direct and radical effect on painting in the last half of the nineteenth century, greatly facilitating painting on location, providing a wealth of visual data, and expanding the artist's palette. Richard J. Boyle has pointed out that "of the many technological innovations during the nineteenth century, three have had a decisive influence on painters: the invention of the daguerreotype; the discovery of the collapsible tin tube as a container for oil colors; and most important of all, the use of new colors from the beginning of the century onward."[2]

The close relationship of early photography and painting has often been understated or ignored in art history. The stable, light-induced image was invented in different forms by Louis-Jacques-Mandé Daguerre and William Henry Fox Talbot. Daguerre was a painter and set designer, and Fox Talbot was an amateur artist, naturalist, and scientist.

Photography, from its beginnings in pinhole projection, the camera obscura, and the light-sensitive copper plate invented by Daguerre in 1839, is tightly interwoven with the history of painting. Almost every painter has used systems and devices for reproducing the spatial world on a flat surface and for measuring and maintaining proportions. Daguerre simultaneously provided the painter with a permanent and convenient image and created another art form: photography.[3]

The use of tubed paints, first patented by the American painter John G. Rand in 1841, greatly facilitated painting on location, or in plein air. As an immediate result, the activity of plein-air painting spread rapidly in America and Europe.

These technical developments were also important for the Luminist painters. "Luminism" is a term first used by John I. H. Baur in 1954 to describe those American landscapes of the mid-nineteenth century in which the effect and emotional quality of light were central, an effect that Baur defined as "a polished and meticulous realism in which there is no sign of brushwork and no trace of impressionism, the atmospheric effects being achieved by infinitely careful gradations of tone, by the most exact study of the relative clarity of near and far objects, and by a precise rendering of the variations in texture and color produced by direct or reflected rays."[4]

But more important than tonality (the gradation from light to dark) to the effect of quietude, clarity, and light so central to Luminism was the facility to control gradual shifts of hue (color range) made possible by the introduction of chemical pigments in 1856. The new cadmiums not only brightened the palette; their wide range of yellow, orange, red, and violet enabled the painters to make subtle color shifts, as opposed to the earlier emphasis on gradations of tone. Joseph S. Czestochowski comments:

So prevalent in the 1860s was the use of hot reds, yellows, and oranges that [James Jackson] Jarves complained, "we are undergoing a virulent epidemic of sunsets." These new cadmium pigments benefited the luminists by permitting a full exploration of light's effects. American artists maintained a sense of precise detail, while their European counterparts pursued a direction that ultimately led to a stylistic dissolution of form, or Impressionism.[5]

While Frederic Church was seeking out some of the most dramatic and primordial sights in this hemisphere and in the Near East, his friend and elder Martin J. Heade, also an inveterate traveler, concentrated instead on the intimacies of the flora and fauna of South America, the quiet marshes of the northeastern states, the swamps of Florida, and those parts of the New England coastline that were specifically marked by shifts of light, weather, and changing tides.

The space and light in Heade's diminutive and deeply personal compositions of those coasts and marshes are carefully punctuated by the calculated placement of sails or haystacks, which he moves through the serene, conceptual space like pawns, or actors on a stage, then stirs to life by an emphatic shift of sun or impending weather.

Church depicted the dramatic and spectacular narrative of nature; Heade sought its poetics and quietude. One painter instills a sense of awe, and the other subtly enchants. These two attitudes typify what Barbara Novak, in her seminal book *Nature and Culture*,

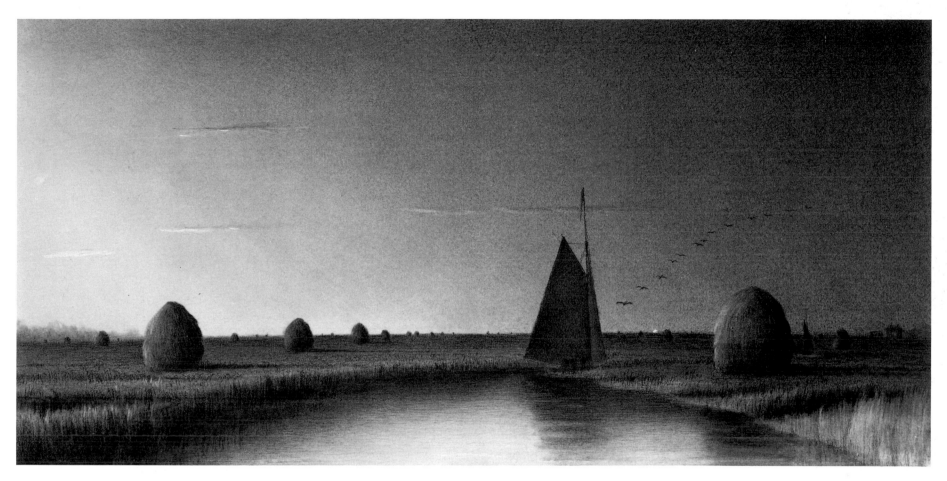

Martin Johnson Heade
Twilight, Salt Marshes, 1862–68
Charcoal and colored chalks on paper, 11 x 21⅝ inches
Museum of Fine Arts, Boston, M. and M. Karolik Collection

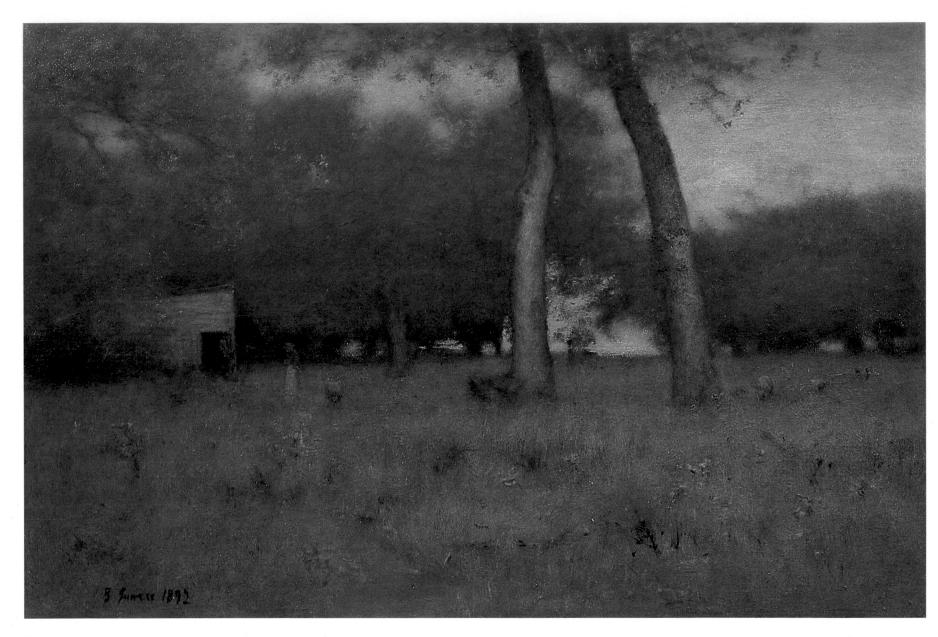

George Inness
Sunset at Montclair, 1894
Oil on panel, 30 x 45 inches
Courtesy of Babcock Galleries, New York

has described as "grand opera and the still small voice." But, according to Novak, "Church, like the panoramists, seems to be equating grandness with largeness." Heade's work, she says, exemplifies Luminist painting's "limitless amplitude" in that "monumentality seems accomplished through scale, but not size."[6]

But Church and Heade share in common the spiritual ground of Luminism:

In the luminist painting, the eradication of stroke nullifies process and assists a confrontation with detail. It also transforms atmospheric "effect" from active painterly bravura into a pure and constant light in which reside the most interesting paradoxes of nineteenth-century American painting. They are paradoxes which, with extraordinary subtlety, engage in a dialectic that guides the onlooker toward a lucid transcendentalism. The clarity of this luminist atmosphere is applicable both to air and crystal, to hard and soft, to mirror and void. These reversible dematerializations serve to abolish two egos — first that of the artist, then the spectator's. Absorbed in contemplation of a world without movement, the spectator is brought into a wordless dialogue with nature, which quickly becomes the monologue of transcendental unity.[7]

But dramatic forces that would disrupt this transcendental mood and vision were moving from the wings to center stage; both attitude and act would soon radically shift.

In 1852, Elisha Otis of Vermont designed the first practical passenger elevator, an invention that would rapidly change the scale of our buildings and the profiles of our cities, and ultimately reshape all urban areas.

A year later Commodore Matthew Perry reached Tokyo Bay with a fleet of four steamships, each with a tonnage ten times greater than the largest Japanese sailing vessel, and coerced the bakufu, Japan's military government, into ending that small island country's isolation. This had a profound effect on the advanced art of Europe and America,

primarily through the export of Japanese prints and other art and artifacts, and would also simultaneously shape the European and American image of that exotic culture. And, although it was unrecognized at the time, our presence convinced the Japanese of their need for military might, industrial strength, and the ability to compete with the advanced science and technology of the West.

The year 1859 saw the death of Alexander von Humboldt, the great German naturalist and explorer. Humboldt had attempted to record the accumulated knowledge of the period in his multivolume work *Kosmos*, which influenced both the arts and sciences and led Frederic Church to South America and Charles Darwin to the Galapagos. That same year, one in which Church completed *Heart of the Andes*, Darwin's *On the Origin of Species* was published, altering scientific, religious, and

philosophical thought from that time on. Neither America nor Europe could avoid the ramifications of these ideas, nor the rapid transformations brought on by the advances of science, technology, and industry.

But the intensity of Church's romantic, transcendental vision could not be altered to reflect those changes; by the mid-seventies his landscapes had fallen from favor and the more painterly and expressive works of George Inness, Winslow Homer, and William Merritt Chase had gained great public esteem.

In 1877 the Society of American Artists was founded as a reaction to the more conservative National Academy of Design. (Frederic Church, who had been elected the National Academy's youngest member at twenty-three, was fifty-one in 1877, too crippled by rheumatism to paint, and was concentrating his creative energies primarily on Olana,

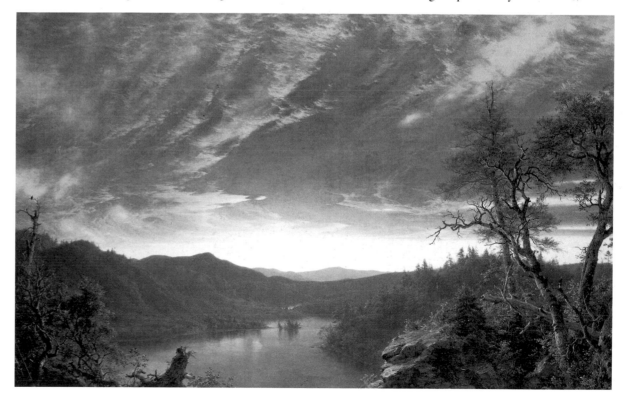

Frederic Edwin Church
Twilight in the Wilderness, 1860
Oil on canvas, 40 x 64 inches
Cleveland Museum of Art, Mr. and Mrs. William H. Marlatt Fund

which would not be completed for another twenty years.) Many of the new society's members, such as Homer, Inness, John La Farge, Homer Dodge Martin, Albert Pinkham Ryder, and J. Alden Weir, had traveled widely in Europe and were more inclined toward the impressionistic approach of the Barbizon School and contemporary French painting than to their elders' strongly shared affinity for the more tightly rendered landscapes of Düsseldorf and the earlier Northern European painters.

George Inness was almost exactly the same age as Frederic Church and a member of both the National Academy of Design and the Society of American Artists. The sickly son of a wealthy grocer, he received some training from John Jesse Barker, and was apprenticed to a map-engraving firm around 1841. Inness constantly carried engravings of the paintings of the Old Masters, even while sketching and painting outdoors. His early works reflect the influence of the Hudson River School, and Thomas Cole in particular, but even in the early paintings, his vision was distinctly his own. In spite of his ailments (he was possibly an epileptic), he moved often and traveled widely. He made his first lengthy trip abroad in 1850, and at that time he became acquainted with the Barbizon School, whose members broke with the classicists and promoted plein-air painting, which paved the way for Impressionism.

Inness considered Corot, Rousseau, and Charles-François Daubigny to be the best of the contemporary French landscape painters. In particular, he followed Corot's practice of making sketches and studies on site, which he then developed into larger works in the studio, always allowing his imagination to prevail over the facts of the topography.

After the Civil War, Inness turned his tonal landscapes toward a new intimacy, a heightened expressiveness, and pictorial invention. He replaced the transcendentalism of the Luminists and the Hudson River School with the mysticism of Swedenborg, and exchanged the clarity of their light for the mystery of shadows. Where Corot incorporated the look of the airy blur of the daguerreotype's long exposure in his late landscapes, Inness gave his silent, dusky scenes the grainy slur of a pinhole photograph and the burnished light of a mezzotint.[8]

When asked once about the locale depicted in a painting, Inness replied, "Nowhere in particular. Do you think I illustrate guide books? That's a picture."[9] He also said of his landscape inventions, "The subject is nothing." But more accurately, he sought to recall his emotional response to a scene, rather than to affirm its visual particulars. In doing so, Inness consciously turned the landscape into a psychological contemplation. The painter, he stated, tries "simply to reproduce in other minds the impression [meaning contemplative response] which a scene has made upon him." The aim of a work, he went on, "is not to instruct, not to edify, but to awaken an emotion. . . . Its real greatness consists in the quality and force of this emotion."[10]

Also a member of the new Society of American Artists was Albert Pinkham Ryder, one of the greatest visionaries in American art, who would invert the landscape further, turning it into a vehicle of interior expression. He was born in 1847 in New Bedford, Massachusetts, across the street from the home of Albert Bierstadt's family. No two artists could have been more dissimilar in temperament, in the timbre of their work, or in the degree of public acclaim and material success they achieved.

Ryder was greatly attracted to the Bible, mythology, and Shakespeare, and those sources provided him with subjects for many of his paintings; but above all, he was a painter of the moods and mysteries of night and the sea.

Unsympathetic to the descriptive paintings of the Luminists, the Düsseldorf-trained, or French-influenced artists, Ryder stated, "The artist should fear to become the slave of detail. He should strive to express his thought and not the surface of it. What avails a storm cloud accurate in form and color if the storm is not therein?"[11] His enigmatic paintings, such as *Moonlit Cove*, are devoid of line and purged of detail and were often fussed over for years. Like memories, they were distilled to their lingering essentials, and their contours were slowly worried and worn into final form through years of reverie. He intuitively shaped his accumulated responses to the sea, the moonlight, the fields, and the forests to fit the contours of myths and legends, then submerged all this in the murky depths of his psyche, ultimately expanding the possibilities of American landscape painting beyond the parameters of simulacra, into the boundless domain of personal expression. It is only during the most recent decades that our notion of expression has been linked primarily to spontaneity and physical evidence of the act of painting, which too often purges the more potent residues of gestation. These preoccupations have ultimately diminished Expressionism's emotive intensity, and its potential for conveying deep angst or edgy enigmas — as seen in the works of Goya, Grunwald, Munch, and Ryder — has been misplaced by the recent Neo-Expressionists, who have reduced it to strident posturing.

Church was the only apprentice ever accepted by Thomas Cole, America's first great landscape painter and founder of the Hudson River School. Heade began his long career by studying coach painting with the Quaker

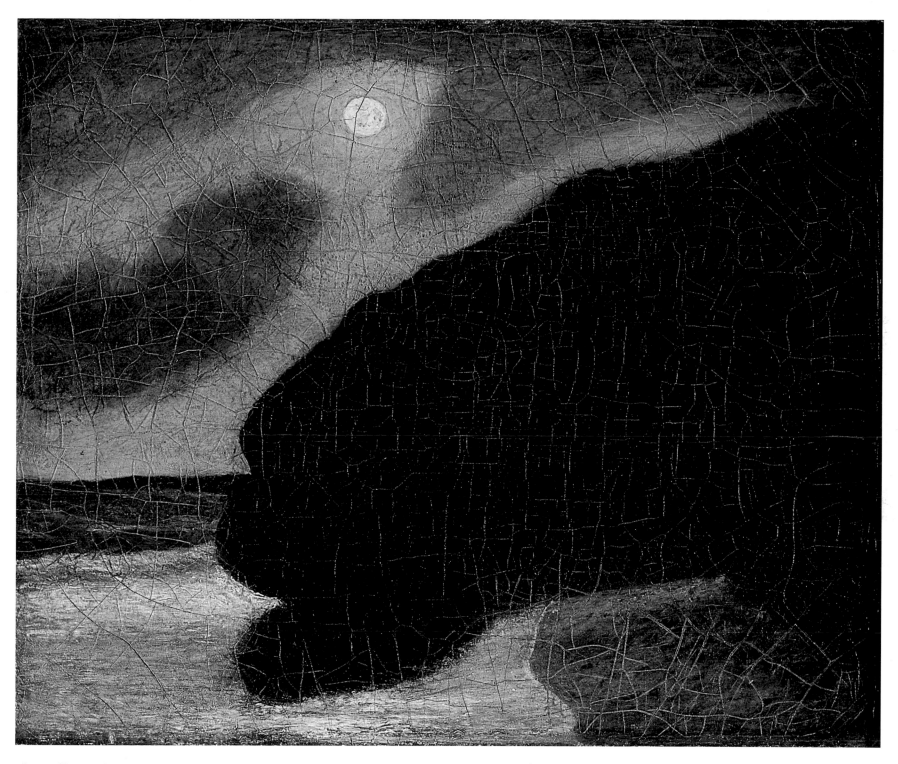

Albert Pinkham Ryder
Moonlit Cove, 1880–90
Oil on canvas, 14⅛ x 17⅛ inches
The Phillips Collection, Washington, D.C.

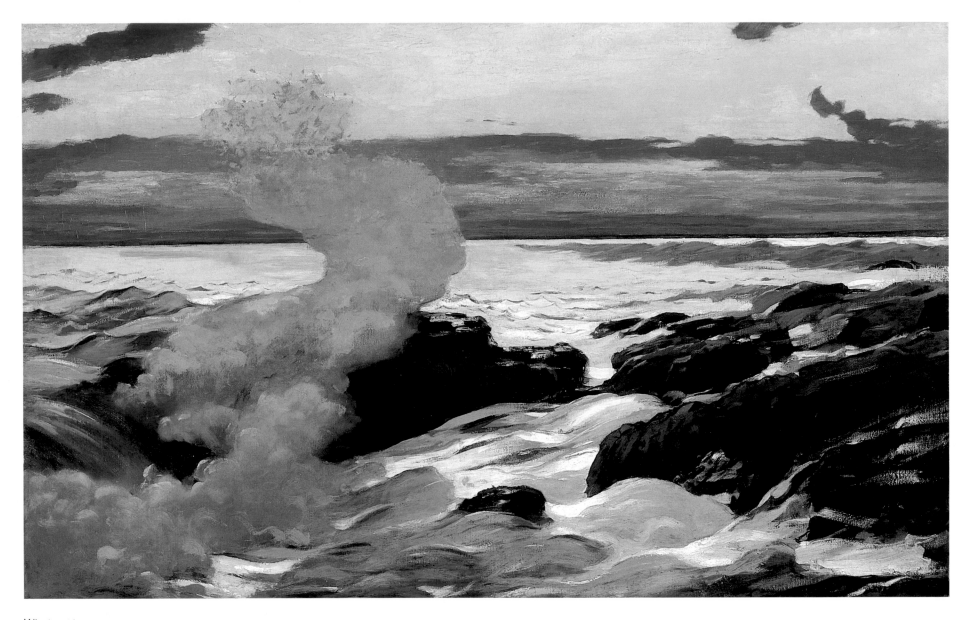

Winslow Homer
West Point, Prout's Neck, 1900
Oil on canvas, 30 1/16 x 48 1/8 inches
Sterling and Francine Clark Art Institute, Williamstown, Massachusetts

artist Edward Hicks. A third great American landscapist took still another road: Winslow Homer learned to draw as an apprentice in a Boston lithography shop, and picked up the rudiments of oil painting from a hack.

Homer, who worked as an illustrator for *Ballou's Pictorial* and *Harper's Weekly*, and served as an artist-correspondent during the Civil War, produced hundreds of wood engravings over a period of more than twenty years and was extremely successful and well known as an illustrator. He studied painting while working as an illustrator, and his oils and watercolors were soon widely exhibited and proved to be as popular as his wood engravings.

Few artists have been as reticent in discussing their work, or as broadly informed, as Winslow Homer. He traveled extensively, making his first trip abroad in 1866, where he saw what was occurring in contemporary French art; as a lithographer's apprentice he would have become familiar with European art through the prints that passed through the shop. Later, as a designer of monochromatic wood engravings, Homer must have been awed by the beautiful compositions, elegant drawing, and extravagant color of Japanese prints coming into the country, for they clearly influenced his best illustrations, and later his watercolors and paintings.

In 1888 Homer purchased an Eastman Kodak No. 1, the first hand-held camera for the mass market. This box camera was sold preloaded, with enough film for one hundred exposures; the entire camera was returned to the factory for processing, then sent back, reloaded, along with the processed prints. From that time on, he used photography as an aid to his paintings and watercolors.

Five years later, Homer traveled to Chicago for the Columbian Exposition, in which he won a gold medal. Louis Sullivan, the great poet of urban architecture, who had designed the lushly ornamented and extravagantly colored Transportation Building,[12] accurately predicted that the fair's Beaux Arts and classical revival buildings (which led to its being nicknamed the White City) would set back American architecture by fifty years. His statement "Form follows function" was Darwinism carried into the aesthetics of design, and he warned that "nature is the source of power; and the city, the arena in which that power is dissipated."[13] (That same year, 1893, Frank Lloyd Wright, the greatest architect of the twentieth century, left Sullivan's firm and began his own practice, and Charles Burchfield was born in Ohio.)

The 1893 Columbian Exposition also included a large exhibition of French Impressionist paintings that brought this work to the attention of a sizable general public in America. Like the clear-hued imagery of the American Luminists, the Hudson River School, and American landscape painters extending into the twentieth century, the look of French Impressionism was made possible by the new chemical pigments; in addition, both Americans and French concentrated on contemporary subjects. Both emphasized light, but for the American painters there was a strong desire to recall the specific look of natural light, whereas their French contemporaries rendered their perception of light and color. For the Impressionists, their subject had become an exterior point of reference for a conceptual expression, while Americans like Homer insistently retained the intrinsic mood and physicality of the landscape.[14]

Unlike the spiritually inclined Luminists who preceded him, Homer described the physical phenomena of nature and the force of its instantaneous acts, which he rendered with painterly spontaneity. He took what he wanted from Europe and the East, and transposed what he took to serve his personal vision. *West Point, Prout's Neck*, painted in late 1900 as a pendant to *Eastern Point, Prout's Neck*, was considered by Homer to be among his finest works, an opinion not shared by the critics of the period. This panoramic stretch of sea recedes to infinity, banded along the horizon by the crimson glow of the last remnants of light, broken by a striation of low, violet clouds. It is a sunset that looks to the Orient. Despite the connections to Courbet's coastal cliffs and breakers, and to Impressionism, the sky and high horizon more closely approximate those found in many of the great Hiroshige prints from *One Hundred Famous Views of Edo* (such as *Senju Great Bridge*, *Horie and Nekozane*, and *Shinagawa Susaki*), while the coiled, frothy wave seems indebted as much to Hokusai's sea "thick with souls" as to Winslow Homer's own mature powers of observation, which are seen here at their height.

Thus, Winslow Homer, like his urban peer Thomas Eakins, moved American art toward its indigenous modern identity. Both were acutely aware of describing with paint, and neither hid the evidence of his hand, unlike the Luminists with their covertly rendered paintings. But both Eakins and Homer were insistent on maintaining a high degree of similitude, as opposed to the more clearly evident formal transformations seen in the work of their French contemporaries.

By the close of the century, the last mysterious details of the national map had been completed, and the full expanse of the continent had been settled. And with the death of Frederic Church in 1900, the dreamers' light of Luminism was extinguished. *West Point, Prout's Neck* was an authentic, fresh, and assertively American vision for the new century.

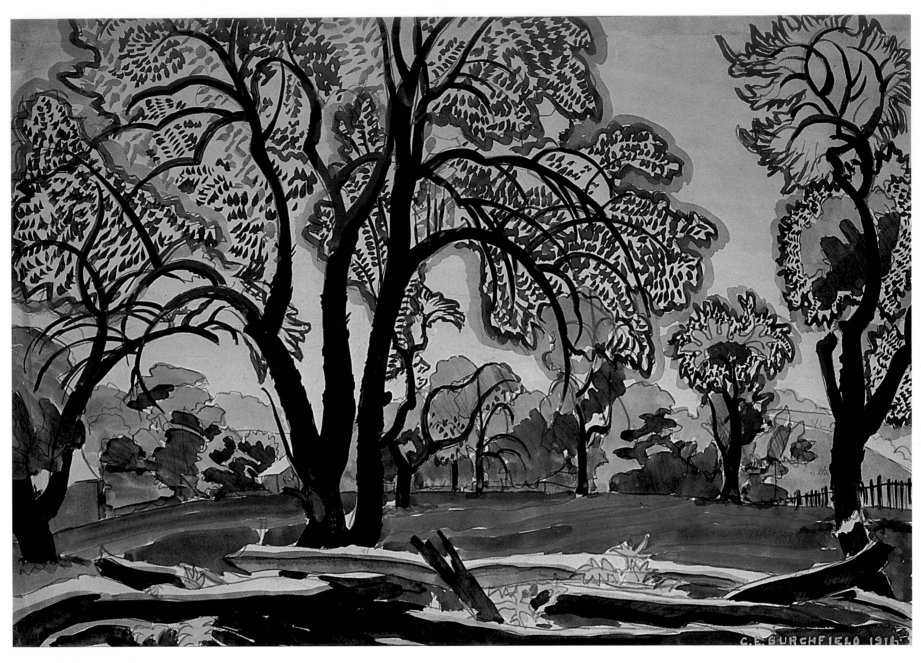

Charles Burchfield
Decorative Landscape, Hot Morning Sunlight (Post's Woods), 1916
Watercolor on paper, 13⅞ x 19⅞ inches
Collection of Munson-Williams-Proctor Institute Museum of Art, Utica, New York, Edward W. Root Bequest, 1957

CHAPTER TWO
THE LANDSCAPE INTERPRETED

The American Nation has a heart and a backbone and a pattern of its own and is rapidly forming a mind of its own.

Frank Lloyd Wright[1]

During the first year of the twentieth century, Glenlloyd, the residence Frank Lloyd Wright designed for Harley Bradley, was constructed in Kankakee, Illinois. It not only extended the Arts and Crafts aesthetic but was one of the earliest indications of the influence of Japanese prints on Wright's highly indigenous architecture.

In the fall of 1900 William McKinley was reelected president, with Theodore Roosevelt as vice president. Edward Hopper was studying with Robert Henri at the New York School of Art, and Maxfield Parrish, already well known in America and abroad for his posters and illustrations, was at work on drawings for the Kenneth Grahame children's book *Dream Days*, a sequel to their popular collaboration on *The Golden Age*.

Wright gave his prophetic speech "The Art and Craft of the Machine" on March 6, 1901. The speech extended aesthetic integrity to the machine-made object, rather than ignoring its inherent potentials, which clearly distanced Wright from the Arts and Crafts movement. Within two years, this thinking was brilliantly illustrated in the Larkin Building (Buffalo, New York), in which was seen the first use of metal office furniture, plate glass, and air conditioning; the next year saw the completion of Unity Temple (Oak Park, Illinois) and the first use of the concrete monolith in cast molds in American architectural construction. The year 1910 saw the publication of the Wasmuth Portfolio in Berlin. This rare and beautiful collection of Wright's drawings and plans of studies and executed buildings from 1893 to 1909 was to have an international impact that would, ironically, be distorted by the German Modernists and would return to tyrannize American architectural thought and practice after two world wars. By the time of its publication, Louis Sullivan's architectural commissions were small, few, and far between.

In 1913 the Armory Show, the most legendary and influential art exhibition ever held in this country, jolted conservative American sensibilities and was ridiculed by the press. (It was seen by almost 70,000 people in New York, and in Chicago by nearly 190,000. Because of the inclusion of avant-garde European works, its reception was often hostile, especially in Boston.) The exhibition contained thirteen hundred pieces by more than three hundred artists, with a large and insightfully chosen group representing the modern movement in Europe. The most highly publicized and shocking pieces were Duchamp's *Nude Descending a Staircase* and Brancusi's *Mlle. Pogany*.

Contrary to the intentions of the organizers, the American artists exhibiting, including the organizers themselves, were completely overshadowed by the Europeans. But the influence of Post-Impressionism would be monumental, and so too Cubism, although in a misunderstood form that would be long-lasting in effect, reverberating even in much of today's art.

By 1910, Ohio-born Charles Burchfield, one of the great artistic visionaries of the twentieth century, was a teenager and already indicating a great facility for drawing, an uncanny instinct for observing nature, and a precocious ability to record his responses in drawings and watercolors. At the time of the Armory Show, he was in art school, and although he did not see the exhibition, he was surely aware of its impact.

After graduating from high school, Burchfield worked in Salem, Ohio, for a year as an accountant, and then with money saved and a scholarship, he entered the Cleveland School of Art (now the Cleveland Art Institute) in 1912. Jinry G. Keller was his most influential teacher and also introduced him to the music of Wagner and Stravinsky. At his urging, Burchfield attended performances of the Diaghilev Ballet. The sets and costumes designed by Leon Bakst had a lasting effect on his work, although not as profound as the influence of Japanese prints,[2] or the monumental impact of an exhibition of Chinese scroll paintings he saw as a student, which paralleled his own pantheistic inclinations.

After a brief, unhappy sojourn in New York, he returned to his old accounting job in Salem and painted during every spare

moment. Between 1915 and 1921, when he moved from Ohio to Buffalo, New York, at the age of twenty-eight, Charles Burchfield produced a body of work that is unique in American art.

Like the paintings of Albert Pinkham Ryder and George Inness, Burchfield's work stems from a deeply personal vision and is expressive rather than naturalistic; and again as in the works of Ryder and Inness, its content is the moods of nature. But Burchfield's watercolors differ from their landscapes in that his are derived from an intense scrutiny of the subtleties of light, weather, and the rhythms of the seasons. He brought these elements to the very brink of mystical vision through the use of heightened color and tone and through the invention of an abstract, almost calligraphic codification of nature and its conditions that pictorially paralleled the specific nuances of sunlight, temperature, sound, and movement.

From the beginning, Burchfield's art was an amplification of nature; and his lifelong intention was clearly stated in 1963: "An artist must paint, not what he sees in nature, but what is there. To do so he must invent symbols, which, if properly used, make his work seem even more real than what is in front of him. He does not try to bypass nature; his work is superior to nature's surface appearances, but not to its basic laws."[3]

Decorative Landscape, Hot Morning Sunlight (Post's Woods) depicts an area on the northeastern side of Salem, Ohio. It was drawn in pencil directly from nature, with color notations made on the paper, and watercolored later. The drawing succinctly records the specifics: rows of trees, an old fence, several small structures, and felled trees in the foreground. A gentle, rhythmic pattern is created in branches of the trees, but the addition of color drastically heightens the mood and radiance of this particular moment . . . sunlight flashing through fluttering leaves, the heat of summer absorbed by the earth, and the utter clarity of the light.

Here we see Burchfield, the first great painter of the quiet secrets of our agrarian heartland, inventing his own form of Fauvism in order to amplify his instinctive pantheism.

While 1916, the year Burchfield painted *Decorative Landscape*, marked the beginning of this great visionary's long career as a painter, it also saw the further decline of Louis Sullivan's career. The preliminary drawings for the Peoples Savings and Loan Association building in Sidney, Ohio, were being prepared by the "father" of modern architecture. The year before, Sullivan's richly ornamented Home Building Association in Newark, Ohio, 150 miles from Salem, had been completed. For Sullivan, alcoholic, down on his luck, and living in a cheap Chicago hotel at that time, the commissions were hard to come by; but his Midwestern small-town banks, with their lush colors and extravagant ornamentation abstracted from nature, were among the greatest and most rare achievements in twentieth-century architecture. Although many of his buildings have been destroyed or badly defaced, these late, small banks show that Sullivan's vision never dulled. Nor is it likely to be surpassed.

Charles Burchfield's career spanned more than a half century. Although his work evolved over the years (at certain points even seeming to converge with Regionalism and urban realism), his images never crossed over into abstraction, as did the extraordinary visionary paintings of Arthur Dove and the geometric distillations of John Marin. He remained true to his deeply held convictions at a time when art criticism was dominated by voices stridently opposed to the viability of his vision. In 1959, Burchfield wrote the following statement, titled "The Barren Road of Decoration":

I would just as soon not comment on the arts of today other than to say that I think any comment is futile; when a decadence sets in, and really gets rolling, there is nothing that can stop it; it must run its course before a renaissance can begin.

I can't possibly see what a course in design would do for an artist if he did not also have academic training in life drawing, still life, and composition — in fact, the renaissance in the arts I mentioned will be impossible unless these subjects are restored to the artist's training. Otherwise we will continue on the barren road of decoration most artists are now traveling. Thank God there are a few individualists who refuse to conform.[4]

Unintimidated by the prevailing aesthetic dogmas, Burchfield considered painting a moral and spiritual act of communication, a position that connects him more with the Luminists than to his peers in contemporary art.

Like Burchfield, Edward Hopper was never swayed by abstraction. In 1900 he enrolled at the New York School of Art. There he studied with William Merritt Chase, Kenneth Hayes Miller, and Frank Vincent DuMond, but Robert Henri would be his most influential teacher. The Chase School, as it was also called, was at its peak in these years: Gifford Beal, George Bellows, Guy Pène duBois, Patrick Henry Bruce, Rockwell Kent, Walter Pach, Vachel Lindsay, and Clifton Webb were Hopper's classmates. (Lindsay abandoned painting for poetry and Webb became an actor.)

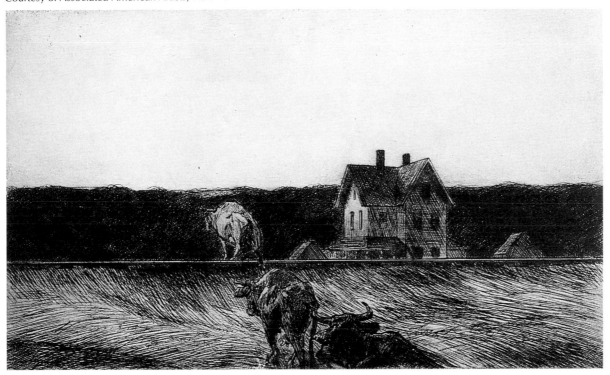

Edward Hopper
American Landscape, 1920
Etching, 7½ x 12½ inches
Courtesy of Associated American Artists, New York

In 1906 Hopper traveled in Europe for eleven months, and when he returned to New York, he once again supported himself as an illustrator and commercial artist while painting in his spare time and summers, and exhibiting with other former students from the Chase School. In 1913 his painting *Sailing* was included in the Armory Show.[5]

Hopper took up etching in 1915, with technical advice from his friend Martin Lewis (one of the most underrated figures in American art). Hopper's etching press remained in his studio until his death, but his output was rather small. In spite of this, the etchings served to crystallize Hopper's vision as a painter, and his most characteristic and well-known paintings were produced concurrently with his best prints. The etchings produced between 1920 and 1925 rely on the most straightforward use of that medium, the bitten line etched for density and the tones built from light to dark by cross-hatching. He printed with the blackest ink he could find, and used a very clean wipe on the whitest paper. Process, image, and content were distilled to their essentials; the ambience of place and season is described by the act of its particular light. When the printmaking ceased, he carried the same qualities into the studies and sketches for his paintings, which were done with conte crayon and occasionally reinforced with charcoal, the two darkest dry mediums available.

American Landscape is one of the most memorable images in the art of our time; it is a scene set with no waste, described with great economy, and conveyed with authority by a laconic master. The clear evening light illuminates the side of a farmhouse and catches a full-bellied cow as it crosses the tracks. The cow is trailed by two others, sauntering toward the grade where they will pass briefly through the late sun in their daily move from pasture to barn. This is a solitary, unvarying routine of man, kine, and nature, recounted without lapsing into sentimentality, idealization, or nostalgia. It is simply milking time.

These same characteristics appear in *The Camel's Hump*, a painting from Hopper's second summer in South Truro, Massachusetts, on Cape Cod, where he would build a studio three years later. As he had done earlier in his etchings and drawings, and then in his watercolors, Hopper purged his oils of painterly ostentation, which in any case had always been well controlled. The sensuality of paint, the emotional potential of color, the artfulness of description, and the ego of the artist are all held in submission to the physical look of the land articulated by light. Hopper becomes a conduit, directing, editing, and intensifying our view of the exterior world in a manner that corresponds with his own personal vision.

Edward Hopper concisely summed up his intentions in 1933. "My aim in painting has always been the most exact transcription possible of my most intimate impressions of nature."[6] Until the end, he kept his distance from American Modernism, but not as a small-minded act of provincialism. In *Notes on Painting*, he stated, "There may come or perhaps has come a time when no further progress in truthful representation is possible. There are those who say such a point has been reached and attempt to substitute a more and more simplified and decorative calligraphy. This direction is sterile and without hope to those who wish to give painting a richer and more human meaning and a wider scope."[7]

Edward Hopper
The Camel's Hump, 1931
Oil on canvas, 32¼ x 50⅛ inches
Collection of Munson-Williams-Proctor Institute Museum of Art, Utica, New York, Edward W. Root Bequest

In spite of Hopper's strong attraction to France, his mature vision is indigenous. He praised his friend Robert Henri for his effort to make "the art of this country a living expression of its character and its people,"[8] a description that also sums up the traits that distinguish Hopper's own work.

For the contemporary Realists, whether their focus is on narrative, urban, or landscape themes, whether they are plein-air painters or Photo-Realists, the work of Edward Hopper is the point at which they all converge.

The years between the two world wars were a time of great social, political, scientific, and aesthetic flux. Americans, restrained by Prohibition, hailed the Jazz Age, while the heartland suffered an agricultural depression and more than half of the country struggled along on an annual income of less than $2,000. In 1922, the tomb of Tutankhamen was discovered in Egypt; Robert Flaherty produced his great silent documentary *Nanook of the North*; the Modernists Charles Sheeler and John Marin were both painting in New York; Eugene O'Neill was completing *The Hairy Ape*; and F. Scott Fitzgerald's *The Beautiful and Damned* was published. A year later, President Calvin Coolidge's speech to Congress was the first to be broadcast over radio. In Germany, Hitler, in his prison cell, wrote *Mein Kampf* and Max Beckmann produced the woodcuts *Before the Mirror* and *Charnel House*.

In the twenties and thirties, a Maxfield Parrish illustration could sell almost anything. Parrish's popularity as an illustrator recalls Winslow Homer's a half-century earlier. Homer, chronicling contemporary events in the period prior to the introduction of photoreproduction, depicted events of the real world; Parrish, on the other hand, evoked an ideal and untroubled world, especially appealing in a period of increasingly oppressive hardship and widespread financial insecurity. His unparalleled success stemmed from his innate ability to create the most unabashedly romantic, pellucid, and seemingly iridescent colored images of this mythical realm. His serenely sentimental work was consciously aimed at a broad general audience when escape from a dismal reality was most needed. In addition, he had the good fortune to be working at a period of rapid technical growth in color printing.

Parrish illustrations were commissioned for almost every kind of advertisement — tires, bath soaps, cosmetics, lamps, and Jell-O. The breakthrough came with the commission for a cover decoration for a Crane's 1916 Christmas gift chocolate box: some ten thousand packages were sold. Crane's Chocolates immediately commissioned the next year's gift box, based on the *Rubaiyat*; this image was also sold as a large reproduction, and earned Parrish, the "businessman with a brush," thousands of dollars in royalties. In fact, the royalties from the images for Crane amounted to more than $50,000.

By 1920, Parrish was making paintings for the sole purpose of reproduction. His *Daybreak*, first reproduced in 1923, remains one of the most widely known and popular images of all time. Within months of its publication, it earned the artist more than $25,000 in royalties. In 1925, when the average income was $2,000, Parrish earned more than $75,000 from reproductions of his paintings. Coy Ludwig, Parrish's biographer, accurately analyzed the reasons for their success:

The paintings, especially Daybreak, *had the appearance that art was expected to have. In it Parrish had painted a modern version of a nineteenth-century academic subject . . . carefully designed, accurately drawn, exquisitely painted, idealized, exotic . . . yet not too foreign and above all pleasant. The paintings were calculated to appeal, as reproductions, to the widest possible audience.*[9]

But Maxfield Parrish longed to devote his energies to landscape painting. In 1929, the year of the stock market crash, Brown and Bigelow, a major publisher of greeting cards and calendars, asked Parrish to paint a landscape for their calendar line, giving him the opportunity he had longed for but would not fulfill until 1934. The painting was *Elm, Late Afternoon*. Parrish, then sixty-four years old, would maintain his relationship with Brown and Bigelow for more than thirty years. Troubled with arthritis and ill health, he stopped painting at the age of ninety-one, and he died at ninety-five, in 1966; his career had spanned seventy-five years.

Although most of his idealized subjects were derived from the New England landscape, they were amalgams rather than specific views. In a letter written in 1952, Parrish stated, "Realism should never be the end in view. My theory is that you should use all the objects in nature, trees, hills, skies, rivers and all, just as stage properties on which to hang your idea, the end in view, the elusive qualities of a day."[10] Whether he was illustrating myths and fairy tales or painting the New England landscape, he never felt the limitations of physical facts; his trees kept their foliage through the worst of winter, his ponds were often painted from plate glass or mirrors, the buildings were sometimes painted from models, and the mountains were likely to be painted from photographs of collected stones. He retained his proximity to the mythic, the ideal, rather than to geographical truths.

The itinerant, melancholy aesthete Marsden Hartley was one of America's first great modern painters. While his grace,

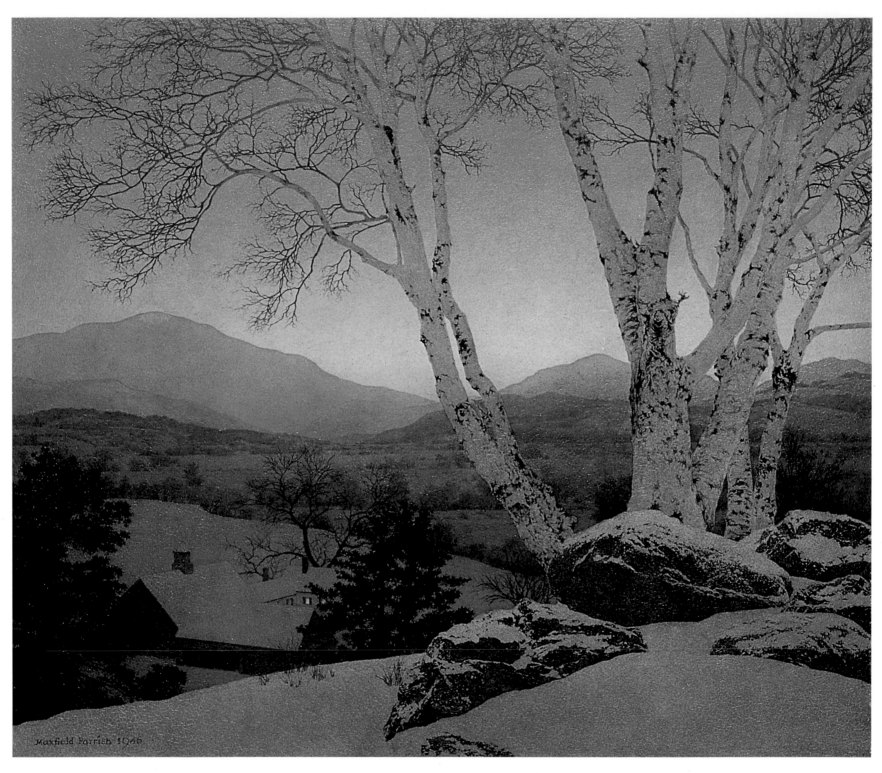

Maxfield Parrish
Birches in Winter, 1946
Oil on panel, 13 x 15 inches
Courtesy of Vose Galleries of Boston

charm, and intelligence gave him access to the most advanced intellectual and artistic circles of his time, his personal demons kept him constantly on the move, and kept his personal vision in constant flux. He was influenced by almost everyone and everything. Though his art was admired by the keenest minds of his generation, Hartley was a careerist and an opportunist who consistently failed, and he never attained financial security. He was an intimate of the best artists, writers, and political radicals of his day, but was equally at home with the fishermen and villagers of New England and Nova Scotia. Ultimately, Hartley could sustain no personal relationships, largely because of his sexual obsessions, and much in his art was a sublimation of his homosexuality.

While Maxfield Parrish was living comfortably from his royalties, Marsden Hartley was forced to destroy more than a hundred paintings and drawings because he could not pay the storage fees. In the early forties, when the immensely popular Parrish was painting his idealized New England landscapes in the comfortable seclusion of his Arts and Crafts home, Hartley was moving between rented rooms in Maine and the Winslow Hotel in New York, and painting some of his most starkly introspective and haunting images in makeshift studios. Three years before his death in 1943, Hartley sold twenty-three paintings for $5,000, far less than Parrish made in royalties per year. The Parrish paintings, which are rooted to the sensibilities of the Arts and Crafts movement, were painstakingly built up with layers of glazes; Hartley's paintings were often completed in a day. Parrish gave us light serenades of tranquillity and nostalgia, which have remained extremely popular; Hartley made visible his gut-wrenching angst,

disguised as landscape, and those works remain as disconcerting today as the day they were painted.

In Nova Scotia in the midsummer of 1936, working from memory, Marsden Hartley began his third series of paintings of Dogtown, a moraine of glacial boulders and dilapidated stone walls on the outskirts of Gloucester, Massachusetts. He described the area as

a place so original in its appearance as not to be duplicated either in New England or anywhere else — and the air of being made for no one — for nothing but itself. . . . A sense of eeriness pervades all the place therefore and the white shafts of these huge boulders, mostly granite — stand like sentinels guarding nothing but shore — seagulls fly over it on their way from the marshes to the sea — otherwise the place is forsaken and majestically lovely as if nature had at last found one spot where she can live for herself alone. . . . No triviality enters such places as these . . . a cross between Easter Island and Stonehenge — essentially druidic in its appearance — it gives the feeling that an ancient race might turn up at any moment and renew an ageless rite there.[11]

That was the summer his beloved Alty, a macho giant of a man, drowned in a foolhardy attempt to row back to Eastern Points, Nova Scotia, in a storm, and Hartley's grief and melancholia saturate the air of these reveries of Dogtown.[12]

The chunky, heavily outlined forms of boulders, trees, and distant hills and the compressed space of the late *Dogtown* paintings reflect back to those mystical condensations of the night coast by Albert Pinkham Ryder, whom Hartley had sought out and befriended in 1909, and to the German Expressionists he had associated with in Berlin before the war; they also contain traces of Picasso's transliterations of Cézanne. These manifestations of personal despair are paintings with a past that map a major path to the present.

Charles Sheeler, like Marsden Hartley, was a Modernist. He was born in 1883, a year after Edward Hopper. In 1900 he entered Philadelphia's School of Industrial Art, which had an Arts and Crafts orientation and provided a solid academic foundation. Three years later, Sheeler studied (as did Hopper, O'Keeffe, Dickinson, and many other distinguished painters of the period) with William Merritt Chase at the Pennsylvania Academy of the Fine Arts, and while a student there made trips to London and Spain with a group led by Chase.

Like many other artists, Sheeler developed a parallel career that served as an alternative means of support (Hopper and Homer were illustrators, Burchfield designed wallpaper). In 1910 he began working as an architectural photographer, and this concurrent interest was never abandoned. He continued to make photographs, and used them as source material for his paintings and drawings throughout his career.

Sheeler's trips to Europe, and the Armory Show, in which he exhibited six paintings, had a deep and profound influence on his early work, and this is clearly reflected in the Cézannesque and Cubist-inspired pieces he produced between 1910 and 1924. But it is in the works after that period that Sheeler appears to have found his personal center of gravity as a painter, and it is those paintings that have had the most profound influence on the art of the past two decades.

These photo-derived paintings, such as *Upper Deck* (which he considered to be a turning point in his career[13]), *Rolling Power*, and *American Landscape*, all classics in American art, are crisply composed, sharply delineated, concisely edited, painterly

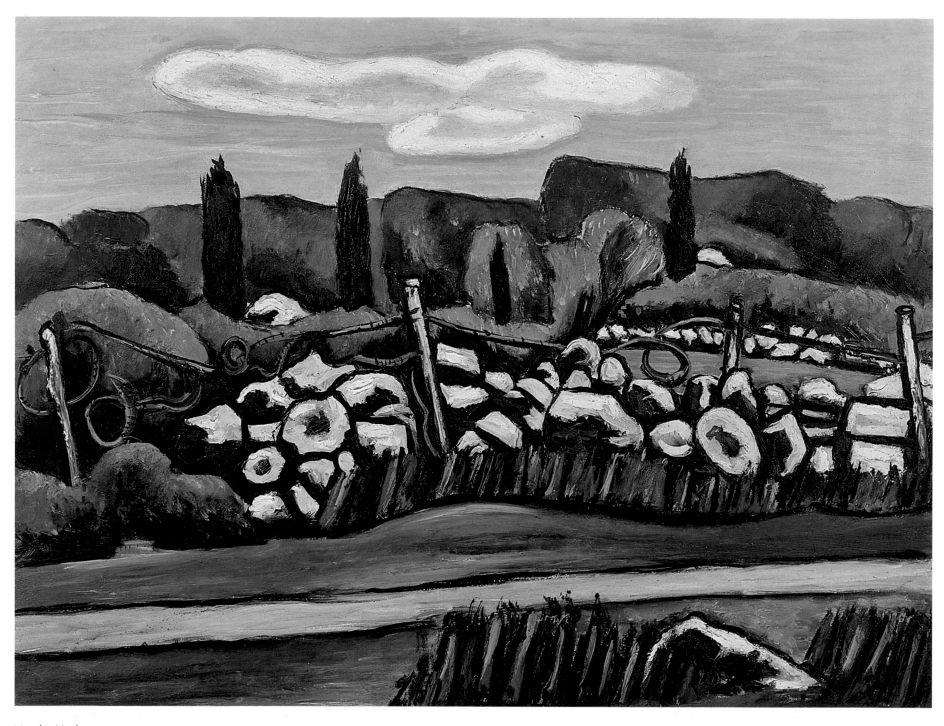

Marsden Hartley
The Last Stone Walls, Dogtown, 1936–37
Oil on canvas, 17½ x 23½ inches
Yale University Art Gallery, New-Haven, Connecticut, Gift of Walter Bareiss, B.A. 1940

Grant Wood
Fall Plowing, 1931
Oil on canvas, 30 x 40¾ inches
Deere and Company, Moline, Illinois

Charles Sheeler
View of Central Park, 1932
Conte crayon, 17½ x 18⅝ inches
Private collection

understated, and emotionally cool — and highly rememberable images.

Sheeler's *American Landscape* is the antithesis of the Hopper etching from the previous decade. Hopper considered the quintessential American landscape to be a place dominated by nature, a scene of solitude and quietude; Sheeler found its greatest reflection in the monumental industrial plants of Detroit. His *American Landscape*, painted in 1930, depicts Ford's River Rouge plant. Each of the natural elements is dominated by the machinery of man: The sky is streaked by the smoke of the furnaces, the ore has been mined and lies heaped in bins, and the water flows through a slip channeled for barges. Blue and green, the colors most often associated with nature, are conspicuously absent.

In 1937 Sheeler wrote, "Photography is nature seen from the eyes outward, painting from the eyes inward. Photography records inalterably the single image while painting records a plurality of images willfully directed by the artist."[14]

Sheeler's drawings after 1930, which were done with conte crayon, not only were based on photographs but also took on the qualities of the photograph. Their clarity, tonality, and lack of emphatic line are all characteristics of that medium. His *View of Central Park*, a drawing Sheeler made for his patron, Abby Aldrich Rockefeller, is striking in its use of velvety blacks in the foreground and the subtle modulation of grays in the middle and background, marking the atmospheric recession to the distant, enclosing wall of skyscrapers.

Almost a half-century later, through his unabashed incorporation of both the means and the look of photography, his control of the medium, his focus on the man-made environment, his seemingly objective viewpoint, and the contemporaneous character of his subjects, Charles Sheeler would emerge as a major progenitor of Photo-Realism.

The work of Grant Wood reflects a drastic turn from the saturated, interior vision of Marsden Hartley and the cool, photo-derived works of Charles Sheeler. Wood's *Fall Plowing* was completed in 1931 as the economy approached its bleakest period.[15] Both the Chrysler Building and Empire State Building, those great symbols of modern architecture and engineering, had been completed, but more than four million people were unemployed, and bank closings continued. Gangster Al Capone had an annual income in excess of $20 million, but as a fairer note in that dark year, he was sent to prison for income tax evasion.

Wood differs distinctly from the earlier landscape painters in his use of art as a means of social commentary, in particular through his advocacy of Regionalism, through his nostalgic view, and his idealization of the virtues of Midwestern agrarianism. This conflict with facts was made dramatically clear by the concurrent documentation of the farmers' plight by the Farm Security Administration photographers, such as Walker Evans, Dorothea Lange, Russell Lee, and Arthur Rothstein — one of the greatest moments in American art. Grant Wood, Thomas Hart Benton, and John Steuart Curry were considered the triumvirs of American Regionalism by the conservative critic Thomas Craven, who argued that Regionalism was a healthy counter to the growing influence of modern art. Wood, while devoted to the American scene, was not a provincial. He had made several trips abroad, and his meticulous technique reflected the influence of Flemish painting. However, his spherical, stylized trees were fondly adapted from the patterns found on inexpensive Chinese-patterned willowware plates, which were in wide use in the thirties.

In the foreground of *Fall Plowing* is the plow, separated from the team at the end of the day and left in midfurrow. The plow is an ancient symbol of the breaking of prime matter, exposing the earth to the influence of heaven, and it phallically represents man's mastery of the fertile, feminine earth. By the mid-thirties the plow had been replaced by the tractor, but here, with the dark, abundant soil of the rolling, tilled fields receding to infinity, it is the center of an idealized American myth, painted during a great national crisis that was particularly severe for the farmer.

In 1935 Grant Wood's reputation was at a peak. He lectured throughout the Midwest, and wrote a manifesto titled *Revolt Against the City*, in which he blamed the Depression on industrialism and urban values.

The present revolt against the domination exercised over art and letters and over much of our thinking by Eastern capitals of finance and politics brings up many considerations that ought to be widely discussed. . . . It is certain that the Depression Era has stimulated us to a re-evaluation, of our resources in both art and economics . . . awakened us to values which were little known before the grand crash of 1929 and which are chiefly non-urban.[16]

Such inflammatory and provincial rhetoric has hampered our ability to see Regionalism accurately: as an authentic native vision, but one that was on occasion parochial and incapable of transcending its time.

In the culture of the nomadic American Indians, plowing was considered a violation of the body of Mother Earth. Using the same symbols as Wood, Alexandre Hogue

emphasized this aspect less than a decade later in his allegorical painting *The Crucified Land*, done in 1939. This highly charged, bitter work parallels the haunting documentary images by Farm Security Administration photographers, and the tragic plight of the "Okies" depicted in John Steinbeck's *Grapes of Wrath*, published that same year. Hogue, born in Missouri in 1898, was raised in Denton, Texas; he saw firsthand the thoughtless abuse and exploitation of the land and experienced the resulting catastrophe of erosion by wind and water. *The Crucified Land* is a powerful expression of social concern but offers no sympathy to those who suffered from the disaster of those erosions, for their own shortsighted actions had brought it on. Hogue explained the painting a few years later:

The red soil from the area south of Denton was chosen as in keeping with the symbolical meaning of land crucified. This is an abandoned field once farmed by the guy who plowed downhill, inviting water erosion to eat through the rows. All furrows point to the tractor which represents man's misuse of the land. . . .
The rain at the upper left has just passed, leaving everything wet and glistening and leaving the overalls on the scarecrow hugging tight to the 2×4 support which thus becomes a dominant cross. . . . The whitish-green needle grass moves in and takes over where soil is depleted.[17]

Alexandre Hogue's paintings of the Dust Bowl and the effects of water erosion are perhaps the first conscious ecological statements in American art, and they are certainly among the most emphatic, deeply felt, and prophetic works of the period.

The iron-willed and fiercely independent Georgia O'Keeffe decided when she was ten years old to become an artist. Like Hartley, Hopper, Sheeler, Dickinson, and Charles Demuth, she studied with William Merritt Chase; but it was her later encounter with the design concepts of Arthur Wesley Dow, based on the principles of the Synthesist painters, Art Nouveau, and Oriental art, convergent with the aesthetics of the American Arts and Crafts movement, that were of lasting significance in her art.
O'Keeffe's relationship with Alfred Stieglitz is legendary. In May 1916 Stieglitz exhibited her work in his gallery, 291, without her knowledge or permission. They met in a confrontation over this event, which marked the beginning of their long relationship. In 1924 they married. He continued to exhibit her work annually, and it was well received by both critics and collectors. Reciprocally, she was the subject of hundreds of his photographs.
Over the years O'Keeffe spent increasing amounts of time in New Mexico, in one of the guest houses of Mabel Dodge Luhan, who had created an artistic circle in Taos by her hospitality to Marsden Hartley, D. H. Lawrence, and other painters and writers. Later O'Keeffe summered at Ghost Ranch near Abiquiu, and in 1945 she bought the house she had stayed in there. After Stieglitz's death in 1946, she moved permanently to New Mexico.
Even in her early work, O'Keeffe moved at will between varying degrees of abstraction and realism, but it is her enigmatic and sensual interpretation of Southwestern landscapes that has left the most indelible imprint in American art. That arid region, with a terrain as foreign and barren as a distant moon, scattered with bleached bones and desert flowers, struck a chord deep in O'Keeffe's psyche, and provided her with themes she would explore for more than a half century.

One of her favorite areas, deep into the Navajo country, she called the Black Place. O'Keeffe painted between twelve and fifteen variations of this spot, some of them from memory, some in shades of reds or greens. The expressive use of color and form in these landscapes apparently reflects back to Dow's principles, while eschewing all signs of Impressionism, the influence of Cézanne, or European Modernism. An aspect that O'Keeffe denied at times is the sensuality of her form and color. Where Alexandre Hogue and Grant Wood made anthropomorphic references through the use of female forms in their landscapes, O'Keeffe modeled the earth, plants, and bones as though they were flesh. There is a consistent undercurrent of animistic sexuality in her emblematic flowers and landscapes, and with the elimination of sky or other elements of clear scale, as in *Black Place II*, the wind- and water-worn land assumes an enclosed, visceral character. She has stated,

It is surprising to me to see how many people separate the objective from the abstract. Objective painting is not good painting unless it is good in the abstract sense. A hill or tree cannot make a good painting just because it is a hill or a tree. It is lines and colors put together so that they say something. For me that is the very basis of painting. The abstraction is often the most definite form for the intangible thing in myself that I can only clarify in paint.[18]

These highly conceptual images were formulated in her period of study with Alon Bement, a Dow disciple, and later with Dow himself, of whom she said, "It was Arthur Dow who affected my start, who helped me to find something of my own. . . . This man had one dominating idea: to fill a space in a beautiful way."[19]
Rather than taking the path to Modernism through Impressionism and Cubism, O'Keeffe, like Burchfield, followed a different but equally vital and more humanistic course

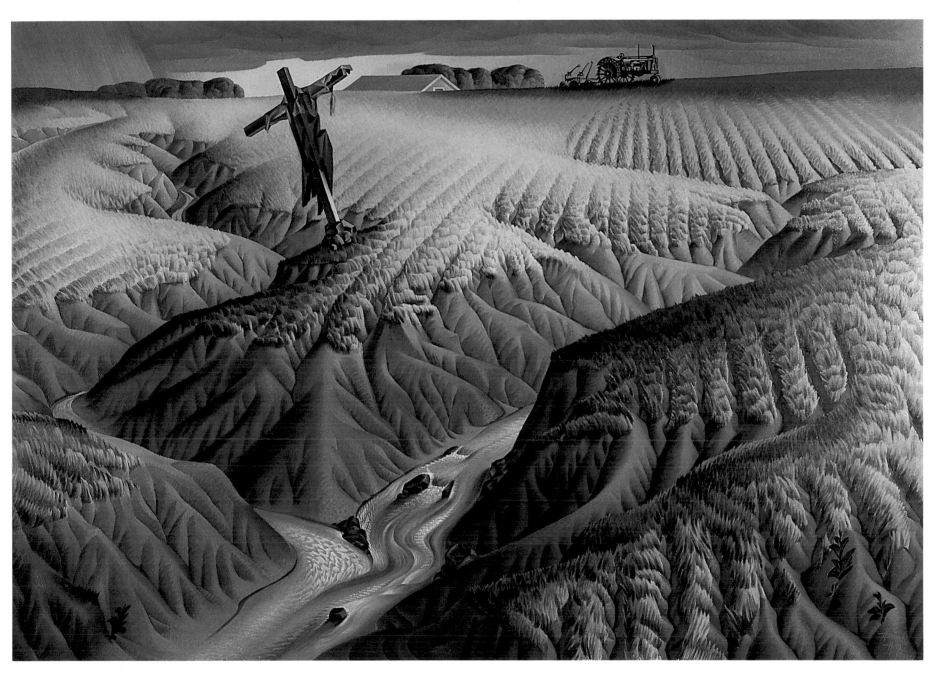

Alexandre Hogue
The Crucified Land, 1939
Oil on canvas, 42 x 60 inches
The Thomas Gilcrease Institute of American History and Art, Tulsa, Oklahoma

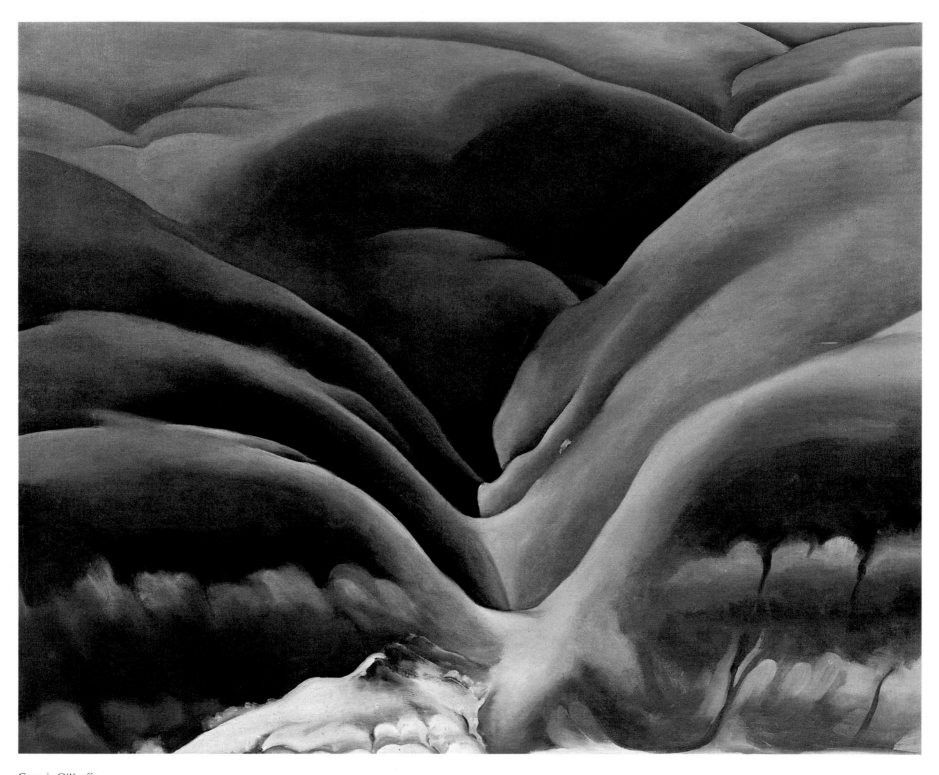

Georgia O'Keeffe
Black Place II, 1945
Oil on canvas, 24 x 30 inches
Courtesy of Gerald Peters Gallery, Santa Fe, New Mexico, and Dallas, Texas

via Gauguin, Japanese and Chinese art, and the Arts and Crafts movement. It is a path with parallels in the leafy ornamentation of Louis Sullivan, the organic architecture of Frank Lloyd Wright, and the warm, gracious southern California bungalows of Greene and Greene.

Equaling the intensity of Georgia O'Keeffe's anthropomorphic interpretation of the southwestern desert is Milton Avery's sensual response to the light and air of Cape Cod. Like her paintings, the more sweet-tempered, poetic landscapes of Milton Avery were widely admired, and opened possibilities for those inclined toward either figuration or pure abstraction. He fused the melancholic and inscrutable vision of Ryder and Hartley with the seductive color of Bonnard and the reductive imagery of the last Matisse cutouts, while maintaining a childlike joyfulness in the quietude and minor pleasures of nature.

Avery was for the most part self-taught. Inauspiciously prepared for a painting career through a correspondence course in lettering when he was nineteen, he then took a night job at the United States Tire and Rubber Company so that he could paint outside during the daylight hours, and ten years later he studied very briefly at the Connecticut League of Art Students.

He met Sally Michel at an artists' colony in Gloucester, Massachusetts, in the summer of 1925 and married her the following spring. She was an illustrator and managed to work steadily through the Depression and after, which allowed Avery to devote his full energies to painting. His work did not sell with any consistency until the fifties, even though he made his first museum sale, to the Phillips Collection, in 1934, and he had his first solo exhibition at the Valentine Gallery in 1935.

The Averys summered at various places on the New England coast, where Milton filled many sketchbooks with small drawings, often with color notations. From these the larger watercolors were developed, and from them the oils were painted. His process was reductive, gradually distilling an image to its most elemental shapes and patterns. The use of color was intuitive and expressive, freed from the dual constraints of nature and theory. Ultimately, the paintings were lyrical expressions of the minor moments and simple pleasures of nature.

This sensual synthesis of nature, filtered of all discord and discontent, brought the image to the edge of pure abstraction. A step further, as demonstrated by his close friend and admirer Mark Rothko, and the subject would evaporate into a mist of eloquent color and pulsating shapes. When Avery died in 1965, Rothko wrote in commemoration:

Avery is first a great poet. His is the poetry of sheer loveliness, of sheer beauty. Thanks to him this kind of poetry has been able to survive in our time. This — alone — took great courage in a generation which felt that it could be heard only through clamor, force and a show of power. But Avery had that inner power in which gentleness and silence proved more audible and poignant.

From the beginning there was nothing tentative about Avery. He always had that naturalness, that exactness and that inevitable completeness which can be achieved only by those gifted with magical means, by those born to sing.

There have been several others in our generation who have celebrated the world around them, but none with that inevitability where the poetry penetrated every pore of the canvas to the very last touch of the brush. For Avery was a great poet-inventor who had invented sonorities never seen nor heard before. From these we have learned much and will learn more for a long time to come. [20]

Edwin Dickinson was of the same generation as O'Keeffe, and like her he studied with William Merritt Chase. But whereas O'Keeffe responded more to the tenets of Dow, with whom she studied later, Dickinson embraced the painterly teachings of Chase, DuMond, and Charles Hawthorne and turned them inward, producing some of the most mysterious and dreamlike images of the twentieth century.

Where the descendants of Cubism shattered the traditional representation of space, Edwin Dickinson turned it, in all its complexities, toward the construction of enigmatic, somnambulistic visions, such as *The Fossil Hunters* (1926–28) and the Piranesian maze *Ruin at Daphne*, which he worked on from 1943 until 1953. Like Hopper, Parrish, O'Keeffe, and Burchfield, he lived a long life, and his career spanned the period of the gritty realism of The Eight, led by Robert Henri, Precisionism, Regionalism, Social Realism, and Abstract Expressionism. But he never turned from his own deeply personal and eloquent vision.

Diametrically differing from the metamorphic procedure used for his large, mysterious studio paintings, which he worked on for years, is the directness of Dickinson's landscapes. Of these he once said, "I am a painter in oils. I have painted many landscapes premier-coup in America and Europe. These I either keep or destroy, but I never work on them more than once." [21] *Rock Edge, Palisades* demonstrates that Dickinson was an absolute master of subtle tonality and delicate chromatic shifts. These carefully honed instincts, combined with his cool,

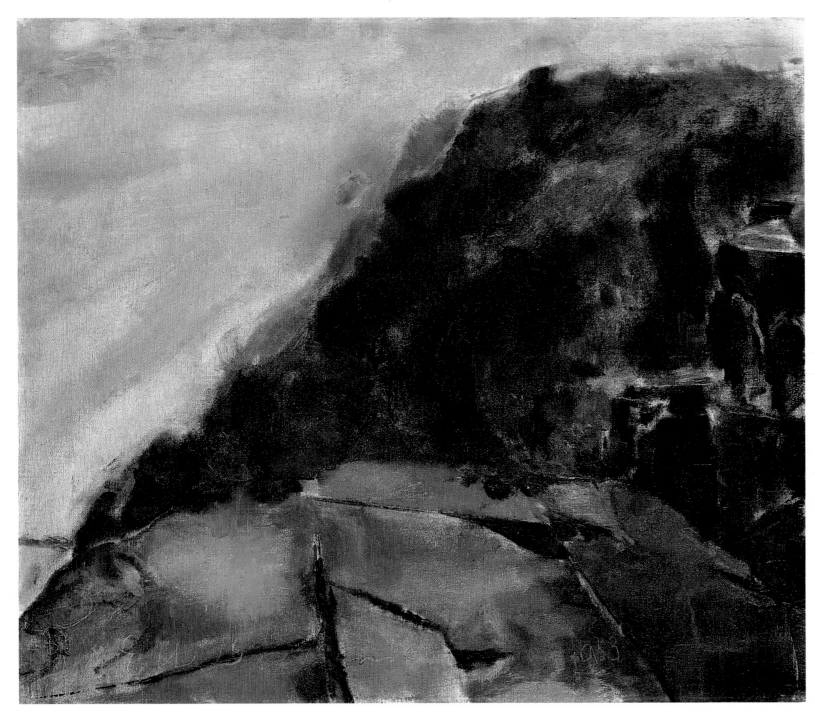

Edwin Dickinson
Rock Edge, Palisades, 1953
Oil on canvas, 19¾ x 22⅞ inches
Courtesy of Hirschl & Adler Modern, New York

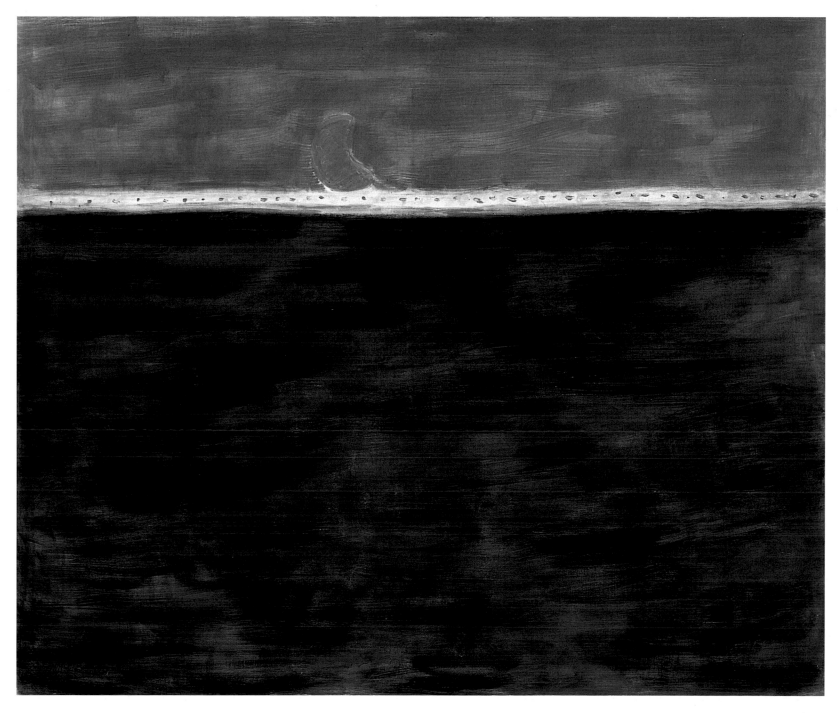

Milton Avery
Tangerine Moon and Wine Dark Sea, 1959
Oil on canvas, 60 x 72 inches
Courtesy of Grace Borgenicht Gallery, New York

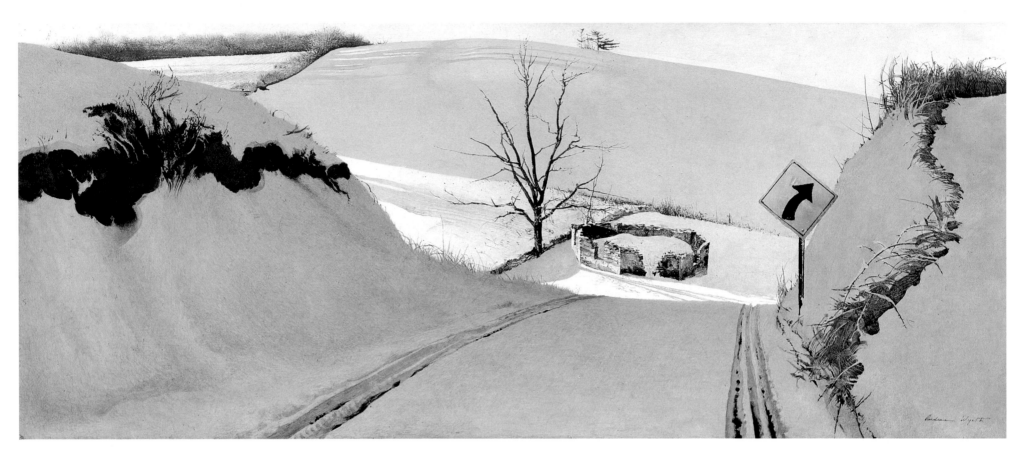

Andrew Wyeth
Ring Road, 1985
Tempera, 16⅞ x 39¾ inches
Courtesy of The Wyeth Collection, Brandywine River Museum
Copyright © Andrew Wyeth

formal control and poetic vision, allowed the plein-air paintings to shimmer with passages of classical lucidity, and then evaporate into blurs of painterly mists.

As Klaus Kertess has pointed out, "Just as the paintings are about to take their place in the 1980's, they slip into the 1880's. Perhaps it is best to leave Dickinson in his mercurial isolation — his tone poems, whether epic or intimate, are more than gift enough."[22]

Dickinson demonstrated not only that it was possible to employ traditional means and create extraordinary, contemporary paintings, but that such pursuits could be as credible as those of Modernism and Abstraction.

To move back to the art of verisimilitude, with roots in both the Realist tradition and the golden age of illustration, one must examine the work of Andrew Wyeth. In a survey conducted by *Art in America* of the "most overrated" and "most underrated" artists, Wyeth was placed in both categories by the noted scholar Robert Rosenblum. To his legions of admirers and imitators, Wyeth is considered the greatest artist of our time, while his detractors would dismiss him as a sentimental illustrator. But if one considers the potency of art in terms of its ability to authentically communicate an interior vision in a form most appropriate to its content, rather than by its proximity to a prevailing aesthetic program, then Andrew Wyeth is a painter of significance.

Wyeth's art descends directly from what is perhaps America's greatest tradition in illustration, through the work of Howard Pyle and Andrew's father, N. C. Wyeth, and indirectly, from the Northern European tradition stemming from Albrecht Dürer. He is a superb draftsman, which is demonstrated in his sketches, drybrush drawings, and watercolors, and a master craftsman, which is evident in the egg tempera paintings.

He was born in 1917, Burchfield's golden year (so called for the year his vision crystallized, which was also a period of great productivity), and had his first exhibition in 1937, which reportedly sold out within twenty-four hours. Until the early seventies, Wyeth's paintings were considered to be photographic, but the advent of Photo-Realism has made the interpretive nature of his work much more apparent, and clarified his strong connections with the past. The haunting intensity in his works is undeniable, as is the fact that their wide appeal is related to their affirmation of traditional values. The latter aspect has become increasingly admirable with the wallowing in triviality demonstrated in much recent art. Wyeth has ignored Modernism, which is not an aesthetic crime; so did Hopper, Burchfield, and Dickinson.

If he is sentimental, he has never indulged in the saccharine excesses of the elderly Renoir; and if his art is illustrational, he has never painted beyond his expressive means, as have some contemporary Realists; nor has he carried his painting into shallow ironies, as did Warhol in his late work.

Edwin Dickinson
Turnbull House, East End, Provincetown, 1935
Charcoal and pencil on paper, 9⅜ x 12½ inches
Courtesy of Hirschl & Adler Modern, New York

Ring Road is almost Oriental in its simplicity and abstractness. The compression of space heightens the rolling contours of the land, which are emphasized by the austere winter whiteness, and punctuated by the bare trees and scraggly boundaries of grass and scrub. One slowly recognizes that almost every protrusion from this fresh cover of snow bears the mark of man: the planted trees, the distant ripple of a plowed field, the thicket rows along the perimeters of pastures, the stone fence, the fragmented walls of a long-abandoned structure, the notch carved in the hilltop for the narrow country route, the road sign's sharp flash of yellow geometry.

Beyond the description of place, Wyeth's contemplative landscapes always convey their quintessential mood unveiled in the flash of the moment. Their illusory descriptiveness is deceptive, for his works are painterly, tactile, and always reveal the sign of his hand.[23]

During the mid-fifties Willem de Kooning was working on his series *Women*, Jasper Johns constructed the cryptic *Target with Four Faces*, Larry Rivers completed *The Pool* and the marvelous *Double Portrait of Birdie*, and Richard Diebenkorn painted *Girl on a Terrace*. In Europe, Matisse had completed the ceramic wall mural *Apollo* shortly before his death in 1954; Picasso was working through his variations *Women of Algiers, after Delacroix* and constructing the totemic *Bathers*; and Balthus painted the enigmatic *Passage du Commerce Saint-André* and the sexually charged *The Room*. These works were steeped in tradition, and relied on traditional forms and devices.

Charles Burchfield
Snowy Owl in Early Winter, 1959
Conte crayon and watercolor, 10¼ x 16⅞ inches
Collection of The Boston Company–Boston Safe Deposit and Trust Company, Boston

Yet in 1948 critic Clement Greenberg had declared in his essay "The Crisis of the Easel Picture" that "for the time being, all we can conclude is that the future of the easel picture as a vehicle of ambitious art has become problematical. In using this [the 'all-over' composition] convention as they do — and cannot help doing — artists like Pollock are on the way to destroying it [the easel picture]."[24] And in the mid-fifties, when the works mentioned were being created, he stated, "Experience, and experience alone, tells me that representational painting and sculpture have rarely achieved more than minor quality in recent years, and that major quality gravitates more and more toward the nonrepresentational."[25]

The most bitter irony is that Greenberg's narrow-minded diatribes were embraced by curators, art historians, critics, and art educators nationwide, and he was considered the dean of postwar critics. These attitudes were so prevalent in the art world of this period that in 1959, when the old Museum of Non-Objective Art moved into its new Frank Lloyd Wright–designed building[26] — a move that symbolized the museum as an important new force in modern art — it incorporated its old name: It reopened as the Solomon R. Guggenheim Museum of *Non-Objective* Art. The name would seem to imply a focus as narrow as that of the Carriage and Harness Museum in Cooperstown. The servant had become the master, and the avant-garde was becoming a mainstream, Geromean academicism. These aesthetic pursuits ultimately led to the painted paucities of Kenneth Noland, Jules Olitsky, and Larry Poons on the one hand, and the synthetic angst and hard-boiled careerism of David Salle and Julian Schnabel on the other.

In 1959, the same year the museum opened, Frank Lloyd Wright died. The Guggenheim and the Marin County Civic Center were his last major projects. His architectural career spanned almost seventy-five years, and for at least a half century he had been widely regarded as the most brilliant architect in America. His influence was international and monumental, and he had designed projects as small as an art gallery and as common as a service station, yet, unfortunately, his total legacy is not what he would have wished. Wright, always a maverick, had never been given a commission by the federal government; the government was usually advised by committees made up of members of the conservative American Institute of Architects, with the result that well-connected but minor architects were given commissions for federal court houses, embassies, post offices, and other projects, while Wright was passed by. Moreover, many of his greatest buildings have been destroyed, or altered with tragic consequence. Some of the worst damage has been done by his own former apprentices.

Writing in the sixties, the then-influential mainstream architectural critic Peter Blake accused him of "fussiness in detail and ornament,"[27] and of "rarely being able to get away completely from the stigma of nineteenth century taste."[28] Blake also wrote that "his last work was totally out of harmony with what the then avant-garde was trying to achieve: his forms and details were, once again, Art Nouveau; his compositions were anti-urban; his preoccupation was with richness and voluptuous form. . . . In a word, Wright was a 'square.'"[29]

This blind allegiance to Modernism on the part of Blake, which typified prevailing

thought, allowed him to eulogize the small, closetless Farnsworth House (Plano, Illinois), designed by Mies van der Rohe in 1950 and built at the extravagant cost of more than $73,000, as "the most complete statement of glass-and-steel, skin and bones architecture Mies or anyone else will ever be able to make. It is also the ultimate in universality, the ultimate in precision and polish, the ultimate in the crystallization of an idea"[30] — and then report, without irony, the fact that the client found it a totally unlivable environment: "Although the Farnsworth house was exquisitely simple and beautiful as an abstract statement about structure, skin, and space, it was hardly a 'house for family living.'"[31]

In 1924 van der Rohe wrote, "We shall build no cathedrals. . . . Ours is not an age of pathos; we do not respect flights of the spirit as much as we value reason and realism."[32] Fleeing Nazism, Walter Gropius, Mies van der Rohe, and Josef Albers, leading figures in the Bauhaus school of architecture, emigrated to the United States in the 1930s. Gropius became chairman of the architecture department at Harvard University and formed a partnership with Marcel Breuer, another Bauhaus émigré, who also taught at Harvard; van der Rohe held the same position at the Illinois Institute of Technology; and Albers headed the art department at Yale University. In his inaugural address at IIT, Mies declared, "Education must lead us from irresponsible opinion to true responsible judgment. It must lead us from chance and arbitrariness to rational clarity and order. Therefore let us guide our students over the road of discipline from material, through function, to creative work."[33] While such a statement has a fine, classical ring, in practice

it led to a purge. Architecture and art were stripped of mystery and poetry, the facility to signify and illuminate, the sense of shelter and comfort, and ultimately their potential resonance.

The dogmatism of the fifties and early sixties was unshakably rooted in the establishment structure: our universities, museums, architectural schools, and art departments. While not completely cohesive, the drive to purge architecture of ornament and symbol, to rid the visual arts of all figurative and "extra-aesthetic" references, and the concurrent low esteem for our own unique aesthetic past was pervasive.

Witold Rybczynski accurately summarized the situation in *Home: A Short History of an Idea*.

With the active support of socialite patrons, museums, universities, and architectural critics, their [Gropius and van der Rohe] *approach to architecture became preeminent. Its antitotalitarian reputation also helped, and it became a "Free World" style, representing democracy and America in the Cold War. In this role it was not seen as just another architectural style; not only white in appearance, it was morally unblemished as well. It was a break with the past that was increasingly seen as worthless and immoral, at least architecturally speaking.*[34]

During that period many of our greatest residential and urban buildings were razed, then replaced by structures of boundless banality. Others were bastardized beyond redemption to fit the tastes of the time. Major museums sold off their holdings of nineteenth-century paintings by Church, Bierstadt, Thomas Moran, and others at modest prices, while shunning the growing ground swell of contemporary figuration, or arguing that such art was reactionary. Simultaneously, American art was not considered a suitable topic for a doctoral thesis in some of our major universities. As late as 1965, the seventh

edition of H. W. Janson's *History of Art*, the most widely used survey text in the country, made no mention of Cole, Church, Heade, Bierstadt, Hopper, Burchfield, O'Keeffe, American Luminism, the Arts and Crafts movement, or any of the major figures in our recent past, with the exception of the Abstract Expressionists.

In this period after World War II, New York became the center of the art world. The aesthetics of the Bauhaus and the International style dominated American architecture and pedagogy, with the Museum of Modern Art usually serving as the spearhead. The prevailing art establishment did not believe that art of major import could be created outside these arenas. Such thinking, when meshed with the unprecedented power of art critics — the Formalist notions of Clement Greenberg, for example, and the persuasive arguments of Harold Rosenberg — amounted to a purge of the romantic impulse in the arts of America. By the mid-fifties abstraction had become an academicism in this country. The bitter irony of the situation was that in painting and architecture it was spearheaded by immigrants who had come to these shores fleeing the spread of fascism in Europe, and by institutions that looked beyond our coasts for aesthetic guidance.

An arrogant and elitist art establishment, and our most respected educational institutions, through their advocacy of Modernism, the wide rejection of other views, and the dismantling of our past, performed what amounted to a cultural lobotomy. Fortunately, their premise was so false and so alien to the creative spirit that it was doomed to failure.

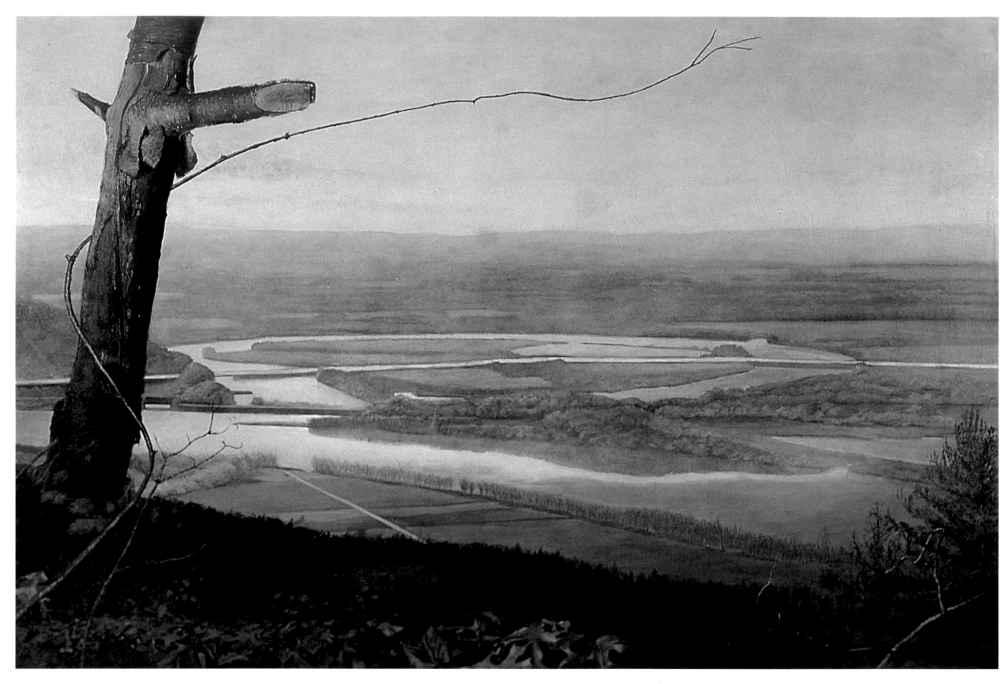

Alfred Leslie
View of the Connecticut River as Seen from Mount Holyoke, 1971–72
Oil on canvas, 72 × 108 inches
Museum of Modern Art, Vienna, Ludwig Collection
Copyright © Alfred Leslie

CHAPTER THREE

TOWARD A NEW REALISM

My practice of painting is directly related to painting prior to the Modern Movement. I share the aim of that art and I try to have the look of that art. I think of my paintings as Post-Modern works. Post-Modernity can be simply seen as a taking back of whatever it was that the Modern Movement felt it had to get rid of in order to succeed.

Alfred Leslie[1]

Milton Avery and Charles Sheeler died in 1965. Maxfield Parrish died a year later. The following year, 1967, both Charles Burchfield and Edward Hopper died.

At that time critical attention was focused primarily on Pop art, Formalism, Minimalism, and other forms of abstraction. Frank Stella was involved with his *Protractor* series, Andy Warhol was producing society portraits, Mark Rothko had nearly completed his Houston chapel murals, and Philip Guston was moving from Abstract Expressionism toward his tragicomic, autobiographical figuration, which would become a seminal influence on a generation of younger painters.

The summer of 1967 Neil Welliver completed the large plein-air-derived paintings *Diane with Soap* and *Johanna Removing Shirt*. Both depicted brave, voluptuous nudes bathing in chilly Maine streams. Also that year, Welliver's close friend Fairfield Porter distilled to its essentials the quiet mood and clear light of early fall in *Columbus Day*, one of his most beautiful paintings. And Philip Pearlstein painted *Nude with a Striped Drape*,

in which he began incorporating decorative fabrics in his paintings of objectively observed figures; Jack Beal was producing his sensual evocations of the nude, dramatized through the use of rich color and elaborate chiaroscuro; and Alfred Leslie was at work on the monumental *Constance West*, one of the key paintings of contemporary American Realism.

By this time, Malcolm Morley had received considerable attention for his glossy, Photo-Realist representations of ocean liners, derived from travel brochures. Joseph Raffael, whose work had been representational since 1963, was creating dense, collagelike images from juxtaposed magazine clippings randomly selected from a box and then precisely painted on white, gessoed grounds. Richard Estes began exhibiting his complex Manhattan street scenes, which had evolved from somber, painterly images of figures in interiors, parks, or on busy city streets. His paintings were recognized immediately as a new and radically different vision of the urban scene, but they were in fact shaped by the work of Hopper and Sheeler, and photographers such as Atget, Walker Evans, and Berenice Abbott.

After months of work, Red Grooms completed his *City of Chicago*, the first of his environmental "sculpto-pictoramas" (for the Allan Frumkin Gallery, Chicago, 1967). With great wit and charm, and an astute eye for art history, he blended Pop, Happenings, Realism, Abstract Expressionism, comics, and film with his uncanny vision of our social, political, and cultural history, emerging with a madcap, on-target, but slightly skewed interpretation of the time.

Concurrently, on the West Coast, Richard Diebenkorn was ending more than a decade devoted to his widely influential figurative paintings and beginning the *Ocean Park* series. The art public was beginning to get the idea that Wayne Thiebaud was more than a painterly Pop artist, as his figures, portraits, and landscapes became more widely known. Primarily through the strong influence of fellow painter David Park, the artists who by the late sixties became known as the Bay Area figurative painters — Diebenkorn, Elmer Bischoff, Paul Wonner, James Weeks, and Theophilus Brown — had developed a vigorous West Coast brand of realism that was fully shaped and widely known by the mid-fifties. In turn, their paintings had a profound influence on young painters and art students from the late fifties throughout the sixties, an influence much more widely felt than that of the East Coast figurative painters.

But in the fifties and sixties, these artists, who were a part of the generation that returned from the war and studied under the GI Bill, were neither widely accepted by the art establishment nor financially successful. Most of the Bay Area group studied and taught at the California School of Fine Arts. Bischoff, Park, Weeks, and others left in 1951, in protest of changes made by the new director, which included the firing of Douglas MacAgy and other key members of the faculty and staff. After their exodus, Weeks worked in the Railway Express warehouse loading

trucks, and later Bischoff drove a delivery truck for the same firm. Diebenkorn taught at the University of New Mexico from 1950 to 1952, and then at the University of Illinois for two semesters. It was during this period that his reputation spread to the East Coast. He spent the summer of 1953 in New York, where he met Franz Kline, a leading American Abstract Expressionist, and Kline introduced him to the dealer Eleanor Poindexter, which led to her representing his work. At the time, Diebenkorn's paintings were abstract but with landscape references. After returning to Berkeley in the fall of 1953, he began drawing with Bischoff, Park, and others in a weekly session with the model, but his move toward figuration in his paintings was not completed until the mid-fifties. Today, Diebenkorn is widely considered to be the preeminent painter of the Bay Area figurative group, but that was not the case at that time. If any one artist held that role, it was surely David Park.

In the mid-fifties and sixties, such metamorphoses from abstract to figurative painting were occurring simultaneously on both coasts. This revitalization of figurative art was marked by two highly significant aspects.

First, most of the figurative painters were strongly influenced by de Kooning, Kline, and Abstract Expressionism, particularly its physical and gestural aspects, which Harold Rosenberg had labeled action painting. Evidence of the physical act of painting was a central element in the renewed figuration, and it should be remembered that figural references were integral in many of the paintings by de Kooning, Pollock, Kline, and other abstract painters. The call for the purge of figural references came more from the critics than the painters themselves, and this was certainly a major factor in Clement Greenberg's low esteem for de Kooning's *Women*.

Second, the critical smugness and zeal surrounding abstract painting from the early fifties through the mid-seventies approached the self-righteous, theocratic fervor of a Savonarola. It was not a period that advocated aesthetic pluralism, particularly for work that took a figurative turn, and this attitude permeated art education, criticism, and the museums.

Most of these new figurative painters began their careers as second-generation Abstract Expressionists, and they approached the realm of representation, no matter how vigorously rendered, with the gingerliness of a shy pornographer. It was a move that was bound to provoke a vitriolic, critical response. To explore the renewed possibilities of figuration, rechartered by the physicality, scale, spontaneity, and improvisational strategies of Abstract Expressionism, was to move into unexplored territory. It was a search for a personal center, which is an artist's only true responsibility, and unlike the situation today had nothing to do with careerism or financial gain. Very few artists expected to live from the sale of their work.

Fairfield Porter had stated that this was a renewed rather than a new Realism,[2] and Elmer Bischoff lucidly enforced this position when he stated:

The more one brings in terms of depth and diversity of art experience to whatever the art one looks at, the more one will gain from it. To put this more pointedly, I would argue that a person who responds positively to African sculpture, for example, will find vital qualities in Rembrandt that will escape a person who is blind to the merits of African sculpture. There is an aesthetic level at which all art forms from all times and all places start to connect.[3]

The Bay Area painters could be differentiated from East Coast figurative painters in that in addition to the gestural aspects of Abstract Expressionism, they employed improvisation and invention. Their conceptual images were more metaphorical and generalized than those of the East Coast painters, and were based only tangentially on past perceptions. The West Coast paintings were full of evidence of the artists' struggles, with the signs of earlier false starts and wrong moves not quite buried beneath the final, but often revealing, layer of pigment.

On the East Coast, Fairfield Porter was one of the few painters who had never worked abstractly. However, he was an early champion of de Kooning and collected his work. Porter and others who would emerge as Realists were entwined with the tradition of direct observation and plein-air painting, and their painting was derived from the particulars of the perceived world and the nuances of specific light. Theirs was an art of empirical interpretation rather than of improvisation. The inventive figuration of the Bay Area painters was such anathema to East Coast painters and critics, with their rigorously held notion of painting an observed image, that the Bay Area painters were as often targets of Porter's vitriolic critical writings as was Clement Greenberg.

In 1955, responding to a Greenberg *Partisan Review* article on "American-type" painting, Porter stated:

Greenberg seems to think that the artist today must give up the figure: the figure has been done and nothing new remains. It was also done by the Greeks, but the success of the ancients was imitated, not shunned, during the Renaissance. American painters have not been supreme in figure painting; perhaps from shyness they have felt more at ease in landscape. There is now figure painting being done

Fairfield Porter
Island Farmhouse, 1969
Oil on canvas, 79⅞ x 79½ inches
Private collection

Philip Pearlstein
Monument Valley, 1976
Watercolor, 29 x 41 inches
Courtesy of Hirschl & Adler Modern, New York

by Americans, but Greenberg doubts its validity, telling them in effect to stick to their old provincialism; and this misunderstanding of value is also provincialism. American abstraction is a development from American timidity, and it is original. . . . However, as a war is not won by brilliant retreats, so creativeness is not advanced by imposed limitations.[4]

As late as 1962, in his review of the Museum of Modern Art exhibition Recent Painting USA; The Figure, whose catalogue had stated the intention of "exploring . . . the renewed interest in the human figure," Porter correctly pointed out that "since painters have never stopped painting the figure, and since the exhibition shows no change on the part of particular painters from a non-objective to a figurative style, it could be said to represent a renewed interest in the figure on the part of critics and the audience rather than among painters."[5]

This 1962 exhibition had been preceded by a 1959 exhibit at MOMA titled New Images of Man, but neither show included any of the growing number of contemporary Realist painters of the New York art scene, even though the work of Fairfield Porter, Larry Rivers, Philip Pearlstein, Alex Katz, and others was widely known on the East Coast. Their exclusion, in both cases, was seen by many artists, critics, and dealers as a conscious curatorial slight. Rico Lebrun, Leonard Baskin, and other "humanists" were included, as were Richard Lindner and James McGarrell, and Bay Area painters such as Elmer Bischoff, David Park, and Richard Diebenkorn. This rubbed salt into a festering political and polemical wound.

In response to the Recent Painting USA exhibit, the Kornblee Gallery in New York organized a major show in May 1962, simply called Figures, which clearly illustrated what MOMA had chosen to ignore. Included were Milton Avery, Robert Beauchamp, Nell Blaine, John Button, Elaine de Kooning, Robert de Niro, Paul Georges, Alex Katz, Alice Neel, Philip Pearlstein, Fairfield Porter, Larry Rivers, George Segal, and others. The point of this "Salon de Refusés" was well made. In the brief catalogue essay, Jack Kroll observed that

these artists . . . manifest no finality, almost, one might say, no fully achieved state of affairs concerning the human image through which their artistic strategy projects itself. The best and most interesting of them are moving toward the next authentic and historically secure image of man, which our century's art is approaching as surely and significantly as it has already formed and continues to form the abstract matrix which is still the seminal and resolving image of contemporary art.[6]

In his *Recent American Figure Painting* review, Porter reserved his most scathing remarks for the Bay Area painters: "A special case of art following criticism is found in the California artists, who bear the same relationship to modern art that Blake bore to Italy. As Blake knew Michelangelo from engravings, so the Californians know the impressionists and cubists from the color plates in Skira Books. They follow the implicit criticism of Skira printers."[7]

In closing, he directed his remarks to the sensibilities of the East Coast Realists, such as those in the Kornblee exhibit: "I believe that in American art there can be no 'return' to the figure. A movement toward painting the figure will be new, not renewed. It will be the first time American painters have tackled the problem directly. And there are in America today a number of artists who paint the figure without affectation, sentimentality or evasiveness, and who do not follow criticism, but precede it."[8]

That post-abstraction forms of figuration had taken shape on both coasts by the mid-fifties is now art history. By the late fifties, there was wide discussion of a "new figuration" or "new realism," although the boundaries were somewhat blurred at that time. As late as 1960, Seldon Rodman published *The Insiders*, and a year later *Conversations with Artists*, with its sympathy clearly toward the figurative work of the so-called humanists such as Lebrun, Baskin, George Tooker, Ben Shahn, and James Kearns, but he apparently remained oblivious to the work of artists such as Porter, Georges, Katz, or West Coast painters such as Diebenkorn. Reviewing *The Insiders*, Porter laconically and accurately stated, "The distortions that are meaningful to Rodman look like affectations to me," and ended his review with the scathing line, "The Insiders protest too much."[9]

John Bernard Myers wrote an extremely insightful piece in 1960, in which he outlined the influence of Surrealism on the second generation of the New York School, for it was to a large degree that connection that moved the artists, in widely divergent expressive forms, back into the arena of figurative art:

The other American painters had no interest in trying to "re-establish man as psychology instead of anatomy," or "to recreate man's efforts in the light of Freud's analysis of the sub-conscious," or "to revivify mythology, fetishism, parable, proverb or metaphor." They did not feel "the necessity of changing the world instead of merely interpreting it." They were interested in the art of painting strong, expressive pictures which were valid in themselves.[10]

Myers then proceeded to discuss Jasper Johns ("the Surrealist of Naming Things"), Grace Hartigan ("the Surrealist of Unknown Landscape"), Alfred Leslie ("the Surrealist of Megalomaniac Murals"), Larry Rivers ("the Surrealist of Daily Life"), Robert Rauschenberg ("the Surrealist of the Re-found Object"), Joseph Cornell ("the Surrealist of Reproach"), and several others. At the end of this perceptive and prophetic essay, he states, "Other artists best represent the tradition of observing nature, that tradition of Bonnard and Vuillard (of which Pollock once said 'there are many veins in that mine still to be quarried'): Nell Blaine, Robert de Niro, Jane Freilicher, Alex Katz, Jane Wilson, Fairfield Porter and Herman Rose." Then he surmises that "Breton would admire the strength, the daring, the courage with which the Second Generation faces the terrible, baffling modern world which, since Sputnik, we see from an Archimedean point outside our planet. The Americans do not flinch; like the poet Allen Ginsberg they all seem to say: 'the universe is a new flower.'"[11]

While the doctrinaire writings of Clement Greenberg and younger critics under his influence, such as Michael Fried and Kenworth Moffett, attempted to narrow the diverse aesthetic range of art evolving from Abstract Expressionism to the works of the Formalists or Color Field painters, in time their criteria proved to be somewhat detached from reality. In fact, almost all of the art of the period was profoundly marked by either the artists' direct contact with the Abstract Expressionists, or the emotional impact of their work.

By the mid-fifties, Jasper Johns had fused Abstract Expressionism with Dadaism; Robert Rauschenberg had connected its gestural bravura with Kurt Schwitters; Larry Rivers had performed an unlikely merger between it and the great historical "machine" paintings of the nineteenth century; Fairfield Porter combined its painterly aspects with the intimate images and lush coloration he admired in the work of Vuillard and Bonnard; and the Bay Area painters bound its expressive and improvisational aspects to the disciplines of Matisse's figuration. This was a search for "personal territory," a rejection of tyrannies, academicisms, and provincialisms, an expansion of the aesthetics of Abstract Expressionism, and a simultaneous reconnecting with various points of the past.

"After 1945, abstract art became so brilliantly inventive and demanding that most of us, myself included," wrote Robert Rosenblum,

assumed that any other kind of painting and sculpture, no matter how appealing it might be, was doomed to play the role of a timid bystander located at a vast distance from the dramatic superhighway of abstraction. But already in the early 1960s, the finest Pop artists successfully challenged the idea that innovative art had to be abstract, although to do so, they had to digest, as well as contribute to, the new kinds of pictorial structure — clear, tough, clean, and diagrammatic — that the best abstract artists of the decade were also exploring. . . . In the 1970s, it would seem that the issue of painting from immediate observation has loomed larger and larger, thanks not to any change in theoretical position, which should always follow, not precede, the experience of art, but simply to the fact that for over a decade certain American artists have been painting realist pictures that suddenly have begun to look so strong, so intense, so compelling that we can no longer ignore them. They are finally demanding attention from audiences that had earlier found them invisible.[12]

America was stirring from its Cold War apathy and entering a period of change. In 1954 the Senate censured Joseph McCarthy for contempt, misconduct, and abuse of members of the Senate, bringing toward a close his Communist witch hunt and intellectual purge. A year later, blacks began their boycott of the Montgomery, Alabama, city bus line, and Martin Luther King, Jr., came into national prominence for his advocacy of civil disobedience and passive resistance, based on the writings of Thoreau a century earlier and the more recent example of Mahatma Gandhi.

This was also a decade of a growing insistence on social and intellectual freedom, and an epoch of bohemianism and defiance. An entire generation was summed up by Marlon Brando in *The Wild One*: When asked "What are you rebelling against?", he responded, "What have you got?" The weekly picture magazines, such as *Life*, *Look*, and *Saturday Evening Post*, were widely read and extremely popular, television was in a majority of homes, and foreign movies were getting nationwide distribution. In 1956 Allen Ginsberg published *Howl*, which was dedicated to Dadaism; in 1957 Jack Kerouac published *On the Road* and Robert Frank's gritty book of photographs *The Americans* was in preparation. Each portrayed the poet and artist as an intransigent, a ragtag, Zen-inspired explorer of America and an authentic recorder of its moods and incidents; together they established the vision of the Beat Generation.

In 1957 Lawrence Durrell published *Justine*, the first volume of the *Alexandria Quartet*, which, coupled with Kurosawa's 1950

cinematic masterpiece *Rashomon*, promulgated an Einsteinian aesthetic of "relative truth." Earlier, the great Italian filmmaker Federico Fellini had described "neo-realism" as "a way of seeing reality without prejudice, without the interference of conventions — just parking yourself in front of reality without any preconceived ideas." It was an acknowledgment that there was no objective reality, for each perspective is altered by one's interior vision and preconditioned past.

By the early sixties, the visual ironies of Pop art had attained national prominence through the mass media. Like a double-mirrored infinity, Pop affected the imagery of popular culture and was in turn assimilated into it, influencing the very sources from which it was derived. A large sector of the art world, in pursuit of the doctrine of "less is more" through the reductive forms of Minimalism, Formalism, and Conceptualism, was caught off guard by Pop's high-impact, familiar symbols and found itself without a rationale. Perhaps more important, Pop found a market of collectors weary of those highly touted, if truncated, forms of visual expression, and ready for a bit more panache, eager for "pictures." Pop art had the advantage of appearing to produce, as Victor Hugo said of Baudelaire, a "new shudder," and it could be justified as an extension of Modernism. With the exception of Wayne Thiebaud, whose paintings of pies and pinball machines were mistakenly confused with Pop art, Pop's Realist contemporaries did not share this windfall, for too many of the critics, curators, and collectors were leery of anything that appeared to be an aesthetic retreat. The experiences of Andy Warhol and Philip Pearlstein, for example, demonstrate this.

Pearlstein and Warhol were contemporaries. After serving three years in the army, Pearlstein enrolled at the Carnegie Institute of Technology. Warhol had entered the year before. After graduating they were roommates in New York, where Warhol worked as an illustrator for *Glamour* magazine and Pearlstein was a graphic designer. In 1952 Pearlstein made an expressionistic rendition of Superman that predated Warhol's well-known Pop classic of the same subject by eight years. Later, both would approach their subjects with a cool, objective detachment, but only Warhol's work would be acclaimed as a new vision and sought after by collectors. By the mid-sixties Pearlstein's sharp-eyed, ascetic accounts of studio nudes were widely known though unsalable, and were usually regarded as "academic" rather than a revision or extension of the Realist tradition; Warhol's photo-silkscreened replications of mechanically reproduced images, on the other hand, were hailed as "avant-garde." But both had their roots in past conventions, and both outraged the bourgeoisie.

In this period of assassinations and political dissent, heightened by our involvement in an unpopular war, freedom of expression was paramount and pressed against all accepted perimeters. This was most clearly symbolized in the arts. In 1959 *Lady Chatterley's Lover* was published for the first time in the United States, after the removal of an obscenity ban that had been fought since the publication of its first uncensored version in Paris thirty years earlier. In the sixties, anything that could be construed as a retreat from the new freedoms was met with open hostility.

The most profound legacy of Pop art is that it legitimized the image and restored respectability to the subject within an art world that had rejected anything approaching simulacra. Moreover, in the period of Pop's

domination, the artist was given celebrity status and was widely recognized as an important participant in contemporary life. Last, but certainly not least, Pop artists established that a painter or sculptor could support himself in grand style solely from the sale of his work. This was a position very few had enjoyed since the heyday of Maxfield Parrish. The downside of all this would be rampant careerism, coupled with a growing cult of personality, which in the eighties made many artists more famous than their work.

Unlike the apparent fresh vision of the Pop artists, the range of possibilities in rendering the observable world seemed strikingly traditional for the Realists in the sixties. There was the figure, which could be as specific as portraiture; still life, which could be expanded to the interior; narrative or allegorical subjects; and the urban or pastoral landscape. That a modern vision could be forged from these traditional themes is extravagantly reflected in the art that was produced.

While all of the Realists, whatever their inclinations or subjects, shared the connection to Abstract Expressionism, particularly to the gestural paintings of de Kooning, Kline, and Pollock, the pulls of the past varied greatly, which can be vividly illustrated through three seminal paintings that were produced within a twelve-year span: Richard Diebenkorn's *View from a Porch*, 1959; *Island Farmhouse*, 1969, by Fairfield Porter; and Alfred Leslie's homage to Thomas Cole and the Hudson River painters, *View of the Connecticut River as Seen from Mount Holyoke*, 1971–72.

Clement Greenberg once described Richard Diebenkorn as a "good graduate school level painter," but it must be remembered that he also denigrated de Kooning's *Women* and later

would attempt to promote Horacio Torres as one of this country's leading Realists. Earlier, Greenberg had apparently been sympathetic toward Diebenkorn's abstract paintings, which preceded his figurative work by a decade. Diebenkorn recounted a visit from Kenneth Noland, who came to his studio at Greenberg's suggestion just after he had begun the figurative paintings. "[Noland] as much as told me, 'What the hell have you done?' He had come expecting to see abstract painting. . . . He was really very disappointed." Also, Diebenkorn admitted, "I had these twinges, because during the '50's abstract painting was a religion, and it didn't admit to any backsliding to representational imagery. . . . When the three of us — Park, Bischoff, and I — had exhibitions of our representational work in New York, we were attacked. You wouldn't believe the incredible things people said to me!"[13]

The painters of both coasts were rejuvenated by the elixirs of Abstract Expressionism, and commonly shared an admiration for Vuillard and Bonnard, but on the West Coast Matisse was the reigning influence. It was erroneous and somewhat facetious for Porter to assume, as he did in his *Recent American Figure Painting* review, that the influences of Modernism came secondhand, primarily through reproductions, in the West. Diebenkorn has consistently acknowledged the profound effect on him in the early forties of the Matisse paintings in the Phillips Collection, the monumental impact of the Matisse retrospective in Los Angeles in 1952 and, twelve years later, of those many paintings he saw in Russia from the extensive private collections assembled by Shchukin and Morozov. In his figurative work there is also lingering evidence of his deep admiration for Hopper, particularly in the interiors with figures and the landscapes. Diebenkorn recalls the first time he came in contact with Hopper's work, which was through a reproduction of *House by the Railroad*. "It changed things a lot for me right there. It was a real focusing. Somehow it had all the important things in it for me. It had the time of year that I loved most — a fall day, when the reflected light doesn't hit the shadows — when the shadows stay black. That kind of day. It was so clear! There was a spareness. And I loved that. I loved the way Hopper looked at the world."[14]

View from a Porch is one of Diebenkorn's greatest achievements, and one of the great icons in contemporary American art. All of the painter's disparate influences — Hopper, Matisse, and de Kooning, among others — converge cohesively with Diebenkorn's deeply personal, intuitive vision.

This expansive space of rolling fields and brightly colored planar sections dips in and out of shadowy patterns in its sweep toward the horizon. A jitter of strokes on a white ground suggests a distant suburban cluster, and a dark band beneath the sgraffito of pale blue sky indicates an earlier, tentative search for the position of the horizon. The undulating recession of land, marked off by the fluid sluice of light and shadow, recalls the compositional structure of Dutch landscapes, but the spatial division of the voids by the rails and uprights of the porch is pure Diebenkorn. Its architecture is appropriated for his instinctively balanced composition. The corner post splits the vertical space in half, and the dark plane of the floor is emphatically edged in orange. Beyond, the landscape is framed by the rhythmic configuration of rails. In the foreground, the steps and handrail descend diagonally, leaving a sawtooth- patterned void of dark, viscous green. Across the bottom, a band of yellow and white — perhaps a beam — seals off and emphatically closes the foreground space. The yellow repeats in a distant field, while the white highlights the porch grid and marks the distant plains.

The architecture seems rooted to some particular urban fact, but the broad spread of fields, with their shadowy, mysterious grids and divisions, has the look of improvisation and the rightness of geometry. It is an enigmatic landscape articulated by bright sun and clear shadows. Like de Chirico's brooding piazzas, this seems to be a place encountered in the past, its visual facts mixed with the lingering fragments and fictions of memory, and remembered with the clarity of a dream.

Ultimately, nothing can be moved without shattering the taut, precarious balance of the composition. *View from a Porch* is only a step outside the elegant abstract symmetry of Diebenkorn's *Ocean Park* paintings.

More than the reach of the continent separates Fairfield Porter's *Island Farmhouse* from Diebenkorn's eloquent suburban mystery. While both men shared an admiration for de Kooning, for Porter it is Vuillard's presence rather than Matisse's that hovers over his work. Porter's paintings are evocations of the ordinary, crystallized through the nuance of light and mood.

The clear, crisp summer light permeates the scene, articulating its space and confirming the mood. This is not the vaporous light of Impressionism that dissolves form into a chromatic ghost, but an illumination of the quintessence of a given moment, which weaves a spell from the incidental — as does the gelatinous, amber quietude of that bourgeois Proustian interior *Le Boudoir au Voile de Gênes* by Vuillard.[15]

Richard Diebenkorn
View from a Porch, 1959
Oil on canvas, 70 x 66 inches
Collection of Mr. and Mrs. Harry Anderson

The white façade of the Georgian Revival house is bathed in brilliant sun, while the golden shadows in the fascia, pilaster, and clapboard crannies reflect the warm light of the lawn. In its cool shadow a large spotted dog stirs from a nap and cocks its head toward some minor incident. Beyond the house and dark trees is the calm water, with a cluster of small islands at the horizon. A fisherman's boat sits offshore. It is a day of absolute tranquillity, suspended in the clarity of New England light.

Porter never shows more than can be visually observed, never interprets or invents, and the best of his paintings are free of unnecessary detail. He is an astute and sympathetic observer — of the remnants of a meal, the effect of sunlight on an interior, the view through a screen door, the look of the landscape — with the capacity to recapitulate the most subtle and essential character. His paintings are quiet interpretations of directly observed or remembered facts of Long Island or his Maine summers.

Unlike Porter, who never painted abstractly, Alfred Leslie was a prominent figure in Abstract Expressionism, and that body of work alone was enough to fix his place in American art. He was a friend of Franz Kline, Jackson Pollock, and Willem de Kooning, an associate of the great photographers Walker Evans and Robert Frank, and collaborator of the writers and poets of the Beat Generation.

Too often overlooked is the fact that Leslie's abstract paintings and collages contained a discernible narrative edge, and that during the fifties he was actively involved in writing, editing, and filmmaking. Jack Kerouac's *Pull My Daisy*, now an underground classic, was filmed in Leslie's loft, and was codirected by

Leslie and Robert Frank. *The Last Clean Shirt* was written by Frank O'Hara and filmed by Leslie. The gestural stripes frequently seen in his paintings of that period (one was reproduced on the jacket back of the first edition of Frank's *The Americans*) referred to a large American flag on his studio wall. He edited and published the literary magazine *The Hasty Papers* and designed sets for several plays.

The subtle narrative aspects of his abstract paintings and collages became increasingly dominant in the works of the late fifties, as Leslie moved toward figuration, and in his Realist paintings of the sixties. Today, the narrative and allegorical element is central to his monumental paintings and drawings.

Although best known for his stark, frontal portraits, for *The Killing of Frank O'Hara* (an allegorical cycle of seven paintings based on the death of the poet, hit by a Jeep on a dark beach in the Hamptons, painted between 1969 and 1980), and for sets of narrative drawings such as *Coming to Term* and *The Nursing Couple*, Alfred Leslie has produced numerous landscapes, including his great homage to the Hudson River painters, *View of the Connecticut River as Seen from Mount Holyoke* (see page 44), finished in the winter of 1972, and a series of monochromatic watercolors, *100 Views Along the Road* (completed more than a decade later), which connect once again with the teachings of Arthur Wesley Dow and the great Japanese printmakers.

Today, it is hard to imagine Leslie's audacity in painting *View of the Connecticut River*, in light of the general low esteem of nineteenth-century American landscape painting at that time. The meandering oxbow in western Massachusetts had been a favorite subject for painters in the second half of the nineteenth century, but the best-known version is Thomas Cole's panoramic *Oxbow*,

painted in 1836. In painting his *View*, Leslie followed the procedure of Cole, Church, and Bierstadt, painting it in the studio from drawings and small oil studies done on location. The view is most likely the spot Thomas Cole and others had selected, and Leslie's painting follows the compositional conventions of that period, including the placement of a large tree that dominates the left foreground of the picture. The distant oxbow is seen from a high, craggy hill, and it is now dissected by a highway and railroad, which Leslie includes. Patterns of cultivated fields, which were also depicted in Cole's version, can be seen in the loop and along the banks of the river. A vast, panoramic space, stretching toward the distant horizon, is seen through the autumn haze. In the foreground, the tree trunk, vines, rocks, and foliage are rendered with emphatic clarity. The slow-moving river in the middle ground and the distant hills were painted in detail, and then methodically glazed with milky colors to replicate the atmospheric condition.

It is a work that is simultaneously modern in its realism, daring in its cogent compliance with nineteenth-century conventions, and radical in its embrace of a discredited tradition. Contemporary Realism, in all its aspects, had been defined and rationalized through its connections to Abstract Expressionism and modern European painting. If reference was made to earlier American art, it was cloaked in humor, as in the Rivers version of *Washington Crossing the Delaware*, or given surrealistic irony, such as a Johns *Flag*. Leslie's version of the oxbow was one of the first contemporary paintings, and the most ambitious, to give homage to our nineteenth-century heritage.

Although he is best known for his nudes, Philip Pearlstein began painting gestural, earth-toned landscapes in the mid-fifties; but he rejected the conscious expression of mood or emotional involvement with nature:

I use nature in a calculated way as a source of ideas. . . . At the moment I like to work with landscape ideas just because they allow me to remain uninvolved. I can look at them abstractly . . . and just concentrate on painting. I choose a subject not because I like the view as such, but because I feel its potential of giving me a structure on which to build an interesting picture. I turned to rocks, pebbles, etc., because I find in them a more interesting variety of ideas than I can dream up by myself. But I look for ideas in nature that already conform with painting ideas I have.[16]

Irving Sandler has described the turn of Pearlstein's painting from that period:

Toward the end of the fifties, a conflict developed between Pearlstein's desire for an empirical realism and his painting ideas. More and more he began to strip away the painterly overlay which struck him as increasingly decorative, to reveal an underlying, precisely drawn, literal realism that, much as it seemed well-known, pointed to one of the uncharted paths realism could take — and did in the sixties.[17]

Those early, gestural paintings and drawings of cliffs, rocks, and twisted roots preceded by eight years Pearlstein's earliest studio nudes, which were first done in 1961. The first directly observed landscape paintings to be done in his mature, deadpan style were painted not in the United States but on the rugged coastal cliffs of Positano, Italy, in 1973.

Philip Pearlstein is an astute historian and an avid collector, and he has had a long-standing interest in the pottery and artifacts of the Indian cultures of the American West and South America. For years a Carleton E. Watkins photograph of the Canyon de Chelly White House ruin hung on the wall of his studio, but it was not until 1975 that he made his first extended painting trip to the Southwest. This was in conjunction with the Bicentennial exhibition America 1976, sponsored by the U.S. Department of the Interior, for which forty-five artists were sent to various locations — Alaska, the Everglades, Hawaii, and so forth — and produced seventy-eight works that then toured American museums for two years. Pearlstein's choice of subject, Canyon de Chelly, responded to his lingering fascination with that region and its ancient culture. His two trips resulted in two large canvases of the ruin, and several large watercolors.

Unlike the fixed triangulation of overhead lights in his studio, a prominent factor in the nudes, the light in landscape presents Pearlstein with the ever-present problem of constant and unpredictable change. Transient weather, regardless of its subtlety, tends to imply mood, which Pearlstein overtly avoids by evening out its effects on the terrain. Limiting his painting session to the morning or afternoon, he compresses the movement of light and strives for a visual consensus of its play on the hard facts of geology. The ripples, striations, and fissures in the stone of *Monument Valley*, for example, are painted with the same detached and emphatic manner he has used in articulating human joints and rolls of flesh.

It is with these skeletal, geological remnants of the worn and eroded deserts and canyons, where scale and space lose their measure, that Pearlstein is at his best as a landscape artist. In spite of the contemporaneity of his vision, he moves strikingly close to the achievements of artists and photographers such as Albert Bierstadt, Thomas Moran, Carleton Watkins, and Timothy O'Sullivan, who more than a half-century earlier risked life and limb on expeditions with John Wesley Powell and other surveyors and cartographers to accurately fill in the yaws, gaps, and voids of this continent's map.

Nothing could be further from Philip Pearlstein's precise accounting of 1976 than Elmer Bischoff's *Landscape Afternoon*, which was painted almost two decades earlier.

Bischoff, moved by the imagery of David Park, made the transition from nonrepresentational painting to a form of gestural figuration in 1952. But the Bay Area artists were more inclined than the easterners to use their drawings and sketches as a way of stockpiling data that could be recalled during the act of painting, rather than as specific studies for paintings. To quote Bischoff's notes: "My purpose was not to find ideas for paintings [from drawings] but to store up memories of the figure in various attitudes so I could invent it as needed during the course of a painting."[18]

But his paintings, whether abstract or figurative, were fabricated, made out of whole cloth.

I learned to just walk up to a bare canvas and start painting; putting down lines and colors, maybe smearing them around . . . anything to get something started . . . adding and subtracting, and on and on until everything in the canvas felt right. And that would be it.

The highest goal was to produce a powerful statement, and the preference was for vigorous, tough, demanding art . . . ugly rather than lovely, raw rather than polished.[19]

Elmer Bischoff
Landscape Afternoon, 1959
Oil on canvas, 68 x 68 inches
Private collection, California
Courtesy of the Barbara Mathes Gallery, New York, and John Berggruen Gallery, San Francisco

Thus the charged, viscous space of *Landscape Afternoon* is an improvised image that, due to chance turns in the spontaneous act of painting, ultimately evolved into a "landscape."

More akin to the procedures of the West Coast are the early, and almost forgotten, landscape etchings by Peter Milton, one of America's most distinguished draftsmen and printmakers. He is now widely known for his elaborate and eloquently articulated allegories set in complex interiors and assembled from a vast array of disparate images and associations, but Milton's vision first began to take shape in those earlier, improvised landscapes.

Peter Milton turned to monochromatic prints in 1962, upon discovering that he was color blind. He had gravitated to printmaking out of frustration with what he called "the macho world of painting," and produced his first lift-ground etching in 1960. This period in American printmaking was dominated by the immense and pseudo-angst-ridden figures of Leonard Baskin; the fussy, self-conscious, and highly mannered etchings of Mauricio Lasansky; the lingering remnants of the virtuoso burin of the Hayter Atelier; and the long shadow of Abstract Expressionism. Given the aesthetic climate of that time, the emergence of such deeply personal, unaffected, and articulate prints was quite remarkable.

Of his early etchings, such as *February 11* and *Panorama 1*, Milton has written, "I think I was remembering my childhood in the Berkshires and all those wonderful open fields. These pieces were pure improvisations."[20] Elaborating on these early works, which respond perhaps, like Burchfield's watercolors from 1916 and 1917, to remembrances of childhood and the invention of a personal vocabulary, he wrote,

"The landscapes follow in a tradition of improvisation which really relates less to time than to place, which is most obviously Far Eastern, though its derivation in my case was Rembrandt and Van Gogh." Regardless of their size and medium, these prints, through their invention, economy, and sense of rightness, evoke a response similar to that aroused by those enigmatic screens and panels of the Zen masters of "Profound Subtlety."

Gabriel Laderman, like most Realist painters of his generation, came to realism from abstraction, but he has always been an intellectual rather than an instinctive picture maker. His paintings stem from the more ordered conceptualizations of Corot and Courbet, but the narrative works are tinged with the edgy psychological currents of Albert Marquet and Balthus. He has said, "I am with Klee on ideas, not Matisse," which indicates his preference for rational construction over improvisation; and he has stated a strong belief in "the metaphoric nature of pictorial construction, and its necessary variability," which implies that his realism favors reordering over replication.

Laderman's landscapes are tightly composed, delicate tonal constructions rather than specific descriptions of place, light, and weather. As a part of his subtle reorganization of the image, there is also a process of editing, a reduction to essentials, that ultimately heightens the clarity of his images. He has been a strong influence in the East, and it is these characteristics in particular that have been adapted by many younger painters.

Today, Neil Welliver is one of America's most widely known painters. While he has done figures, portraits, and wildlife, and is an accomplished watercolorist and printmaker, Welliver's reputation is based on his large, ambitious paintings of the vast wilds and dense woods of northern Maine, where he has lived and worked since 1961. Most of his generation of Realists, those immediately

proceeding from the Abstract Expressionists, have included landscapes in their oeuvre, but these have been subsidiary works. Welliver (along with Nell Blaine, Jane Freilicher, Wolf Kahn, and to a lesser degree Porter and Laderman) has been an exception, making landscape his primary concern.

Like the late Fairfield Porter, Welliver is a thoughtful and committed environmentalist. He lives in an eighteenth-century farmhouse, which he disassembled and rebuilt deep in the Maine woods. Electricity is generated by a windmill, and the rambling house and connecting studio are heated with woodstoves. Produce is supplied by a large organic garden.

Although he never strays beyond the immediate vicinity, his subjects are as varied as that landscape, rugged and densely vegetated, with drastic shifts in weather and clearly marked seasons. Except in the cruelest winter months, Welliver works directly from nature on small canvases, which then serve as the source material for his large studio paintings. The image is redrawn from the small painting onto sign-painter's paper, and then, using the old system of perforating wheel and ponce bag, he transfers the line drawing to the canvas. Then, working *alla prima*, he paints from top to bottom, with little or no reworking.[21]

The large *Late Squall*, which was produced in the studio from a 36×48 plein-air painting, resonates with the eerie stillness brought by a northern blizzard. The seasonal remnants of muted colors are buried beneath the drifts and further blurred by the kaleidoscopic haze of swirling snow. It is typical of Welliver's work, in which he maintains a Realist's faculty for specificity while bringing to landscape painting the sense of monumentality, the environmental size, and the gestural physicality of Abstract Expressionism.

Peter Milton
Panorama 1, 1963
Etching, 18 x 24 inches (plate size)
Courtesy of the artist

Gabriel Laderman
West Dover, 1968
Oil on canvas, 36 x 45 inches
Collection of the Herbert W. Plimpton Foundation, on extended loan to the
Rose Art Museum, Brandeis University, Waltham, Massachusetts

Neil Welliver
Late Squall, 1984
Oil on canvas, 96 x 120 inches
Nelson-Atkins Museum of Art, Kansas City, Missouri, Gift of the Enid and Crosby Kemper Fund
Courtesy of Marlborough Gallery, New York

Alex Katz
Full Moon, 1987
Oil on canvas, 102 x 180 inches
Courtesy of Marlborough Gallery, New York

Wayne Thiebaud
Coloma Ridge, 1967–68
Acrylic and pastel on canvas, 74 x 75¾ inches
Courtesy of Allan Stone Gallery, New York

Alex Katz is known primarily for his sleek, urbane portraits, but he has produced a large number of landscape paintings and prints since the early fifties. A key aspect of those early, reductive images was his frequent use of collage. Working with colored paper and a minimum of pictorial essentials, Katz distilled the subject to an immediately legible posterlike representation, and that elegant simplicity has remained central to his paintings and prints, regardless of their subject.

Katz has said that he looks for "the big line," and there is always a subtle but careful weaving of shapes, patterns, and colors, which fit onto the canvas with the authority of an Utamaro courtesan. While generally honoring, but intensifying, the local color, he compresses and simplifies the tonal range and often shifts to a decorative colored background in his portraits and flower paintings.

Just as it is hard to discern much about the personalities of his subjects from the stylish portraits, it is difficult to identify the locale of his landscapes, which are more a depiction of conditions than a description of place. It is certainly not apparent that the site of a Katz landscape is literally a short distance down the road from one by Welliver, so divergent are their points of emphasis. This is exemplified by the elegant *Full Moon*, which has no specific clues to place. Like Welliver, Alex Katz refers to small, directly observed oil studies for his large studio paintings. In this large canvas, which is from a group of night paintings, the trees are reduced to a velvety black silhouette against the royal blue of the evening sky. The bright disc of the light of the full moon is fragmented and diffused by the branches and foliage. Here, a clichéd and discredited symbol is given back its romantic mystery, while simultaneously recalling the marvelous night prints of Hiroshige, the dark, vaporous mysteries of Rothko, and the crisp,

close-keyed minimalism of Ad Reinhardt. It is the qualities of night, rather than the physical specifics of place, that are the subject of this painting.

Wayne Thiebaud is another who often bases his studio paintings on small, directly observed studies; but his subjects are likely to spring from any combination of sources — from direct observation, improvisation, remembrance, or the imagination. He has explored a wide range of subjects in his paintings, prints, and drawings, and has used almost every medium available.

Thiebaud has described himself as "a sign painter gone uppity," and like many other artists, including Homer, Parrish, Hopper, Hogue, Pearlstein, and Estes, he spent years in commercial art, including an early stint as a Disney animator. He came to prominence in the early sixties with his colorful and creamily painted still lifes of pies, pastries, gumball machines, and delicatessen counters, rendered with affection, sly humor, and a nod toward the slightly surreal quality of these contemporary cultural artifacts. Rather than banal Pop ironies, these classic still life paintings are, in fact, homages to that venerable tradition, and loaded with references to Chardin, Van Gogh, Giorgio Morandi, and Joaquin Sorolla.

Although he was best known in the sixties for his still lifes, and in the past decade for his somewhat fictionalized views of San Francisco, he has also painted a staggering array of portraits, figures, and landscapes.

Many of the landscapes are based (but more distantly than the paintings of Welliver or Katz) on small, plein-air oils, pastels, and drawings. The large, iconic *Coloma Ridge* contains references as diverse as the Italian Macchiaioli, the Bay Area painters, and Morris Louis's *Veil* paintings. While it is based upon a particular range of mountains in California, the severe sweep of the ridge wall is emphasized and punctuated by the

compositional cropping of the scene. The gauzy ripple and swell of the cliffside, coupled with Thiebaud's use of transparent acrylic stains heightened with pastel, is a simultaneous play on the impressionistic atmosphere and elegant fluidity of form and space in the late fifties *Veils* by Louis.

Ultimately, Thiebaud presents us with Aristotelian archetypes, the "pieness" of pies, the "cliffness" of cliffs, graced with his warm charm, and retold with the panache of a good fisherman's tale.

The roots of the figurative painters of this generation connect primarily to French Modernism — witness Diebenkorn's ongoing relationship with Matisse, Porter's love of Vuillard — and all were enveloped by the monumental influence of Abstract Expressionism, which is evident in their use of scale, gesture, and acceptance of the physical propensities of their media. For this first generation of Realists, it is de Kooning who casts a lingering spell. Hopper still lies in the background, like a slumbering giant; his presence is clearly seen only in Richard Diebenkorn's figurative paintings and landscapes, but he will be a major influence on the generation that follows.

For the first generation of Realists, the Hudson River School was as distant as the frescoes of Pompeii, though Alfred Leslie was an exception, making what was perhaps the first strong, clear reference to those nineteenth-century painters.

The most significant achievement of these artists, as a group, together with many of their contemporaries, was to reestablish verisimilitude as a major form of contemporary expression in a period distinguished by its lack of sympathy for such goals. In doing so, they reclaimed and widened the possibilities for the art that would follow them.

James Weeks
Berkshire Landscape, Boat Landing, 1972–83
Acrylic on canvas, 60 x 66 inches
Courtesy of Hirschl & Adler Modern, New York

CHAPTER FOUR
PAINTERLY REALISM

The American mainstream has fanned out into a delta, in which the traditional idea of the avant-garde has drowned. Thus in defiance of the dogma that realist painting was killed by abstract art and photography, realism has come back in as many forms as there are painters.

Robert Hughes[1]

Realism is an art of describing, and the shared point of convergence for both the painter and viewer lies within the physical look of a tangible world. Its visual qualities can either be simulated, as in the art of Church, Kensett, Eakins, Pearlstein, or Estes, or paralleled by the physical propensities of paint, as in the work of Inness, Homer, Sargent, Porter, or Diebenkorn. Both approaches have a very long tradition, with the former traceable to the Van Eycks and the invention of oil painting, while the latter has numerous precedents in the great age of *alla prima* fresco painting.

Writing more than a half-century ago, the great art historian Heinrich Wölfflin described these different approaches as the "linear" (draftsmanly, plastic) and the "painterly" (tactile and visual), in his classic book *Principles of Art History*.

Although in the phenomenon of linear style, line signifies only part of the matter, and the outline cannot be detached from the form it encloses . . . linear style sees in lines, painterly in masses. Linear vision, therefore, means that the sense and beauty of things is first sought in outline — interior forms have their outline too — that the eye is led along the boundaries and induced to feel along the edges, while seeing in masses takes place where the attention withdraws from the edges, where the outline has become more or less indifferent to the eye as the path of vision, and the primary element of the impression is things seen as patches. It is here indifferent whether such patches speak as colour or only as lights and darks.[2]

Wölfflin's distinction remains true of Realism today. But the Realism that evolved from Abstract Expressionism in the fifties and sixties was gestural and painterly, and would not clearly separate into the two distinctive traditional courses of "painterly" and "linear" until the late sixties and early seventies. Pearlstein once remarked, when asked about the looseness of his rendering in his works of the early sixties, that "they looked more tightly painted at the time"; the context of the art of that period was a dominant factor, emphasizing the more painterly attributes of figuration. However, as the painters' skills of observation sharpened, and their faculties for accurately describing with paint developed, the divisions once again became a matter of personal proclivity.

Pearlstein, Leslie, Laderman, and Beal in their mature work moved noticeably toward a controlled, precisely rendered, and tactile description; Fairfield Porter, Neil Welliver, Jane Freilicher, Paul Resika, and George Nick maintained a painterly stance, and never denied the viscosity of the medium. Like the tactilely descriptive painters, the Photo-Realists took the act of describing to its extremes, but their work was, for the most part, a sharply defined transliteration of monocular images rather than a one-to-one encounter with an empirical reality. As for the Bay Area artists, they never abandoned the painterly traits that had characterized their work since the fifties.

But on both coasts, painterly realism has always simultaneously described object and act, whether the image is invented or observed.

James Weeks, one of the central figures in Bay Area painting, moved to New England in 1970, to teach at Boston University. He has also taken part in the Boston University Art Program at the Tanglewood music festival in western Massachusetts, and has taught at the Skowhegan School in Maine. His influence in the area has been clearly evident. The summers at Tanglewood have provided Weeks with an abundance of source material, including musicians in rehearsal and the Berkshire landscapes.

Three factors distinguish Weeks's paintings from those of his Bay Area contemporaries such as Diebenkorn, Bischoff, and Park. First, he is one of the few in that group to deal with narrative and allegorical subjects; his paintings describe the specifics of place, individual, or circumstance.[3] Second, his landscapes since 1970 are primarily of New England. And last, most of his major paintings since 1966 have been done in acrylic rather than oil.[4]

Space, light, and form are the key elements in his eloquently ordered paintings, which are developed from drawings and studies done from various spatial view points. A painting such as *Berkshire Landscape, Boat Landing* goes through many subtle changes and adjustments, a process in which the image is continually refined, but it always retains the specifics of place.

Thus Weeks occupies a unique position: He has maintained the extemporaneous physicality that typifies the Bay Area while retaining the look and spirit of each subject.

In the mid-forties, Jane Freilicher joined Hans Hofmann's classes at the urging of her friend Nell Blaine. In this period immediately following World War II, Larry Rivers was playing the saxophone and studying painting with Hofmann under the GI Bill. Among the Hofmann students were Richard Stankiewicz, Paul Georges, Wolf Kahn, Robert Goodnough, Leatrice Rose, and Paul Resika. Unlike another distinguished abstractionist and teacher, Josef Albers at Yale, Hofmann stressed the connections to the past, and the vitality of the painted surface, as well as his unique and complex spatial concepts.

Hofmann's ideas and pedagogy were open and broad enough to be carried into figuration as well as abstraction, and the paintings by Rivers, Blaine, Georges, Kahn, Resika, and Freilicher testify to the possibilities opened by him.

Jane Freilicher met Fairfield Porter at the time of her first show at the Tibor de Nagy Gallery, in 1952, which he reviewed for *Art News*. Porter's paintings in turn were recommended to John Bernard Myers, the director of the gallery, by Freilicher, as well as by Rivers and by Elaine and Willem de Kooning. Freilicher and Porter became close friends, and their reciprocal influence enriched the work of both.

Freilicher's paintings from the fifties were more gestural and expressive than her later work, reflecting their connection to Abstract Expressionism and French moderns such as Matisse and Bonnard, but by the sixties she had settled into a more casually fluid description of her subjects.

She summers on eastern Long Island and is best known for views of that landscape, which are often combined with interior still lifes. *Thicket and Field* is typical of her evocations of the conditions of summer light and weather. Freilicher's way of drawing with paint, and her summation of mood through the subtle heightening of color, are coupled with the ability to sustain the freshness of her original response.

In sharp contrast to Freilicher's landscapes are the raw, premier-coup paintings of Paul Resika. A fellow Hofmann student, Resika has been occupied with plein-air painting for more than thirty years, and has worked in Mexico, France, Italy, New Jersey, and on Cape Cod. While his earlier works were the result of his "marriage to Corot," his landscapes

from the past decade reflect a matured and reasoned authority and his ability to compress the particulars into their essential, emotive character. The transient quality of the Cape light, as in *Horseleech Pond, Indian Red Sky*, is stripped of all that is superfluous, leaving only the pith of its fleeting mood.

Vincent Arcilesi is perhaps best known for his monumental, multifigured studio compositions, portraits, and unblinking depictions of erotic acts, but he has been occupied with landscape painting for more than two decades. Occasionally some of the paintings are reworked in the studio, but Arcilesi is primarily a plein-air painter, and his best landscapes are charged with the authenticity and emotional impact of direct reporting, qualities recalling the grand Swiss views by Ferdinand Hodler.

Grand Canyon was painted entirely on location for the Bicentennial exhibition America 1976 over a period of almost a month. After the drawing was established, Arcilesi worked four to five hours daily, refining the structure on cloudy days, and concentrating on the rich colors and shadows during the periods of bright sunlight. While the work appears to represent a moment in time, it is in fact worked up in sections, in periods from early to late light. Ultimately, the painting acquires a heightened intensity from this compression of the artist's prolonged investigation.

Like Arcilesi, Jerome Witkin is primarily a painter of narrative and allegorical subjects. He is an artist of grand and complex pictorial ambitions and possesses extremely seductive

Jane Freilicher
Thicket and Field, 1984
Oil on canvas, 74 x 74 inches
Collection of Theodore C. and Betsy Browning Rogers
Courtesy of Fischbach Gallery, New York

Paul Resika
Horseleech Pond, Indian Red Sky, 1984
Oil on canvas, 24 x 36 inches
Courtesy of Graham Modern, New York

Vincent Arcilesi
Grand Canyon, 1975
Oil on canvas, 48 x 60 inches
Collection of Philip Desind, Silver Spring, Maryland
Courtesy of Capricorn Galleries, Bethesda, Maryland

Jerome Witkin
Large (Entering) Rock, Oregon Coast, 1986
Charcoal on paper, 18 x 24 inches
Courtesy of Sherry French Gallery, New York

painterly skills, which are coupled with a gift of authoritative draftsmanship. While he can charm with the painterly grace of John Singer Sargent, he often simultaneously disrupts the spell he has cast through the emotional weight of his complex, turbulent themes.

Witkin is a prolific draftsman, and his drawings form one of the most underrated bodies of work in contemporary Realism. He has made very few landscape studies, only a handful of drawings of the Oregon coast, such as *Large (Entering) Rock, Oregon Coast*, but they are exceptionally authoritative descriptions, and are somewhat reminiscent of the landscape drawings of Edward Lear.

Perhaps more than any other painter, George Nick, through his study with Edwin Dickinson, extends the painterly plein-air tradition of William Merritt Chase into the arena of contemporary Realism. Nick is primarily an urban painter[5] and works from the back of a large truck equipped with a skylight and picture window, moving from one location to another on a schedule dictated by the prevailing light. From Dickinson he has learned the significance of tone, and that, coupled with his ability to dissect the subtleties of color, and his careful fitting of the picture within the perimeters of the canvas are the keys to his paintings.

All of this is evident in Nick's skillful evocation of winter in *Over Pemigewasset River*, with its careful modulation of tone and subtle shifts of hue and reflective colors, which move fluidly from icy blues to warm pinks and violets in the drifts of snow.

But it is important to note, for it is not readily apparent, that Nick's realism does not share the influence of Abstract Expressionism that was a constant factor in the figurative art of the fifties and sixties. While George Nick is close to Welliver, Pearlstein, Laderman, and the generation proceeding from Abstract Expressionism, this is a point of contact he simply does not share. Instead, his roots trace back to the tradition of the painterly realists, such as Sargent, Chase, and Dickinson, a path that will become more common with the younger generation of painters. They will admire Pollock, Kline, and de Kooning as historically significant but distant figures, and the influence of Abstract Expressionism will be remote, if felt at all.

Although many of the younger figurative artists who have emerged throughout the seventies and eighties studied with abstract painters in various schools around the country, they consistently voice their admiration for the Bay Area figurative painters of the fifties and sixties. That group and Fairfield Porter are named as the major contemporary influences on their work, although for the most part they have had little or no direct contact with either. Yet most of the younger artists show little awareness of their distinctly divergent aesthetic positions.

Unlike many of the earlier Realists, these artists of the seventies and eighties are primarily landscape painters, linked together through a profound respect for their subjects and common ecological concerns. But most of them are scattered across the country; they have little or no contact with one another, except occasionally through their galleries and various group exhibitions.

Richard Crozier, for example, is from Virginia, and although he has painted in the Southwest and Maine, most of his subjects are from his home state. He does many small, descriptive plein-air paintings, which are used primarily as background information for the large and more classically inclined studio paintings, such as *Owlshead from Mount Battie*. Distinctly differing from the small premier-coup paintings, the large compositions are more improvisational. Crozier has written: "I do not have a preconception of what I will paint, but rely on memory, intuition, and the process of painting. There are many changes and false starts, and I begin expecting that the finished painting will surprise me. These studio pieces are more likely to be paintings about landscape than representations of actual sites." Elaborating on his attitudes as a contemporary landscape painter, he states, "There is no truly virgin landscape to be found; the nineteenth-century concept of wilderness is neither interesting nor valid today. There is always a human presence, even if subtle or oblique, that must be dealt with." It is the implied human presence that distinguishes many of the landscape paintings of this century — from Burchfield, Hopper, and Porter to the present — although this characteristic may be challenged by other young painters of different persuasions.

The plein-air, premier-coup paintings of the back roads of Nebraska by Keith Jacobshagen are remarkable evocations of place and mood. Jacobshagen works in the studio on large landscapes four to five hours a day, and then paints his small works, which are oil on

George Nick
Over Pemigewasset River, 1986
Oil on canvas, 40 x 40 inches
Collection of Chemical Bank, New York

Richard Crozier
Owlshead from Mount Battie, 1986
Oil on canvas, 24 x 36 inches
Courtesy of Tatistcheff Gallery, New York

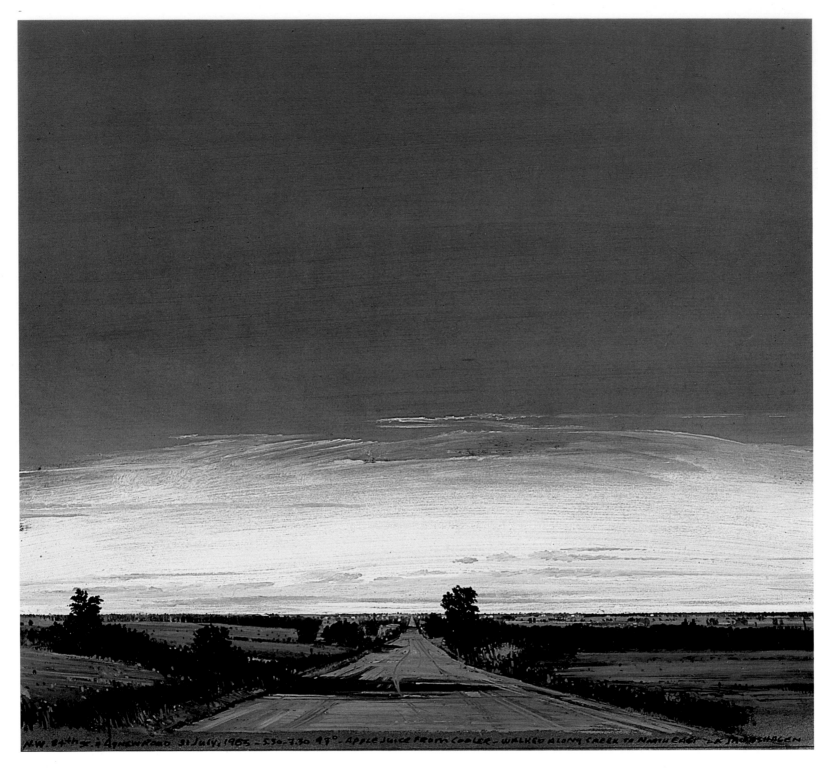

Keith Jacobshagen
N.W. 84th St. & Agnew Road, 1983
Oil on paper, 11 x 12 inches
Courtesy of Roger Ramsay Gallery, Chicago

stained rag board, from late afternoon until dark. These diminutive pieces, such as *N.W. 84th St. & Agnew Road*, are distinguished by their painterly explicitness, expansive scale, and deep affection for the land. Typically, there are notations across the bottom describing the weather and other particulars of the moment.

Jacobshagen has described the impulse behind his landscapes in a recent letter:

Something about the road paintings — they came about as a kind of way to go home — a formal epiphany of the journey. When I was a kid in the midwest it was a tradition to go for a Sunday drive. If the day was hot, then a country drive in the late afternoon to escape the heat of Wichita was a treat. I have fond memories of those warm late afternoons with their cool shadows stretching across gravel and dirt roads — sitting in the back seat of my father's Ford looking between my parents' heads at the road that seemed to move out, cutting through the wheat or grass fields. I think the space and thrust of those roads and how they defined the slight slope and flatness of the planes — the distance of things attracted me in an intuitive way.

Here is a revival of the best spirit of Regionalism, now in the eighties in abundant evidence, marked by the intimacy of the landscape experience. But the painters currently working in this spirit are separated from those Regionalists of a half-century earlier by a more sophisticated awareness of the art of the past and present, by their avoidance of strident provincialism, and through their acceptance of the pluralism of our time.

Another important development of the seventies was the revival of watercolor, which must be attributed primarily to the Realists and Photo-Realists. Both Fairfield Porter and Neil Welliver were at home with the medium, as were Richard Diebenkorn and Paul Wonner, but its use for highly informed imagery must be attributed to the urban-inclined Photo-Realists. Later, it was adapted to large-scale landscape painting by Susan Shatter, Joseph Raffael, and Don Nice.[6]

Don Nice lives on the Hudson River, in an area noted for its many associations with the art of the nineteenth century, but he has traveled widely, and along with many paintings of the Catskill region, he has produced works related to the landscapes of California, Idaho, France, and Africa.

Nice is best known for his heraldic combinations of an animal or landscape with arrays of indigenous plants, vegetables, animals, and objects encased in predellas above and below the central icon. He thus gives a uniquely contemporary look to what is traditionally a religious format. In addition to his oils, acrylics, and prints, he is an experienced watercolorist whose work is steeped in the custom of plein-air painting, which in turn serves as the basis for his larger and more complex studio constructions. Even when working in oil or acrylic, he dilutes the pigment to a stain and relies on transparent colors.

Don Nice is also a seasoned printmaker, and his painting and printmaking skills converge in the *Hudson River* series of monoprints. In these works, the craggy bluffs, dense foliage, and river below are succinctly recounted through the fluidity of the thin, pressure-transferred colors, suffering no loss of the spontaneity of his original watercolor notations.

Sheila Gardner works with both oil and watercolor, painting from direct observation, studies, and occasionally photographs; her subjects range from the Rocky Mountains to the northern woods. Her watercolors of Maine, such as *Silver and Gold*, are distinguished by her ability to recapitulate the intimacies of the region's moods, the shifts of its weather, and the specifics of its seasons.

Worked up from small plein-air watercolor sketches, Gardner's large watercolors never suffer from the usual losses of transcription. Instead, she has repeatedly demonstrated her ability to sustain the casualness of that first response while heightening the intensity of her original observations. She is able to refine the particulars of a given moment and place, while maintaining the integrity of this absorbent, stainlike medium. Gardner's virtuosity with watercolor is understated, never calling attention to itself.

Today, the camera is regarded primarily as a Photo-Realist tool, and while its use in painting calls to mind the cool, replicative achievements of those essentially urban artists, the history of the photograph is entwined with both the urban and pastoral landscape, particularly in American art.

The vast panoramas of Susan Shatter are based on a combination of source materials, including color slides and photographs, as well as numerous directly observed sketches and watercolors.

Shatter studied with Alex Katz and James Weeks, a background that fuses two different impulses, and she was also associated with

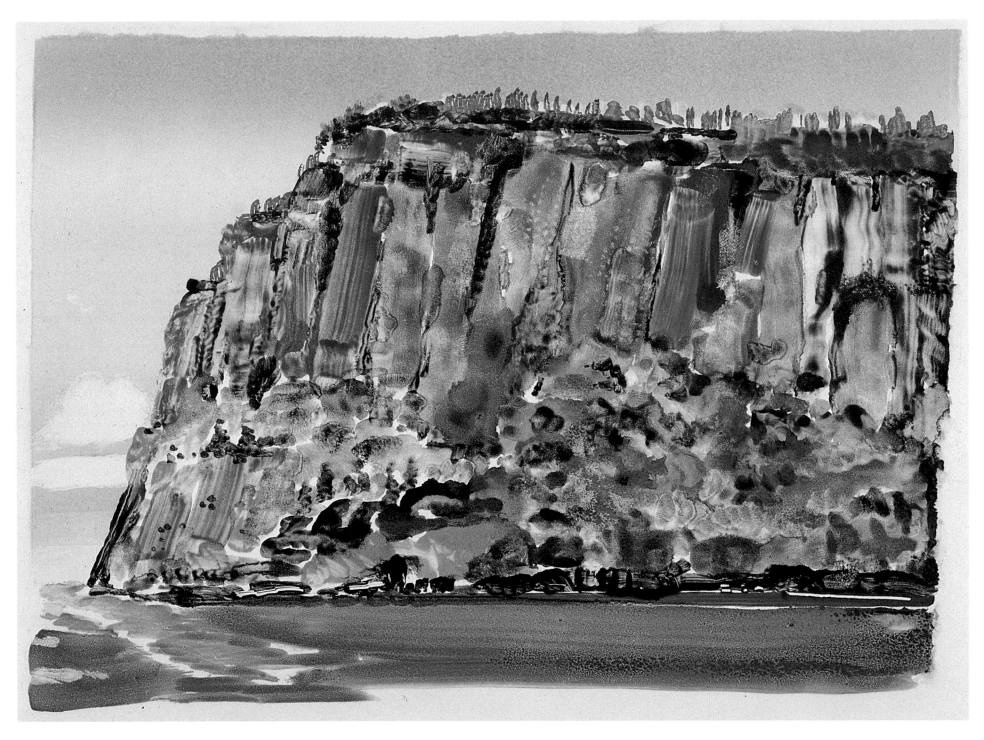

Don Nice
Palisades I, 1986
Monotype, 11 × 15-inch image on 22 × 30-inch Arches paper
Pace Editions, N.Y.

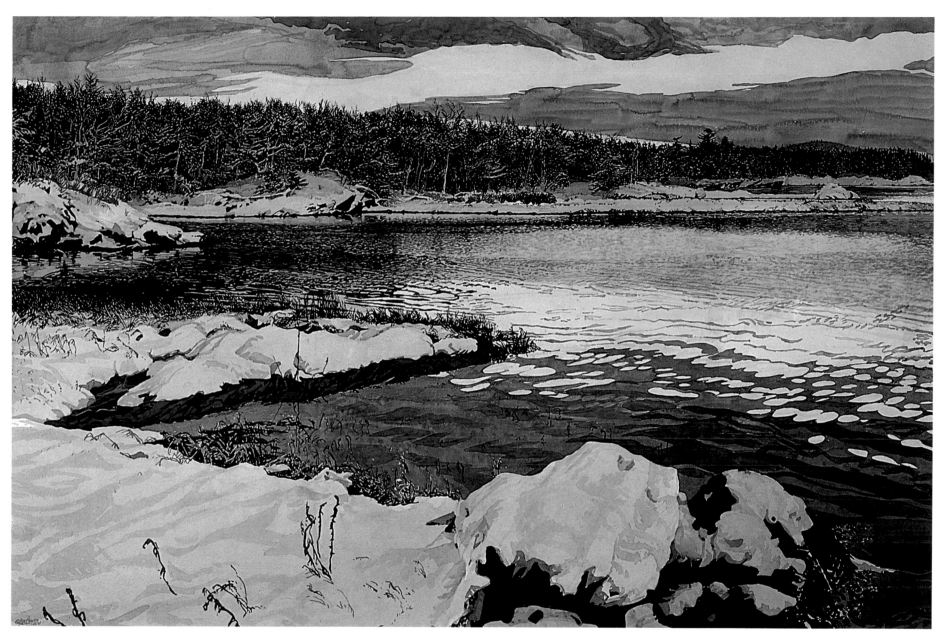

Sheila Gardner
Silver and Gold, 1987
Watercolor on paper, 40 x 60 inches
Collection of Arthur Andersen & Co., Boston

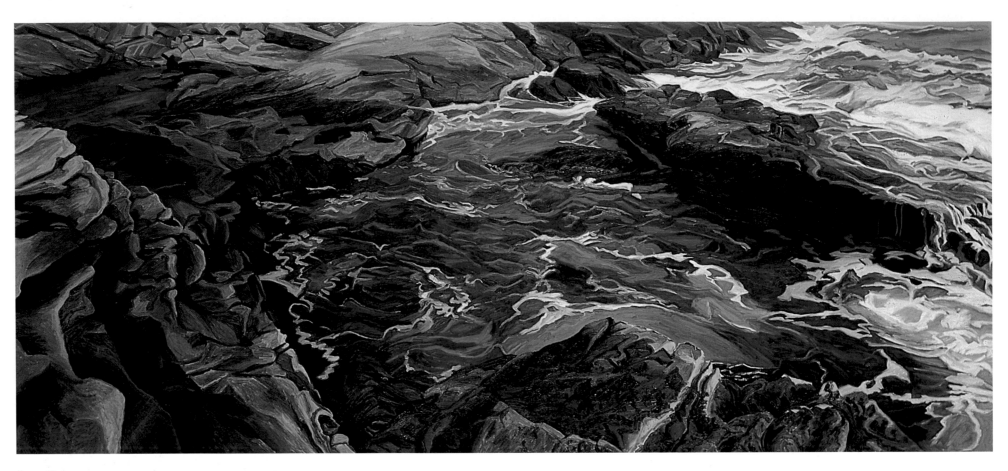

Susan Shatter
Ice Blue, 1981
Oil on canvas, 40 x 90 inches
Courtesy of Fischbach Gallery, New York

John Gordon
Ione's Backyard, 1982
Oil on panel, 36 x 60 inches
Private collection
Courtesy of Tatistcheff Gallery, New York

William Nichols
Corkscrew Bog, 1987
Oil on canvas, 60 x 87½ inches
Courtesy of O. K. Harris Works of Art, New York

Fairfield Porter and his circle of New York painters, poets, and writers. She has always been inclined toward painterly realism, and while a graduate student painted large panoramic views of Manhattan and Boston. She has traveled widely, producing panoramas of Greece, South America, the New England coast, and the canyons of the Southwest. Her influences are as scattered as the topography she depicts: She cites Arshile Gorky, Porter, O'Keeffe, Bischoff, and Guston; the landscape prints of Hokusai and Hiroshige; and a broad assortment of nineteenth-century European references, such as Manet, Gauguin, Bonnard, and Cézanne, plus American masters Homer, Heade, Church, Bierstadt, Fitz Hugh Lane, and others.

Equally comfortable with oil or watercolor, Shatter is at her best with strong geological formations, the canyons of the American deserts and the rocky coasts of Maine. Her subjects are purged of the romantic associations with which they are usually imbued, and assert instead the physicality of nature and the tension between representation and abstraction.

John Gordon has chosen the quietude of small town streets and yards as his subject, and his affection for these familiar themes instills his paintings with a sense of intimacy and graciousness. Backyards and summer gardens, with their shapes and colors defined and animated by the chiaroscuro of summer sun and cool shadows, are transcribed into lush, richly patterned images that are more akin to the hushed mood of Vuillard's interiors than to the narrative landscapes of the American Scene painters.

He works on hardboard, using its color as a middle tone, and begins with a projected image to establish the composition and tonal patterns, which he then proceeds to edit and translate to strengthen the pictorial effect, emphasizing the quality of light and its bleaching of color.

Walls and columns of dark, thick foliage informally mark off the lots while providing privacy and welcome shade in *Ione's Backyard*. A birdhouse replicates in miniature the simple frame dwellings beyond. Laundry, long dried by the sun, flaps on the line next door and flickers in the late afternoon light. Tall stalks of hollyhocks shiver with the breeze, their waxy, crepe petals (these are the old-fashioned "single mixed" variety) catching the last of the waning sun.

John Gordon's paintings capture the fundamental character of the American small town, and linger on those aspects that have changed very little over the last century.

In landscape painting, no matter how broad the expanse or deep the space represented, the view must remain a chosen fragment. Nothing can change this, and there is always an immutable act of selection, with its implicit limitations. Landscape extends beyond the containment of every painter's canvas.

This principle is acknowledged as one of the four essentials in Japanese gardens of the *shakkei* style, which implies "a landscape captured alive." *Mikiri* is the device of trimming in order to limit the features a garden designer wishes to show, while concealing others that are irrelevant or undesirable. Thick and luxuriant hedges are one of the most appropriate means for achieving the latter, for they close off naturally and inconspicuously.[7]

The landscapes by William Nichols recall this principle of *mikiri*. Enveloping like an overfurnished interior, they only hint at the expansive space beyond by means of light penetrating the dense enclosure of thicket and foliage, and reflecting into broken facets on the water's surface. Nichols's claustrophobic views disorient, for no clues are provided to their context. Such microcosms of landscape can be found throughout the country, but those he paints are in fact fragments of small creeks and streams in Milwaukee, adjacent to a busy highway or at the back of a suburban yard.

While Nichols's paintings, whether oil or watercolor, are begun from a projected slide, the image obtained provides only a framework for the further development of the painting, which is constructed of loose stains of wet, transparent color. What appears to be a glut of specific visual data melts into impressionistic chips and patterns of light and dark.

The works of these painterly realists are marked not by their degree of invention or improvisation, but by the subtle variations of their personal interpretations, which are physically distinguished by their individual formal and gestural traits. They hark back to their painterly antecedents in American and European art from the turn of the century, to Inness, Homer, Chase, Bonnard, Vuillard, and Matisse, and both the French and American Impressionists — a tradition that, after the decades of gestural abstraction, was revitalized and authoritatively returned to its representational roots by the first generation of Realists, painters such as Porter, Welliver, Weeks, and Thiebaud.

Rackstraw Downes
Dragon Cement Plant, Thomaston, Maine; The Rock Crushing Operation, 1986
Oil on canvas, 32 x 66½ inches
Courtesy of Hirschl & Adler Modern, New York

CHAPTER FIVE

THE MIRROR OF NATURE

A true account of the actual is the rarest poetry, for common sense always takes a hasty and superficial view.

Henry David Thoreau[1]

Among contemporary painters of the precisely rendered image, there are three great painters of the urban landscape. The Spaniard Antonio López García, with his grand, pearlescent panoramas of Madrid; Richard Estes, the enigmatic vedutist of New York, Paris, and Venice; and Rackstraw Downes, with his crystalline views of Manhattan and the edgy, industrial alterations of the land, water, and skyline. Downes (like López García) relies entirely on his acutely honed skills of observation, which are reinforced by his tight, subtle organization of the image on canvas and the perfect pitch of his color and tone. Estes follows the tradition of the Italian vedutists Canaletto and Guardi, who relied on the camera obscura for views, and bases his paintings on color photographs rather than drawings.

No painters could be further apart in temperament or painting procedure than the two Americans. Since his student days at Yale, Downes has made a gradual transition from abstraction, under the influence of

Al Held, through painterly realism, a phase stemming from his relationship with Fairfield Porter and Neil Welliver, to the naturalism of his recent panoramic plein-air paintings.

In an essay on landscape, Downes said of Constable's paintings: "They show a trustworthy, empathetic intimacy with his subject. Constable's love of landscape passes beyond the euphoria aroused by the unexpected or the unfamiliar; beyond the dulling effects of habituation or methodical study, to that more sure-footed sense of poetry which sees magic where there is no mystification and feels the mystery in the known and the explicable."[2]

This passage also describes Downes's own landscapes, as well as much of the naturalism in the painting of this century. It is a subtle act of turning the commonplace into something extraordinary, without making a discernible departure from the facts of place. The picturesque and the dramatic are eschewed in favor of a straightforward account of the ordinary, but an account retold with an authority that can be obtained only through prolonged familiarity. Often this goes beyond the ordinary, to the depiction of subjects that are visually unappealing, such as López García's *Skinned Rabbit* or *Water Closet*, Estes' *Grand Luncheonette* or *Union Square*, or Downes's *Two Dumps in the Meadowlands; April, Lowtide, A Grassfire;* or *Dragon Cement Plant, Thomaston, Maine; The Rock Crushing Operation*.

Dragon Cement Plant illustrates this heightening of a commonplace subject within the boundaries of naturalism, and the perfected harmony of Downes's color and tone, now reminiscent of Corot's small plein-air views of Italy or Constable's painting *Weymouth Bay*. In his more recent paintings Downes has developed a way of intensifying the illusion of space by warping its horizontal stretch and planar expanse, an effect that closely parallels the perceptual act of scanning. While this spatial elasticity is more clearly evident in the panoramas, it can be seen in *Dragon Cement Plant* in the hill, which seems to jut beyond the picture plane while bowing back and inward along its crest, and then is repeated in the linear perspective of the cement plant structures.

Downes makes drawings and oil studies for each painting and then, using the grid system, enlarges the sketch that most closely corresponds to the character of the particular space. The canvas is then painted from start to finish on site.

Unlike Rackstraw Downes, Richard Estes works entirely from photographs, and although his name has become synonymous with Photo-Realism, his work differs from other photo-derived paintings in that he has never relied on a projection or any mechanical means for transferring a composition to the

Richard Estes
Central Park, Looking North from Belvedere Castle, 1987
Oil on canvas, 36 x 80 inches
Courtesy of Allan Stone Gallery, New York

canvas. Also, rather than using a single image, Estes works from an assortment of large color photographs for most paintings. Another distinction that should be noted is that unlike many of the Photo-Realists, Estes is not identified by a single subject, such as the diner, derrière, or human countenance. He has broadly addressed the urban landscape, American and European, for more than two decades.

Where Downes is a master of tone, Estes is a master of chiaroscuro; while Downes is an intellectual painter, Estes works intuitively. Both render complex, panoramic views, but neither Downes's nor Estes' space can be charted by the conventional means of two-point perspective. Both have converted the proverbial sow's ear, producing remarkable paintings from the most mundane views of Manhattan, and for more than a decade Estes has also included romantic and picturesque scenes of Paris, Rome, and Venice in his oeuvre.

Estes' painting of Frederick Law Olmsted's invented woods, *Central Park, Looking North from Belvedere Castle*, perfectly illustrates the instinctive methods he employs in constructing a painting, and shows that he can handle the natural elements with the same degree of authoritative, painterly grace that he has consistently demonstrated in the depiction of the glass, steel, and mortar of the urban environment.[3] But the foundation of this painting is too easily overlooked. Estes typically avoids the monocularity of the photograph by fusing his panoramic scenes from an assortment of photographs, which are often taken at different times of day, even different times of year. For this view of Central Park, more than a hundred photographs were taken, and approximately

fifteen were used for the painting. The right (Central Park West) section of the painting is shown in morning light, while the left (Fifth Avenue) side is in the light of afternoon. The casual strollers are warmed by the summer sun, and are dressed for that season, but the trees and vegetation in the park indicate that it is autumn. While these instinctive moves seem inconsistent, the result is a visual harmony that denies the petty nag of logic and offers a reminder that this is a painting rather than a factual accounting of the park.

Ultimately, art is evaluated from painted results rather than from an artist's pictorial intentions. Unfortunately, as a result, there has been a tendency since the early seventies to associate the precise image with the photograph and to categorize these images as Photo-Realism. Richard Estes and Rackstraw Downes demonstrate that a lucid accounting can be achieved by radically divergent procedures, but for each the procedures are contemporary variants of the two traditional courses available to the painter of the empirical world: reliance on either direct observation or the camera obscura.

Inherent in every painting is, as Wölfflin describes it, the matter of "individual style, national style, and period style," or the "expression of the temper of an age and a nation as well as expression of the individual temperament."[4]

A López García painting looks contemporary, but it also looks Spanish, regardless of the subject, just as an Estes or Downes painting looks like an American work. Cubism lost that indescribable sense of authenticity in American hands and, conversely, Abstract Expressionism lost its spirit in France, which is confirmed by the paintings of Pierre Soulages, Georges Mathieu, and Hans Hartung.

This subtle cultural quality was most poignantly described by the great Japanese novelist Junichirō Tanizaki.

One need only compare American, French, and German films to see how greatly nuances of shading and coloration can vary in motion pictures. In the photographic image itself, to say nothing of the acting and the script, there somehow emerge differences in national character. If this is true even when identical equipment, chemicals, and film are used, how much better our own photographic technology might have suited our complexion, our facial features, our climate, our land.[5]

Within the national characteristics of the precisely rendered imagery of contemporary American Realism, individual distinctions are readily apparent. The painter's craft demonstrated by William Beckman is quite different from that of Downes and Estes, but it is no less extraordinary. He has produced a number of directly observed self-portraits, full-length nudes, and portraits of his wife, Diana, which are unrivaled in their penetrating frankness, extreme lucidity, and technical virtuosity. His landscapes, which always include signs of agrarian activity, are no less impressive, and have the same sense of sustained, specific scrutiny. They differ from the figure paintings in that they are produced in the studio from numerous drawings and sketches, made on repeated visits to the site, and most are pastel on museum board rather than oil.[6]

The large *Baldwin Farm*, its grazing cattle and spring clouds so reminiscent of Constable's *Wivenhoe Park*, is in a mixture of oil and pastel. It is based on very precise pencil drawings, which record the general composition, placement, and specifics of the silos, outbuildings, and agricultural equipment, but which contain little or nothing of the particulars of light, weather, and local color. That information is built up in layers, which are gradual accumulations of specific data derived from numerous daily visits to the site. Beckman was raised on a farm and has a sympathetic knowledge of rural life that instills his landscapes with a trustworthiness that can only be obtained from experience.

This characteristic recalls the paintings of Constable and Jacob van Ruisdael (when he chose to be honest in his representation of the landscape) and the narrative descriptions of Thomas Hardy and Ernest Lewis.

Working nearby in Poughkeepsie, New York, and a friend of the Beckmans, Catherine Murphy is best known for her meticulous depictions of quiet suburban moments and her self-portraits, but she has also produced a number of remarkable landscape drawings and paintings. Like her genre paintings, her landscapes are inclined toward those aspects that usually go unnoticed.

Murphy's pristine paintings are based almost entirely on direct observation. The painting is developed from a very loose oil drawing, which roughly establishes the image and composition on the canvas. Then the painting is slowly resolved by working up the entire canvas simultaneously.

The scraggly, calligraphic tangle of trees, brush, and weed in *Scrub* (see frontispiece) has the wiry fluidity of a Cy Twombly scribble, as it flutters between abstraction and heightened naturalism. Its closed, receding space, muted color and texture, the warm earth tones of the rough bark and dried leaves protruding from the satin skin of gray and violet snow streaked by light and shadow, turn this minor detail of nature into an eloquent vision of winter.

Marjorie Portnow, Altoon Sultan, and Ben Berns adhere to the tradition of painting in situ. Although Portnow and Sultan travel widely, they always work entirely on location.

Marjorie Portnow has painted in New England, California, Long Island, and the Southwest, and has produced a large number of diminutive oils on panels and some large canvases that are remarkable in their fidelity to the unique look, light, and spirit of place.

She carefully works out her composition by viewing through a string grid, an old device used by Dürer and Van Gogh, and blocks the image onto the canvas with loose, colored washes of oil; she then slowly develops and tightens the composition, bringing it to the clear, airy conclusion that typifies her work.

View from Olana, a vast, arching panorama of the Hudson River as seen from the south lawn of Frederic Church's estate, was begun in 1986 and completed in the summer of 1987. The great nineteenth-century romantic designed his grand Olana to capture this view from the loggia he called the Ombra, a sweeping scene of the river for which our first great school of landscape painters was named. Portnow's painting is simultaneously a link to that past tradition and to contemporaries such as Gabriel Laderman, Fairfield Porter, Rackstraw Downes, and Alfred Leslie. But ultimately it is an ode to the grandeur of nature.

The subject of *View over the River, Hudson, New York*, painted a few years earlier by Altoon Sultan, is literally down the river from Olana. It is an equally specific and accurate observation of place, and a distillation of its summer mood and quietude. *View over the River*, like all of Sultan's paintings, maps the particulars of man and nature; the side of a Victorian house in the late morning shade, the translucent glow of light through the filigree of foliage, the lush vegetation receding to the river below, and beyond its banks the hazy range of the Catskills. This little tableau has the casual look of a snapshot, but the casual effect disguises her skill in creating compositional order, her ability for subtle emphasis, and the discreet manner in which she sustains and heightens the mood of the moment.

Alexandra Anderson has said of Altoon Sultan, "She is an eye, not an ego,"[7] which succinctly describes not only Sultan but all of the painters of the group discussed here.

Working in North Carolina, Ben Berns paints the lush countryside of Stokes County, its gentle rolling hills, dense woods, and extravagant vegetation. He has, over the past two decades, made a gradual transition from minimal and conceptual art to the direct act of painting as accurately as possible the perceived world, which is probably the most conceptual activity of all.

Berns has developed an unerring instinct for hitting a most accurate and delicate balance of naturalistic color and light, the color remaining clean in the darkest shadows and almost iridescent in the light-drenched passages. He delineates space articulately and, as in *Blue Ridge Mountains*, maintains the sharp focus of the detail throughout the rolling fields and groves caught in the passing shadows of clouds. It is an art of scrupulous describing.

Like Ben Berns, Peter Poskas has spent many years exploring the small area where he lives, in this case northwestern Connecticut. His paintings of the farms, fields, and surrounding landscape are distinctive in that he describes the nuance of change brought on by the progression of seasons, and the subtle shifts of mood created by the transient acts of light and weather.

Poskas is a traditional painter, a resolute image maker whose sensitivity, restraint, and intimate familiarity with his subjects leads him straight to their substance. The procedure he has developed differs from that of others in this group: Instead of painting directly from nature or working from sketches, he does numerous small, thinly painted oil studies on scraps of canvas, and these serve as preparatory works for his large studio compositions. Like Catherine Murphy's, his color is extremely delicate and uncannily accurate, but Poskas is also a careful observer of the skies, and more than anything,

William Beckman
Baldwin Farm, 1982
Oil and pastel on paper, 40⅜ x 74½ inches
Courtesy of Frumkin/Adams Gallery, New York

Marjorie Portnow
View from Olana, 1987
Oil on canvas, 30 x 50 inches
Courtesy of Fischbach Gallery, New York

Altoon Sultan
View over the River, Hudson, New York, 1981
Oil on canvas, 12 x 22 inches
Collection of General Electric, Stratford, Connecticut
Courtesy of Marlborough Gallery, New York

Ben Berns
Blue Ridge Mountains, 1988
Oil on canvas, 60 x 96 inches
Courtesy of Schmidt Bingham Gallery, New York

Peter Poskas
Dawn, Nettleton Hollow, 1987
Oil on canvas, 22 x 38 inches
Courtesy of Sherry French Gallery, New York

Daniel Dallmann
Quarry, 1985
Oil on canvas, 54 x 66 inches
Courtesy of Robert Schoelkopf Gallery, New York

it is the attention to the seasonal quality of light as distinguished by time and weather, and the tint it casts on the land, as in *Dawn, Nettleton Hollow*, that characterizes his paintings.

The Pennsylvania painter Daniel Dallmann, like most of the contemporary Realists, emphasizes the relationship of man to the land, which is occasionally discordant. In addition to figures and portraits, he is interested in the outer edges of suburban sprawl: the truck farms, light industry, and housing developments, which he records accurately and objectively. In Dallmann's meticulously rendered *Quarry*, the cavernous geometry of a surface mine occupies the middle of a pastoral landscape like some ancient, enigmatic ruin. It is old enough to be covered in patches by saplings and undergrowth, but the large earthen embankment with a compacted path across its ridge indicates that the quarry is still in use. As in a story by Alain Robbe-Grillet, the physical evidence is minutely described but the act and intent remain evasive, just beyond grasp. It is a scene watched but not judged.

Dallmann's procedure is unique in that he does direct studies, and makes a key drawing that is developed daily and simultaneously with the large studio painting. As the drawing accumulates more specific data and is refined, a daily parallel occurs on the canvas.

Walter Hatke has written that "for every state of being there is a corresponding reflection in landscape. Perhaps I am attracted by the revitalization that experiencing the landscape brings, it seems to call forth ancient forces and speak of timelessness, while being completely at the mercy of time." Indeed, his paintings are ultimately revelations of the familiar: the velvety sheen of polished wood, the movement of light across a room, the serenity of neighborhood yards in small towns, and the stillness and modesty of the rural landscape.

The richest alluvial deposits lie in the broad, flat floodplains that stretch out from the meandering course of an old river, providing the farmer with some of the best land. In Hatke's *River Fields* the space is marked off by the receding planes of the fields, the corrugated rows of crops, and the checkered greens and golds of the new growth. In a more subtle way, this depth is accentuated by the orderly recession of the fence posts, by the low, scattered clouds and the movement of their shadows across the fields. It is an objective depiction of the ordinary.

Many of John Moore's paintings result from his summers in Maine, but nothing could differ more from the Maine wilderness depicted by Neil Welliver and Sheila Gardner than his rural townships of that region. His crisply painted views of those small villages, such as *Monroe*, have a sense of authenticity that moves beyond their overly familiar and quaint picturesqueness to touch the quick of their character. This is the New England described by John Updike and Russell Banks, with its simple boxy houses in a random scatter beyond a town center made up of a filling station and general store — a landscape marked with butane tanks, aquamarine aluminum siding, pickups, campers, and trailer homes. It is the New England of nagging, gritty necessities nestled amid natural beauty.

Moore begins by making preliminary studies from direct observation; once the general subject as well as the size and proportion of the canvas are established, he takes slides from various points of view and under varying conditions of light and weather. The composition is scaled up, and the shapes and their placement broadly indicated with pastel, then blocked in with flat areas of generalized color. Referring to the slides, which are sometimes projected on the wall, he gradually builds up the details. The final painting is a synthesis, intended to convey a sense of the location rather than to transcribe it exactly.

Also stemming from this pattern of a mixed use of drawings and photographs are Stephen Fisher's rich chiaroscuro etchings of the woods of New England and Virginia. Fisher studied at Yale with Rackstraw Downes and the printmakers Gabor Peterdi and Richard Claude Ziemann. Their influence, as well as his admiration for the landscapes of Church, Heade, and Inness, and of Europeans such as Claude, Constable, Palmer, and Friedrich, give Fisher's highly tactile intaglios, such as *The Valley Sleeper*, a romantic and enigmatic tinge coupled with a strong pictorial order. Like Hopper's etchings, his prints are technically straightforward, the plate is cleanly wiped, and the blackest ink is used on a very white paper. As a result, Fisher's etchings have the tonal quality of a mezzotint.

Whether it is used tangentially as backup material or specifically for photo-derived work, we must remember that photography, from the camera obscura to Daguerre's light-sensitive plate, was invented as a painter's device. From its earliest use, photography has informed painting, and each form has simultaneously imitated the look of the other.

In considering Photo-Realism, there is a tendency to associate the use of photographic aids almost exclusively with urban subjects and sharply delineated replication. This belies both historical precedent (such as the use of photographs by Corot for some of his late landscapes, by Delacroix, Courbet, Degas, and Bonnard for figures, by Vuillard for interiors, Eakins for portraits, and so on) and recent fact. For example, Harold Gregor has been producing remarkable photo-derived paintings of the fertile agrarian flatlands of the

Walter Hatke
River Fields, 1983
Oil on canvas, 23½ x 39¾ inches
Collection of Chemical Bank, New York
Courtesy of Robert Schoelkopf Gallery, New York

John Moore
Monroe, 1985
Oil on canvas, 90 x 144 inches
Courtesy of Hirschl & Adler Modern, New York

Daniel Chard
Route 22A, 1983
Acrylic on paper, 8½ x 19½ inches
Courtesy of O. K. Harris Works of Art, New York

Harold Gregor
Illinois Landscape # 65, 1984
Oil/acrylic on canvas, 39 x 68 inches
Courtesy of Tibor de Nagy Gallery, New York

James Butler
A View from Albrecht Acres, 1985
Pastel on paper, 48 x 72 inches
Courtesy of Struve Gallery, Chicago

Midwest since the early seventies. His works have the replicative look of Photo-Realism and are for the most part derived from slides and photographs, but there is always evidence of his hand. Although they are indistinguishable from the photo-derived works, approximately a third of Gregor's paintings, such as *Illinois Landscape #65*, are completely fabricated. Such improvisational acts are made possible only by the strength of the lingering memory of these dark, expansive tilled fields, and an abiding faith in their importance.

Prior to Gregor's landscapes, the flat plains and open skies of the heartland seemed to offer few prospects for the painter, unless the artists emphasized the anecdotal, like the American Scene painters, or fictionalized its topography, as did the Dutch in the Golden Age. Gregor brought to that landscape an authenticity and sense of history that were quickly recognized in the East, and through his work he paved the way for a generation of younger painters.

Equally important are Gregor's philosophical links to the past. His firm belief in the sublime experience of nature connects him with both the German Romantics and the American landscape painters of the nineteenth century. He is one of the most influential teachers in the Midwest, a status best reflected in the paintings of his former student James Winn.

Gregor was the first contemporary landscape painter in the Midwest to achieve national prominence, but over the last decade an impressive and diverse array of younger artists of the region has emerged. James Butler's pastels of Illinois farmlands differ noticeably from the paintings of Harold Gregor in their tone and color, and more subtly in their viewpoint. Gregor's view (with the exception of his "flatscapes") is close to the earth; perhaps he looks across the dark fields from a crouch, thus tilting the space upward

and shortening the perspective. This instills in the viewer an acute sense of being surrounded by his fields. Like the farmer, one constantly measures the distance back to the house and barn, which usually are silhouetted against the sky. Butler, on the other hand, assumes a position slightly above the ground, as in *A View from Albrecht Acres*, which increases both the space and planar distance. Gregor's landscapes spread horizontally; Butler's views recede to the horizon.

The deep, receding vista of *A View from Albrecht Acres*, with its checkerboard of fields, scattered farms, and emphatic light, is slowly built up in layers of pastel. In spite of its explicit look, the work underwent many changes in the course of development and does not exactly replicate the photographic material from which it was derived.

James Butler also acknowledges the influence of the Luminists, particularly the work of Martin Johnson Heade. He has stated: "There is a wonderful, fantastic quality to his work. For me, it is the perfect blend of direct observation combined with the artist's interpretation and manipulation of the subject."

The monumental and enigmatic narrative paintings, portraits, and still lifes produced during the past decade by James Valerio have moved him from the peripheries of Photo-Realism to a position of prominence in contemporary Realism. The richness and lucidity of his painting technique are awesome and give great probity to his most inexplicable and complex fictions.

Valerio's paintings are distinguished by the heightened clarity of their color, the extravagance of their tactile descriptiveness, and their Mannerist light. The drawings are equally lavish and highly finished. While nature has served as a background for some of Valerio's paintings[8] (such as *Paul's Magic* and *Paul and Lucky*), he has made only a few forays into pure landscape, and these have been drawings. The exaggerated tonal patterns

and elephantine skin of the earth in *California Landscape* give this large graphite drawing a somewhat obsessive and hallucinatory edginess. In temper, this piece corresponds more to Balthus's cryptic *Gottéron Landscape* than to the traditional, bucolic landscape. Though an isolated foray (as is Jan Vermeer's *View of Delft*, one of the great masterpieces of *vedute* and a departure from his Dutch interiors), it is singular in its evocation of the West Coast landscape.

The California painter Peter Holbrook is attracted to the rugged aspects of the rocky landscape, reshaped over millennia by wind and water. He has produced paintings of the coasts of California, Hawaii, New England, and the canyons of the Southwest. Holbrook has said that he "tries to do what Winslow Homer might have done with a Nikon instead of a Brownie," relying on the mobility and lightness of the camera and its ability to freeze an instant. Some of his aerial views are based on photographs taken while soaring in an ultralight airplane.

Holbrook differs from the other artists in this chapter in that his works, such as *Mammoth Hot Springs III*, have the appearance of precision but are actually composed of dabs and washes of transparent and opaque color, which fluctuate in subtle shifts from warm to cool tone. Working with oil on gessoed paper, he combines the characteristics of transparent watercolor with the painterly and gestural traits associated with the oil medium.

Sarah Supplee, trained as an abstract painter and taught to reject Realism as a viable form of contemporary expression, began the transition to representational work through a growing interest in nineteenth-century American landscape painting, particularly the work of Church, Heade, and John F. Kensett, and also in the paintings of English Pre-Raphaelites such as William Holman Hunt. This interest in landscape came at the time

of the rising popularity of Photo-Realism in the early seventies, which expanded the possibilities for large, elaborately informed, and precisely rendered paintings. Her first realist paintings were of sweeping highway vistas, but it was the shift to expansive yards, fields, and farms that brought to Supplee's work a quietude and sense of intimacy that are distinctly her own.

She has stated:

I think of my work as a celebration of nature, of its abstract order and decorative abundance of forms. I would like to impress people with the spiritual importance of nature. By never including a person I enforce the viewer's attention to landscape itself. Perhaps at times I come close to a sublime aspect of the everyday suburban landscape. I would be gratified if I felt that my work helped to intensify the feelings people have for nature, in the wild or in their own yards and gardens.

These silent, golden afternoons, as in *Field near Brewster, New York*, are based on an assortment of photographs and some studies. The image is transferred from a gridded photograph and blocked in with loose turpentine washes. Then it is gradually worked up to finish, rich in tone and color, over a period of two to three months.

For his personal gratification, the New Jersey painter Daniel Chard made a quantum leap — with no intermediate steps — from large, geometrical abstractions to crystalline miniature landscape paintings. These exquisite little paintings are highly deceptive: there is minimal sign of the artist's hand and their suggestion of vast scale, like the visual deceit of Dali's *Persistence of Memory*, belies their diminutive size. *Route 22A*, which is typical of Chard's work, has the look of a photographed view, is the size of a photograph (it is 8½ x 19½ inches), and is reminiscent of the nineteenth-century landscape photography by Eadweard Muybridge, Carleton Watkins, and Timothy O'Sullivan. Chard's works are photo-derived, based on a panoramic composite of drugstore-processed color photos that the painter tapes to his drawing board above the stretched watercolor paper. The image is first drawn in with pencil, then the shapes and tones are blocked in with acrylic washes and progressively built to a meticulous finish in layers of increasing detail.[9]

It is immediately obvious that Daniel Chard is an impeccable craftsman. His ability to suggest the tactile particulars of a vast view in miniature is fused with an inclination for formal order and spatial structure.

Like William Beckman and James Butler, Bill Richards pushes his landscape drawings to obsessive extremes. Richards and Beckman both studied at the University of Iowa in the late sixties, in an art department dominated by the printmaker Mauricio Lasansky, which would explain their emphatic sense of drawing; fortunately, neither shows any trace of Lasansky's effete mannerisms. Instead, Richards's pristine works have precedents in the early sixteenth-century watercolors of Dürer, such as *The Large Piece of Turf*, and the prints of Lucas Van Leyden. Indeed, Richards's small, elaborate drawings have the quality of silverpoints but are in fact graphite on paper. His interpretations of the organic mysteries of the forest floor are based on an assortment of slides, which he views with a magnifying glass but does not project, and occasionally on specimens carried back to the studio. The drawings are fully developed from left to right, and then the image is reworked to further refine it. While they are truthful accounts of the swamps and woodlands of Westchester County, these drawings serve more broadly as metaphors of the intricate mysteries of life.

All of these works present a truthful account of nature, but there is always that inevitable edge of personal vision. The work of any one of the artists discussed in this chapter would never be confused with that of another. Rackstraw Downes has provided an explanation of why this is so:

There's a style that consists in not making a big fuss about things. "One may as well begin with . . ." E. M. Forster begins with in Howards End; *and in a wonderful poem James Schulyer writes that he wants "merely to say, to see and say, things as they are." The artist may present himself as diffident or offhand, while working his intensity into stating the facts in a way that doesn't draw attention to itself.*[10]

These are artists who found their personal creative centers in the early seventies and eighties. For most of them, the decision to work figuratively rather than abstractly was a matter of inclination at a time when both forms were approaching equal viability. Some, particularly in the East, had direct contact with artists such as Porter, Pearlstein, Beal, and other major Realists. Others, especially in the Midwest, felt the influence of Diebenkorn and the Bay Area painters but had little or no contact with them. For all, there was the heroic example of the Abstract Expressionists, and for each, there were diverse links to the art of the past and to the landscape tradition. Another underemphasized but consistent factor in the development of these painters who mirror nature is a return to the tradition of craftsmanship in painting and drawing, which is implicit to the character of these works. Their highly disciplined, forthright accounts of the landscape reconnect with the comforting graciousness and sturdy, straightforward ideals of the American Arts and Crafts movement, and parallel its recent revival.

There is now also clear evidence that the influence of the Luminists and Hudson River painters will grow into a prevailing aesthetic and spiritual force for younger landscape painters in the years to come.

James Valerio
California Landscape, 1984
Graphite on paper, 29⅜ x 41½ inches
Glenn C. Janns Collection, Sun Valley, Idaho

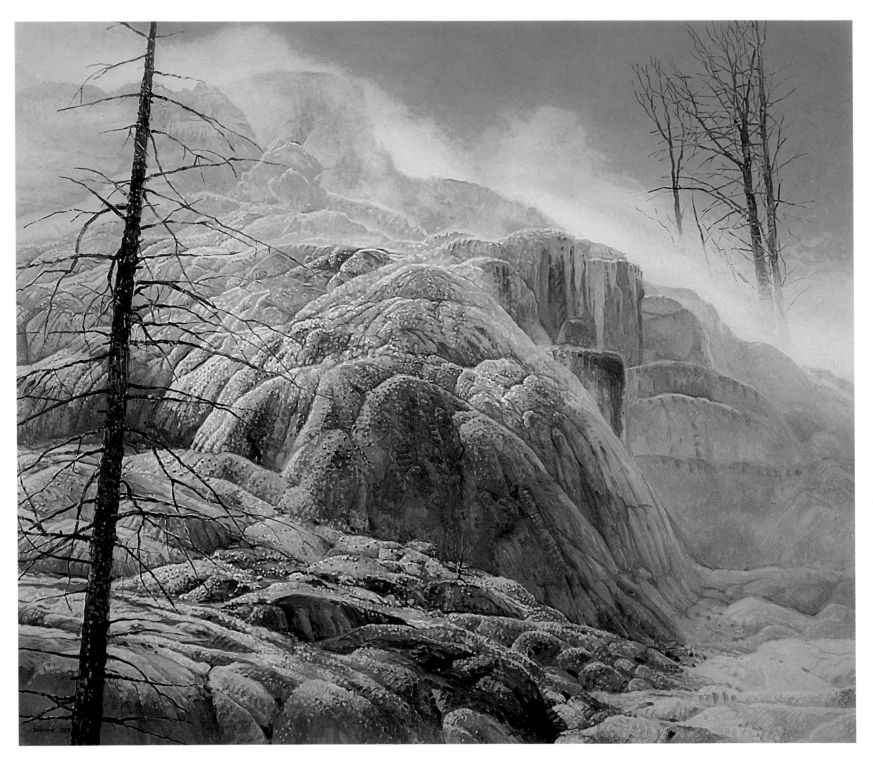

Peter Holbrook
Mammoth Hot Springs III, 1987
Oil and gesso on paper, 43 x 50 inches
Courtesy of Tatistcheff Gallery, New York

Sarah Supplee
Field near Brewster, New York, 1981
Oil on canvas, 54 x 54 inches
Courtesy of Hirschl & Adler Modern, New York

Stephen Fisher
The Valley Sleeper (Gothic Landscape No. 12), 1984
Etching, 16 x 24 inches
Courtesy of the artist

Bill Richards
Shilly-Shally at Hidden Pond, 1982
Pencil on paper, 18¾ x 24½ inches
Private collection
Courtesy of Nancy Hoffman Gallery, New York

Jack Beal
Dark Pool, 1980
Pastel on paper, 48 x 60 inches
Collection of Alice Adam, Chicago
Courtesy of Frumkin/Adams Gallery, New York

CHAPTER SIX
THE ROMANTIC LANDSCAPE

Great art is the outward expression of an inner life in the artist, and this inner life will result in his personal vision of the world. No amount of skillful invention can replace the essential element of imagination. One of the weaknesses of much abstract painting is the attempt to substitute the inventions of the intellect for a pristine imaginative conception.

Edward Hopper[1]

Charles Burchfield painted the intimacies and apparitions of landscape. Hopper painted its moods, Dickinson reduced it to quiescent shadows, Parrish converted it to an idyllic land of dreams, O'Keeffe fused its bared sinews with her sensuality and mysticism, and Avery distilled the landscape to a remnant of sweet memory. All of them probed beyond its appearance, and transformed its image to mirror both the facts of the terrain and the shapes of their psyches. They interpreted, but they did not invent, and we recognize the acuteness of their deeper truths.

The landscape of the true romantic bears the look of nature and the intensity of the spell it has cast upon him. Jack Beal's pastels illustrate this perfectly.

Beal came into prominence in the mid-sixties, with the large, complex nudes of his wife Sondra in elaborate, makeshift studio constructions. As opposed to the cool, detached accounts of Philip Pearlstein, and the monumental, confrontational grisailles of Alfred Leslie, Beal's nudes are sensual, erotic, and highly romantic. These are emotionally saturated allegories of women reclining in a recurring inventory of studio props and elaborately patterned fabrics, and are bathed in a baroque light. They are among the best works of contemporary Realism, and clearly reflect the romantic and idealized humanism that is central to Beal's art.

Jack Beal began his personal evolution toward realism with a series of highly charged landscapes, which he painted in the yard of a dilapidated farm. These were rendered with a bravura reminiscent of that of Chaim Soutine, but he gradually trimmed the gestural evidence of the painting act while intensifying the moods of his psychological narratives. Over the years his paintings have become more inclined toward allegory, but his practice of drawing and of carefully composing even the most minor sketch has remained consistent throughout his career.

With the exception of those early oils, and one small oil study from 1972, Beal's landscapes have been in pastel, charcoal (for example, *Hutton's Great Oak*), or ink wash. Simultaneously with the large studio paintings of allegorical subjects, he has produced numerous charcoal portraits and pastel studies of plants, flowers, and landscapes. The majority of the landscapes are pastels on a colored paper, which was used as a middle tone. In his earlier drawings the tone of the paper was allowed to assume a major role. Over the past decade, Beal's pastel landscapes have become increasingly informed and inclined toward nuance, and now have the complexity of paintings.

Although the landscapes are of specific, recognizable views (*Dark Pool*, for example, is a short distance from the Beals' house), they have retained their compositional tautness and emotional verve, and are steeped in a diverse blend of the past — Dutch, Flemish, and Italian painting, Japanese prints, and the grand American landscape tradition. Above all, and regardless of the subject, Beal's is an art of humanistic concerns.

Like Beal, Richard Claude Ziemann is a romantic. His delicate, atmospheric prints have a dreamlike quality that seems to parallel the mood of Rodolphe Bresdin's *Forest of Fontainebleau* and Odilon Redon's marvelous lithograph *Tree*; but unlike those artists' improvised fantasies, his landscapes are etched directly from nature.

Ziemann draws in the Connecticut woods around his home, using an etching needle on zinc or copper plates prepared with a hard ground. After it is proofed, he reworks and completes the plate by engraving it in the studio. The engraving can either reinforce his original response to the landscape or follow a course dictated by the subject's structure.

In describing these prints, he writes,

I have a romantic attachment to landscape and feel a sense of exhilaration when viewing the interior of woods, fields of grass, the forest floor, flowers and foliage. I work directly in the landscape experiencing the play of light and daily atmospheric changes along with form and textural variety of the seasons. Nature, with its combination of serenity and wildness, is an inexhaustible visual source for my work.

Remote, removed, and detached from the art world, Russell Chatham lives and works in Montana. He is a painter and printmaker, and also a gourmet cook, raconteur, and expert angler. His paintings are most widely known from the jackets of his friend Jim Harrison's novels, but Chatham has also collaborated with Thomas McGuane on a portfolio titled *In the Crazies*. He has produced a large body of lithographs and etchings; written on fishing, food, and wine for periodicals from *Sports Illustrated* to *The Atlantic* and *Rolling Stone*; and endorsed shirts for Banana Republic, a clothing store chain that caters to the Hemingwayesque fantasies of suburban yuppies.

Chatham is the grandson of the Swiss-born California painter Gottardo Piazzoni, and like his grandfather's work, his paintings reflect an ability to distill the moods and mysteries of the Western landscape while avoiding all its inherent potentials for mundane and picturesque clichés.

He is at his best portraying a sense of season and the late evening light, when the landscape is in its most solemn mood: that period before or just after the last light, when the stands of trees turn into apparitions before fading further into the darkness. And always, there is the prevailing sense that he knows what is in these mountains and woods.

Robert Jordan, like Beal and Chatham, paints the landscape he is most intimate with; this is primarily the area around Conway, New Hampshire, where he has spent summers for more than three decades, and the Mississippi and Missouri rivers near St. Louis.

Jordan is an art historian and has a long-standing interest in European landscape painting. But unlike most historians in the sixties (from whom he was also separated by being a serious, productive painter), he also cherished the work of the Luminists and other nineteenth-century landscape painters who had not yet gained the esteem of many scholars.

This feeling for the past is reflected in his work, for Jordan's paintings are evocations of the moods and quiet mysteries of the landscape, and reaffirmations of the undiminished import of the moral and aesthetic values of the American tradition.

The tranquil, idyllic view of the Catskills depicted in Richard Chiriani's *Schoharie Marsh Spring*, with its still water, golden light, and distant, undulating mountains, recalls Emerson's lines in *Nature*: "When the eye of Reason opens, to outline and surface are at once added, grace and expression. These proceed from imagination and affection, and abate somewhat of the angular distinctness of objects. If the Reason be stimulated to more earnest vision, outline and surfaces become transparent, and are no longer seen; causes and spirits are seen through them."[2]

Chiriani's paintings are based on direct observation, but they are tightly structured and their light reordered to intensify the vast, receding space of the landscape. Ultimately, they are classical interpretations of specific views. As with most contemporary Realists, Hopper is a prominent force, but Chiriani has also learned from the dusty tonality of Morandi and alludes to Morandi's metaphysical sense of serene space. Chiriani's version of reality is shaded by the influence of the classical vision of Paolo Uccello, Piero della Francesca, and Georges Seurat, which infuses his works with tranquillity and a dreamlike order.

This spirit of classicism and order also prevails in the drawings and paintings of the California painter David Ligare. But Ligare moves from the imagined specifics of a classical theme, as in his *Landscape for Baucis and Philemon*, to appropriations from selected photographs of types of trees, rocks, skies, and mountains, which are redrawn to fit his underlying structure. The drawing is transferred to canvas using a grid, and then the image is blocked in as a grisaille underpainting, which enables him to establish the tonal composition. Then the overpainting begins with the sky, establishing the lightest and darkest areas first. There is no counterpart in nature to Ligare's landscapes. Instead, they are classical archetypes invented by the painter.

The beautiful, highly ordered drawing *Landscape Study* illustrates his conceptual constructions. The overall rectangle is divided diagonally and then into vertical thirds, and the masses of rocks and trees are fitted into this symmetry.

Ligare has succinctly summarized his attitude: "Landscape controlled in the manner of Poussin or Claude represents the balance between order and chaos which is at the heart of classicism. I am interested in that perception as a sign of 'symmetria,' or the commensurability of parts, which in turn is a metaphor for responsible interaction within the world."

The landscapes by Bonnie Sklarski are also invented, but they have a solid basis in geological and biological fact. She describes her paintings as contrasting a "state of wilderness" with evidence of man's "material nature"; they are allegories on the physical alteration of nature by man.

Sklarski's *Early Man in the Wilderness* is the first in an envisioned series of paintings of man's relationship to the natural world, from his first small tamings to his present arrogantly destructive acts. The rugged limestone cliffs are patterned on the quarries of southern Indiana and are geologically accurate, but they are turned toward a narrative course. Dwarfed by the barren, striated walls of the canyon, these prehistoric men flee some unseen act of nature.

Jack Beal
Hutton's Great Oak, 1972
Charcoal on paper, 25½ x 19⅝ inches
Courtesy of Frumkin/Adams Gallery, New York

Richard Claude Ziemann
Sunlit Woods, 1968–69
Etching and engraving, 30 x 40 inches
Courtesy of Jane Haslem Gallery, Washington, D.C.

110

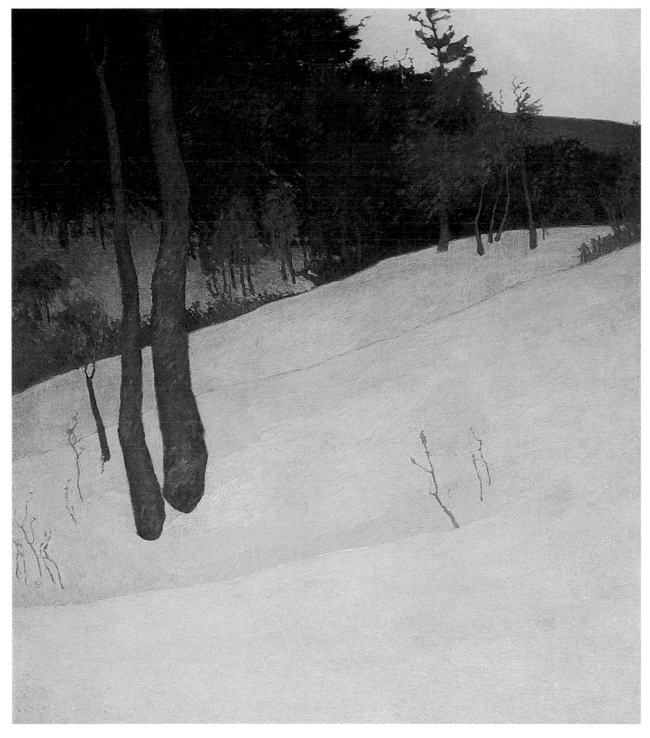

Russell Chatham
Winter Evening, 1980
Oil on canvas, 76 x 60 inches
Collection of Jack Nicholson

Robert Jordan
The Trail to Champney Falls, 1983
Oil on canvas, 36 x 50 inches
Courtesy of Sherry French Gallery, New York

Richard Chiriani
Schoharie Marsh Spring, 1978
Acrylic on paper, 55½ x 88½ inches
Collection of Technimetrics, Inc., New York

David Ligare
Landscape Study, 1986
Pencil and chalk on paper, 11½ x 20½ inches
Courtesy of Robert Schoelkopf Gallery, New York

Bonnie Sklarski
Early Man in the Wilderness, 1984
Egg tempera and oil on canvas, 44 x 55 inches
Courtesy of Robert Schoelkopf Gallery, New York

In regard to her studio procedure, Sklarski writes,

The scene and geological structure [are] invented with particular emphasis on the type and magnitude of erosion. . . . Studies of details done from the source are used to increase believability. The drawing [on canvas] rarely changes. Color and overall tone [are] constantly manipulated, starting with tentative washes, moving to very specific effects.

The drawing is transferred with carbon paper to the canvas and inked in. Solid forms such as the rocks, architecture, people, and animals are worked up in gray egg/oil tempera, and then glazed in local color. The sky and water are done directly wet into wet in oil.

Through this ambitious and elaborate process the painting evolves into a complex allegory that has been given the weight, clarity, and authenticity of affirmable, scientific fact.

Pursuing these transformations of the landscape toward a poetic and deeply personal interior expression is the enigmatic imagery of the Cuban refugee Juan Gonzalez. His works are minutely specific and richly referential, steeped in a complex mixture of the art of the past, his Catholic upbringing, films, Latin poetry, and literature. They are among the most unique and thoughtful works in contemporary art, and they are magically seductive.

Gonzalez has described the impulse behind his work as follows:

My concern with twentieth-century issues of content, psychology, and presentation has kept me from a full concentration of the skills I admire so much. When it comes to working within the traditional vocabulary of realism, I define myself as a kind of primitive painter. . . . For me, to deal with the landscape from a purely formal point of view is not enough. At the core of my creative drive there is a search for the poetic mystery that lies at the center of the art that interests me. I feel this split in attitude makes my efforts a kind of stylistic hybrid that produces what can be defined as eccentric art.

A frequent mistaken assumption is that these enigmatic, dreamlike images are surrealistic; they are not. Each element is referential, religious, or symbolic, and is the result of a highly conscious but deeply personal association: "Influences come from various sources and they vary at different times of our life. . . . Growing up as a young artist in Cuba, in a very conventional society, made me very conscious of my alienation. This feeling of being always an outsider forced me to invent a world of my own." Then Gonzalez mentions "the Catholic Church with its imagery, iconography . . . reaching back to my Hispanic past through poets like Lorca . . ."

For example, it is easy to overlook his frequent references to the paintings of Martin Johnson Heade, whom Gonzalez describes as "a mentor, a patron saint to my work. . . . I love his magic. His poetry lifts his work beyond whatever formal explorations he deals with in his various subjects . . . whether they be storms, the flowers, landscapes, or orchids and hummingbirds. These last ones I link to [Joseph] Cornell's vision . . . a kind of American eccentricity."

Songs for My Father refers formally to the series of charcoal drawings of Plum Island by Heade, one of which is *Twilight, Salt Marshes*, but Gonzalez gives the subject an autobiographical turn. Gonzalez's drawing is predominantly a monochromatic work, like the Heade series, but it contains flashes of the three primary colors. The juxtaposition of varying scales that is so apparent in Heade's pictures of hummingbirds and orchids is seen here in the images of the artist at various ages: as a baby with his father, as a child, and as a man. Where Heade divides the space with haystacks and a sail, Gonzalez marks it off with the figures, daybed, and a beach umbrella. Heade's use of the relative scale

of the haystacks to map the receding plane is paralleled here by the use of waves and waterspouts in the ocean; and where Heade grades the sky to a dark tone on the left, Gonzalez darkens it with black glass and lightens it again with a curtain. Heade's punctuation of the open sky by a flight of birds is exchanged for a mysterious veil. This is the greatest form of homage, for referring back to a poetic vision, it weaves a new spell from the punchcard of an old jacquard.

Bill Sullivan has also turned to the past, and his paintings pay homage to Frederic Church and his guide von Humboldt. Sullivan's major themes are "sunset, moonlight, and dawn," and he paints "the lower Hudson River and New York Harbor, Niagara Falls and the volcanoes, waterfalls and sacred places of the equatorial Andes and the Caribbean coast of Colombia and Venezuela."

Although the look of his paintings seems to correspond to certain current trends, his vision predates them, and the apparent correspondence is rather more a matter of Sullivan's being engulfed by less substantial stylistic parallels. He is keenly intelligent, literate, and an astute observer. Often he repeats his compositions but alters the emotional content by drastically changing the light and color. His images are condensations derived from observation.

Sullivan has stated that "the attitude I wish to convey is one of hopeful seduction; a beauty and charm that become a hypnotic daydream that asks disturbing questions." His updated night view of the garishly lit and tourist-tarnished but nevertheless awesome and metaphorically potent waterfalls, *Niagara Honeymoon* (see page 6), turns that Luminist

Juan Gonzalez
Songs for My Father, 1980
Watercolor and conte crayon on gessoed board, 22 x 42½ inches
Courtesy of Nancy Hoffman Gallery, New York

test for rendering natural grandeur on its ear. "Ten thousand years ago," Sullivan writes, "Niagara and Cotopaxi weren't that different, but now we seem to have lost the mysteries of secret places. Our culture prefers Disneyland to the consideration of mortality inherent in a great waterfall or the vision of immortality in its rainbow."

That, perhaps, is the crux of our modern predicament.

To step further in this direction, consider the plein-air paintings of Adele Alsop, such as *The Pond*, which simultaneously record the quintessence of place, the artist's sensual and emotional response, and the physicality of the act of painting. "I believe painting is more than an attitude or idea," she writes. "Painting is a magic, alchemical spell that has an absorbing, merging effect. It can clear the air, entertain, [provide] a vehicle for a person to dream."

Compositionally, the structure of *The Pond* is strikingly similar to Chiriani's *Schoharie Marsh Spring*; it unfolds from the pond's edge, and repeats the sky and trees like a Rorschach inkblot. But there all similarity ends. The Chiriani painting is a work of classical restraint. It is contemplative and serenely quiet. Alsop's closes at the bank in a tangled, jittery skein of woodsy growth. It is laid in with spontaneity and painterly bravura, and quivers with an animistic intensity.

Alsop now lives in Utah, but she has also lived and worked in the Tyringham Valley in western Massachusetts. *The Pond* typifies the spritelike, mystical intimacy of her vision, and the nervous, electric energy that saturates her paintings.

Daniel Lang combines the contemplative aspects seen in Chiriani with a painterly reconstruction of the landscape, which is in fact closer to the inventive poetics of Inness than to the contemporary Realists.

Lang divides his year between New York and Montone, Italy, where he has a home that was built into the wall of that ancient village. He is an inveterate traveler and has produced paintings of the European, Asian, and American landscape, and has had an exhibition based entirely on his paintings of Antarctica.

Lang's interpretive landscapes, especially those from the past decade, are sensual, subtle, and more inclined toward nuance than literal appearance. They are highly evocative of mood, which is allowed to settle over his scene, rather than being distilled from its natural counterpart.

It is important to recognize that, like the work of Juan Gonzalez, Lang's paintings do not follow the main course of contemporary Realism, but edge off into his personal vision. He writes:

I have tried to learn and absorb the lessons of many artists. The masters of Chinese, Japanese, and Korean landscape painting continue to exert a strong influence on my painting. . . . I study the works of Piero della Francesca, Vermeer, Pieter de Hooch, Rembrandt, the Italian fresco painters, Corot, Matisse, Morandi, Friedrich, Turner, Kensett, Eakins, Degas, Balthus . . . the list is long. One thread that connects my chosen ancestors is a quality they share: their paintings suggest so much more than what is spelled out before us. An incessant subjectivity is intrinsic to their art and acts as a magnet to my own sensibilities.

In *Breadloaf*, an isolated chair faces across a field from the edge of an empty backyard. This poetic narrative of abandoned chairs in quiet evening yards has been a recurrent

theme in Lang's paintings and drawings.[3] In this version, a cottage sits at the extreme left, beneath a stand of trees, enveloped in their shadow. It faces a clearing, its details articulated by the light from a distant, late-night moon. The solitary Adirondack chair is situated between the house and the right edge of the canvas on an aquamarine lawn. Above, the moon is diffused and fragmented by the violet blur of clouds. This painting seems to allude to the nostalgic remembrance of quiet summer nights in the country, and perfectly illustrates that Lang is above all a conjurer of moods.

The wooded creeks and streams depicted in the watercolors of George Harkins, with their images fragmented into abstract cloisonné-like patterns of rich colors, not only intensify the magical moods of the forest but also serve jointly as metaphors of emotions and experience, and as warnings against the cavalier endangerment of the environment.

These large watercolors, such as *September Gathering*, are studio constructions based on photographs. However, Harkins does not replicate this source material but shuffles the various elements to compose an image, emphasizing the shapes, patterns, and line, and orchestrating the movement and passages of color. The imagery of these paintings is recognizable only as a total composition. The parts flake into abstract shapes, as in the fluttering confetti of Robert Goodnough, or as in the late landscapes of Augustus Tack.[4] But the paintings of Harkins have their roots in the watercolors of Hopper, Marin, Demuth, and Reginald Marsh, and strike affinities with the work of Welliver, Porter, Kahn, and Raffael.

Daniel Lang
Breadloaf, 1982
Oil on canvas, 48 x 72 inches
Collection of Mr. and Mrs. Harrison Young, New York

Adele Alsop
The Pond, 1985
Oil on canvas, 56 x 72 inches
Courtesy of Schmidt Bingham Gallery, New York

George Harkins
September Gathering, 1982
Watercolor on paper, 40 x 60 inches
Courtesy of Tatistcheff Gallery, New York

Brooks Anderson
Dulce Vida, 1986
Oil on masonite, 48 x 96 inches
Courtesy of Schmidt Bingham Gallery, New York

The young West Coast painter Brooks Anderson has produced some astonishing landscapes of California and the coast of Maine. They display a virtuosity and tenderness that is reminiscent of Maxfield Parrish, but they are more specifically rooted to the mood and look of a particular place.

Anderson considers his major influences to be Diebenkorn, Beckman, and Jacobshagen, and also the Italian Macchiaioli; the last is most apparent in his emphatic use of light. There is also the pull of Gauguin, Van Gogh, Burchfield, and Hopper that lies like an emotional undercurrent beneath these moody, romantic works.

The late afternoon light lingers in the tips of the trees and crests of the distant hills, etching the details into sharp relief, and casting the peaceful *Dulce Vida* with a warm glow. There is a Pre-Raphaelite, or perhaps Nazarene, attention to the specifics of the foreground plants and shrubs, but the artist insists that "it doesn't matter where the landscape is; the main point is the . . . emotional appeal that is consistent in the mind's eye, which we all share. . . . The mental impressions are the key."

There is a turning here, first sounded by Juan Gonzalez, who said of his own works, "I think they differ from the nineteenth century . . . in the depiction of nature to create a landscape of the human condition, rather than to mirror nature."

But once again, as in the nineteenth century, the landscape is employed not only to poetically signify a mood but also to express spiritual or religious feelings. Brooks

Anderson hesitantly notes, "I realize I've used the word 'mental' a number of times. Since I am a religious person, and giving God his due, you can replace 'mental' with 'spiritual' and still arrive at the heartbeat and essence of my work."

This renewed expression of the spiritual in art is also found in the work of Simeon Lagodich, who writes, "I try to discover . . . a place in nature where an event may have occurred or a ritual may have been performed. The painting *Tree Knot* is a good example of this." There is a sense of fervor in this wooded scene. Its details are sharply articulated, each element is intensely described; the local colors, as in the glowing foliage, are intensified but always held within a believable chromatic range. The scattered, striated rocks appear to have dropped from the sky, or to be remnants of a totemic ruin. Rising up in the center of the scene is a dark, gnarled, and knotted tree, with lichen growing on its twisted hump. Its strange form and foliage recall, more than anything, that ancient "Sleeping Dragon Plum" (the plum tree Garyubai) depicted by Hiroshige in *Kameido Umeyashiki* (and later copied by Van Gogh), which was the most famous tree in Edo. Garyubai's double blossoms were said to be "so white when full in bloom as to drive off the darkness."[5]

Lagodich's attitudes were shaped, he writes, by

a strict religious upbringing in the Pentecostal Church, by parents who also had a great love of camping and traveling. My early artistic outlook grew out of the rituals, teachings, and iconography of the charismatic faith, coupled with the sense of discovery in the natural world. As I began my exploration as an artist . . . the environmental movement led me to the study of other primitive cultures. I found in them a key to a spiritual reconciliation with nature.

In a similar way, James Winn's beautiful soliloquies on the acts of light and shifts in the elements follow a traditional course. In their reverence for the past, they venerate the spirit of their lineage without imitating it.

Winn was born in the Midwest and has remained there. He now lives in a small town in Illinois, in the heart of America's fertile, agrarian flatlands. He is intimate with that region's persona and moods, and he is as drawn to its pantheistic mysteries as was Burchfield a half-century earlier. But where Burchfield had the soul of an Oriental, Winn descends from the American Luminists and Scandinavian mystics. He studied with Harold Gregor, who turned him toward the Luminists, and spent several years on a farm in Finland, where he became familiar with the Scandinavian painters of the nineteenth century (he names as influences Albert Edelfelt, Arkseli Valdemar Gallén-Kallela, Eero Järnefelt, and Eilif Peterssen, as well as Russian painters such as Levitan and Kuindzhi). It is clear that their work, and the paintings of the Luminists, struck a deep, responsive, emotional chord.

Emerson said, "The health of the eye seems to demand a horizon. We are never tired, so long as we can see far enough."[6] Winn's panoramic views of the flatlands divide along the taut, planar spine of a distant horizon into two vast and expansive regions; above, the sky, where shifts of light and skits of weather unfurl, and below, the earth, marked by the seasons and patterned by the expansively spreading crops. It is this interplay of the elements — earth, air, fire, and water, or the spiritual and physical sides of man — separated by a metaphorical rood screen formed by the distant horizon, that is at the heart of these

paintings. To confuse them with earlier regional anecdotes or recent acts of simulacra is to sell them short, for they are neither. The rare, sweet spells of Winn's images can only be fully comprehended through the acknowledgment and the acceptance of their profoundly religious character.

A similar pantheistic and mystical quality can be found in an earlier painting, *Island Lilies*, by Joseph Raffael, done for the America 1976 exhibition. This large canvas, based on slides from his sponsored trip to Hawaii, was the first of his many images of waterlilies and is one of his best-known paintings.[7]

In an earlier interview Raffael has declared, "Basically, I see art as a glorification of the individual, that sign of a human presence behind the object." But in spite of a transcendental pull, and strong feelings about being an American artist, Joseph Raffael has long felt the lure of the East: the contradictory turns of Zen, and the Shinto concept of God in nature, attitudes that bear a striking similarity to those of the American painters of the nineteenth century.

"I believe the Oriental artists depicted nature from an essential point of view, as the haiku poets did. For me that's what great art does; reminds me of who I am and the part of me I've forgotten. It conveys that sense of seeing something for the first time. It is the 'beginner's mind'! The Oriental artists had that."[8]

While perhaps not sharing these mystical or spiritual inclinations (Raffael changed the spelling of his name from Raffaele on the advice of an astrologer), Paul Wonner is one of the most romantic and sensual painters in contemporary Realism. He is one of the original Bay Area figurative painters, but his earlier work usually contained a narrative edge — a sense of anticipation — that was not characteristic of the paintings of Diebenkorn, Park, Bischoff, or the others. For more than a decade Wonner has painted large, complex still lifes; they are based on direct observation in their various parts but are ultimately invented compositions. These paintings are loaded with references to the art of the past and correspond most closely to the elaborate Dutch still lifes of the seventeenth century, but they are certainly not without parallels to the lush, hedonistic nineteenth-century inventions by Severin Roesen.

Although they are not well known, Wonner has painted occasional landscapes, including a beautiful set of small acrylic paintings on paper called *Twenty-seven Romantic Views of San Francisco*, which were done around 1980. The reference to the *Views*, or *Meisho* (famous places), by Hokusai and Hiroshige is clear. One of Wonner's paintings, like the famous Hiroshige print, depicts fireworks; in this case the display is over the Golden Gate Bridge. In all of them there is a vast sweep of space, dramatized by the sky, as in *#2, Dawn with Yellow Clouds*, which also intentionally recalls the paintings by the Luminists.

All of the paintings in the series are based on a view from a hill above Noe Valley, and Wonner describes the origin with typical modesty. "I jogged there early each morning, and came back and tried to put down what I had seen that dawn. Sometimes, I'd go back later in the day or at evening for a different kind of light and [different] effects on the city and the sky." When asked how closely the paintings correspond to nature, he replied, "They have the feeling I started with [which he had earlier described as one of awe], but aren't very close. The subject becomes dramatized and idealized."

Also sharing this painterly character and unabashed romanticism on a small scale is the melancholy twilight image *On Noyac Path*, by the late John Button. This gouache is typical of his little plein-air studies, which served as the source material for larger studio paintings.

Button was a friend of Fairfield Porter's, and Porter acknowledged his work as an influence on his own, but Button's painting was the most romantic of that group of East Coast Realists. Unfortunately, he never found a wide audience, even though his work was always held in high regard by other painters.

Of the Post–Abstract Expressionist landscape painters, John Button and Paul Wonner were perhaps the first romantics. Like Hopper and Burchfield, they emphasized nature's moods over its physical character. If they painted what they saw, then it must be remembered that they selected those moments to retain. It was a move away from the objective stance of contemporary Realism, but it was also the beginning of a return to the spirit of the Luminists of the nineteenth century, who viewed the landscape with a sense of wonder.

It is these expressive qualities that have prevailed in the landscape painting of this decade. It is an act of solace and an art of contentment in a disquieting period of national distress and international turmoil.

That great romantic Lafcadio Hearn wrote from Japan almost a century ago:

Assuredly those impressions which longest haunt recollection are the most transitory; we remember many more instants than minutes, more minutes than hours, and who remembers an entire day? The sum of the remembered happiness of a lifetime is the creation of a few seconds.

. . . As the scene, too swiftly receding diminishes . . . I vainly wish that I could buy this last vision of it, . . . and delight my soul betime with gazing thereon.[9]

And that describes the spell of the landscape.

Simeon Lagodich
Tree Knot, Stokes State Forest, 1985
Oil on linen, 30 x 35 inches
Courtesy of Tatistcheff Gallery, New York

James Winn
Late Rain: No. 3, 1987
Acrylic on paper, 27½ x 76¾ inches
Courtesy of Sherry French Gallery, New York

Paul Wonner
Twenty-seven Studies for Romantic Views of San Francisco: #2, Dawn with Yellow Clouds, 1980
Acrylic on paper, 18 x 17 inches
Courtesy of Hirschl & Adler Modern, New York

Joseph Raffael
Island Lilies, 1975
Oil on canvas, 78 x 114 inches
Collection of Graham and Ann Gund, Cambridge, Massachusetts
Courtesy of Nancy Hoffman Gallery, New York

John Button
On Noyac Path, 1982
Gouache on paper, 14 x 10 inches
Courtesy of Fischbach Gallery, New York

Bernard Chaet
Changing, 1986
Oil on canvas, 42 x 48 inches
Courtesy of Alpha Gallery, Boston

CHAPTER SEVEN
THE EXPRESSIONIST LANDSCAPE

Some persons suppose that landscape has no power of communicating human sentiment. But this is a great mistake. The civilized landscape peculiarly can; and therefore I love it more and think it more worthy of reproduction than that which is savage and untamed. It is more significant. Every act of man, every thing of labor, effort, suffering, want, anxiety, necessity, love, marks itself wherever it has been.

George Inness[1]

Expressionism in the visual arts has come to be primarily associated with its most obvious and superficial traits: high angst, emotional turmoil, and the rapid, gestural description of an inner state of being. The emotive effect has replaced substance while narrowing the emotional range to one of stridency and/or replacing it with false fervor. For example, if the most significant contemporary response to the tradition of Expressionism is the egotistical posturings of Julian Schnabel, which appear to be little more than a hip updating of Leonard Baskin's decorative figures of doom, then it is a tradition trivialized.

Such work ignores Expressionism's historic lineage: Grünewald's epic, multipaneled *Isenheim Altarpiece*, El Greco's haunting *Assumption* (painted for a brooding Inquisitor's Spain), Goya's nightmare visions in *Los*

Caprichos, *Disasters of War*, and *Disparates*, the mystical landscapes of Friedrich and Böcklin, the melancholy light of Inness and Blakelock, the passionate vision of Van Gogh, the modern torment of Munch.

The Expressionist die was cast in American landscape painting through the later works of George Inness, such as *The Monk* and *The Home of the Heron*, the taut enigmas of the "moonlightist" Albert Pinkham Ryder, the pantheistic vision of Burchfield, the brooding images by Marsden Hartley, and the joyous summer odes of Milton Avery. But while these painters are distinguished by the intensity of their personal vision, their art is not a break with the landscape tradition; it is described by Robert Rosenblum as an extension of the Romantic and Expressionist "search for a contact with a world that lay beyond or beneath the outer shell of matter."[2] As Rosenblum said of Mondrian's pre–World War I paintings and drawings: "He belongs, like Munch, Hodler, and Van Gogh, to the emotional community of artists who sought to penetrate a world of spirit rather than of surfaces."[3]

The subconscious, improvisational volatility of Abstract Expressionism was to a degree a reaction against the American tradition, and in particular the moralizing parochialism of the American Scene and Social Realism. But as Rosenblum points out in *Modern Painting and the Northern Romantic Tradition*, "Such a search for primal myth and

nature characterized many of the Abstract Expressionists, as it had, before, many of the Northern Romantics."[4]

Mark Rothko, in a confrontation with Seldon Rodman, stated,

I'm not an abstractionist. . . . I'm interested only in expressing basic human emotions — tragedy, ecstasy, doom, and so on — and the fact that lots of people break down and cry when confronted with my pictures shows that I communicate those basic human emotions. I communicate them more directly than your friend Ben Shahn, who is essentially a journalist with, sometimes, moderately interesting surrealist overtones. The people who weep before my pictures are having the same religious experience I had when I painted them. And if you, as you say, are moved only by their color relationships, then you miss the point![5]

With this statement, which is central to the comprehension of Rothko's paintings, the artist not only skewers Rodman's "tin eye" and superficial comprehensions of Abstract Expressionism, but the Formalist critics as well.

Alfred Leslie once recalled encountering Rothko at the Metropolitan Museum, where he was examining the late Rembrandt paintings. Rothko commented, "This is what I am trying to do, but without the figure."

Alfred Leslie
Approaching the Grand Canyon, 1977–81
A series of five watercolors from *100 Views Along the Road*, 18 x 24 inches each
Courtesy of Oil and Steel Gallery, Long Island City, New York
Copyright © Alfred Leslie

In turn, Leslie too would fuse the emotional intensity and formal traits of Abstract Expressionism with Realism. As has been pointed out earlier, Alfred Leslie not only incorporated narrative aspects in his Abstract Expressionist paintings and collages, but later he carried elements from those abstractions into his narrative paintings.

Between 1977 and 1983, Leslie produced an interrelated series of monochromatic watercolors of the American landscape called *100 Views Along the Road*. These rich and brooding images are simultaneously about the physical nature of the medium, the spirit of the landscape, and the recurring narrative structure of the series. In his "Notes on the 100 Views," Leslie wrote:

All of the Views were painted in the studio from drawings. Most of the drawings were done in a moving car looking out of the window . . . others were done traditionally, standing or sitting at the site. The ones done while moving are of course rapidly executed and are an amalgam of the view, condensing many percepts into one. It tends to a special kind of mythic specificity, a singular site not heightened, but given breadth. So the truth to the site I painted was not to a literal exactness, but a parallel exactness. . . .

The transition of light — these nature stories — have built into them the passing of time. I help express light by alluding to time. But the light I paint is paint, not light, and what I allude to I adjust always to remind us we are looking at pictures.[6]

In reference to these monochromatic works, Alfred Leslie uses the term "notan," which he has taken from the writings of the Arts and Crafts artist and teacher Arthur Wesley Dow. Dow's concepts are rooted in Oriental art,

and "notan"[7] was supposedly a Japanese term with the same implications as chiaroscuro, but referring to a perfection of the relationship between black and white. The reference to the *Meisho*, or famous places, by Hiroshige and Hokusai is inescapable.

The works in this series — for example, *Approaching the Grand Canyon* — fuse elements from Abstract Expressionism, particularly the spontaneity and intensity; the concepts of Dow, which were themselves a blend of *Japonisme* and Arts and Crafts aesthetics; narrative imagery; and the concept of a collection of views, as depicted in Japanese prints. Here is an art of the present, intensely expressive, and rich with the ramifications of the past.

Hans Hofmann was one of the most influential purveyors of the principles of Abstract Expressionism, and earlier had had firsthand contact with the Fauves and Cubists. His school on Eighth Street is now a part of art historical legend. Of his studies with Hofmann, the landscape painter Wolf Kahn has said,

Two main ideas emerged for me after I had absorbed enough of Hofmann's teaching to feel that I understood what he was driving at. The first stated that there was a formal logic which governed the masterpieces both of the past and the present. . . . Secondly, and related to the first, there was the ideal of the perfect painting, toward which we were supposed to be constantly striving, in which the aforementioned formal logic found its completed expression.[8]

Wolf Kahn and Nell Blaine both studied with Hofmann. Both painted abstractly in the forties, and the work of each gradually evolved into a personal form of expressive, gestural Realism. In Frank O'Hara's essay "Nature and the New Painting," written in 1955, Blaine and Kahn, with Jane Freilicher and others, were discussed as "artists who turn away from styles whose perceptions and

knowledge are not their own occasion, who seek their own perceptions and in doing so have turned voluntarily to nature, their way made clearer by the Gorkys and de Koonings which they admire but do not emulate."[9]

Wolf Kahn bought a farm in Vermont in the late sixties, and the landscape of that vicinity, with its weathered barns and country houses, has provided the major themes for his paintings ever since.

He has spoken of his intentions of "doing Rothko over from Nature,"[10] a goal borne out by the sonorous skeins of pulsating colors in his landscape paintings and pastels. The paintings have the effect of a lingering retinal afterimage; his colors, which are intuitive rather than conceptual or replicative, hover on the surface of the canvas in gestural layers, constantly reminding us that they are records of his response to nature.

"What is a painter's subject?" he asks. "Anything which jolts his mind into a tension which only work will resolve. This begins for me when I respond to a situation, most often a specific outdoor spot, where the light quality and the scale combine to produce the hint of an image."[11]

Kahn's procedure differs from those of the other painters discussed in that he begins many paintings, working directly from nature, over the course of each summer in Vermont, then finishes them in his New York studio during the winter.

Nell Blaine, when asked about her contemporary influences and affinities, responded, "In the forties [my] abstract work was influenced by Hans Hofmann, Jean Helion, Arp, Mondrian, and Léger. In the transition period, 1948–52, [it] was most affected by Helion, and by peers such as Leland Bell, Albert Kresch, and Robert de Niro, a bit by expressionists . . . both German and American . . . such as Kokoschka."

Wolf Kahn
Barn atop a Ridge, 1987
Oil on canvas, 72 x 86 inches
Courtesy of Grace Borgenicht Gallery, New York

Nell Blaine
Gloucester Harbor from Banner Hill, 1986
Oil on canvas, 24 x 46 inches
Courtesy of Fischbach Gallery, New York

She has painted the New York cityscape, Austrian mountains, England, Mexico, and numerous views of Gloucester, Massachusetts, where she now lives. In addition, there are still lifes, interiors, and flower studies. Blaine had her first New York show when she was twenty-three, has had more than forty-eight solo exhibitions since then, and has supported herself primarily from her work for more than thirty years.

Her paintings, such as the beautiful *Gloucester Harbor from Banner Hill*, are lovely and spirited evocations of place, enhanced by the richness of light, and clear in their articulation of open, sun-drenched space. Nell Blaine has articulated her attitudes perfectly:

I wish to convey a sense of spiritual expansiveness and depth, of a passion for the land and its richness, of a deep involvement and empathy for both the particular characteristics of the land: the hardness of rocks versus the openness of foliage or the tangle of plant growth, but above all the light expressed by way of paint . . . as directly and as honestly as possible. I want the canvas to breathe and to have a flow and rhythm which can carry the eye on an interesting journey, intricate and varied and continuous. I want the work to hypnotize!

The sensual joy of light and the great pleasure Blaine derives from the act of painting are communicated with an empathetic directness that is rare in contemporary art.

Painters such as Wolf Kahn, Nell Blaine, and Jane Freilicher have carried the open-ended attitudes and stratagems from their studies with Hans Hofmann directly into the arena of figurative art. Others, such as Jack Beal and Richard Estes, continue to incorporate the compositional tensions of Hofmann's "push-pull" and "clamshell space,"

which they learned from Isobel MacKinnon, a former Hofmann student. Also, as Kahn has pointed out, Hofmann stressed the connections with the painting tradition and emphasized the lessons to be learned from the past. "Figurative or abstract was not the important question."[12]

An unusually high concentration of Realists have come out of Yale, including Neil Welliver, Peter Milton, Michael Mazur, Joseph Raffael, Robert Birmelin, George Nick, Rackstraw Downes, and Patricia Tobacco Forrester, of the painters discussed here, and others such as William Bailey, Janet Fish, and Chuck Close. But in sharp contrast to Hofmann's teaching, the pedagogy of the dictatorial Josef Albers at Yale, particularly his highly formal theory on the perception and interaction of color, contained very little that could be carried directly into the realm of figuration. For the rigid Albers, like the Formalist critics, the linear history of painting led inevitably to a cubist-derived, perspectiveless, geometrical abstraction, with no major diversions. While he would permit landscape painting, he was opposed to the use of local color, and if there was to be figuration, he violently objected to the exploration of expressive, narrative imagery, such as that of the *Buchenwald Pit* drawings of Rico Lebrun, who was on the Yale faculty. Also, for Albers, there was no room for gestural painting, such as Abstract Expressionism. After almost a year of silence, the only criticism he offered to Joseph Raffael was the stinging words, "Acht, boy. Shit!"

Basically, the students of Hofmann could carry his concepts directly into figuration, but for Albers students, the use of imagery was more often a reaction to his rigidity. Fortunately for Raffael and others at Yale, there was a counterbalance to Albers in the classes taught by Bernard Chaet.

Bernard Chaet has been one of the most influential teachers in the country, and there are legions of distinguished artists who have been shaped by his classes at Yale. Chaet's career as a painter has spanned more than forty years. He is perhaps best known for his watercolor still lifes and landscapes, but he has also painted portraits and interiors and is equally comfortable with the oil medium. In fact, Chaet's *The Art of Drawing* is one of the better books on procedure and technique.

Chaet's landscapes of the New England coast, such as *Changing*, are painted from the motif — directly observed — and like the premier-coup works of Edwin Dickinson are usually completed in one session. *Changing* is worked up on a pink-stained canvas, which is exposed in the foreground while assuming the role of underpainting beneath the sky. It is a vigorous work, with the energy and verve of a Marin watercolor, belying the careful chromatic balance and Fauve-like parallels to the local color. Chaet's paintings evoke the moods of the landscape and the sensory experience of being in the open air.

The large landscape drawings of Michael Mazur, such as *The Island* and *The Edge of the Woods*, are also plein-air works, and like Chaet's paintings, they evoke the spirit of the landscape but do not imitate it. Mazur is a prolific artist, at home with almost any medium, and all of his works are distinguished by their vigorous graphic quality. Like Leslie's "notans," these large charcoal drawings convey a lavish sense of color in spite of the monochromatic medium.

Michael Mazur
The Edge of the Woods, 1984
Charcoal on paper, 42⅜ x 59⅜ inches
Courtesy of Barbara Krakow Gallery, Boston

In addition to the abundant expressive vitality of his work, Mazur has the uncanny ability to suggest, at times with great economy and understatement, both the light and physical qualities of the landscape, such as the scalelike striation of clouds, the fractured reflection of trees in a wind-rippled surface of water, scabby bark, and sun breaking through a patchy canopy of foliage in the woods.

Mazur has indicated that these landscapes were inspired by Burchfield. He states: "Light is always a subject-object in landscape, but no matter how metaphorical, the image is only as vital as the drawing or painting itself."

The English expatriate Graham Nickson is an extraordinary contemporary draftsman. He is best known for his tautly composed, monumental, and chromatically saturated paintings of beach figures. His sunbathers are depicted in acts of disrobing, drying off, and spreading their beach towels, and arranged with an interrelated, cat's-cradle tautness, like Giacometti's sculpted plaza figures in *The Square*. They are modeled in the summer sunlight and set off against brooding, ominous skies, which are darkened by rain, split by lightning, or punctuated by the swirl of scavenging gulls.

Nickson's large chiaroscuro drawings have the rich, velvety tonality that is the virtue of charcoal when it is used well and with authority. His forms are rendered with a confidence gained through solid academic training, but they are painterly and expressive, never academically dry or conservative. *Study for "Tracts"* depicts a stretch of beach in the South Fork of Long Island. An empty lifeguard's chair faces the ocean, and the deeply rutted beach is raked by the ardent evening sun. The sky is worked with a rag, and the light gathered at the horizon is picked out with a scumbling eraser. The particulars of this moment take on a heightened, almost magical intensity, like Heade's sudden flashes of light.

For more than a decade, Robert Birmelin has concentrated on narrative, nerve-jangling, cinemagraphic views of Manhattan streets, but earlier he painted some striking landscapes of the Maine coast. Even these are given a subtle narrative twist, such as an untended fire on the beach, or the twentieth-century intrusion of a jet, as in *Tidal Flats, Deer Isle, Sunset*. These are painted in acrylic, and recall the late evening scenes of Heade, Lane, and Friedrich.

Birmelin has described his move to the landscape paintings: "In the late sixties, I had reached an impasse in [my] invented figure compositions, and turned to landscape to cleanse my sight . . . to learn more about light, and as a relief from the anxiety engendered by painting figures."

And of the landscapes he writes:

When painting landscape I find myself worrying about how I can move into the space . . . by this I mean literally, what path can I take? Most of the landscapes start from very near (the tips of my shoes). . . . The space is more idiosyncratic [than in nineteenth-century paintings] . . . probably under the pervasive influence of Cubism, and finally irrational, though it carries the trappings of being decipherable.

Birmelin, like Wolf Kahn, starts his landscape paintings from direct observation and finishes them later in the studio. Working very quickly, he blocks them in loosely, with an approximation of the local color. They are faithful to the light and the sense of space, but their moods are intensified. Birmelin describes them as "closer than Courbet to his landscape sources, [but] not as close as Millais is to his best Pre-Raphaelite bramble thickets."

Patricia Tobacco Forrester works exclusively with watercolor, and along with Don Nice, Carolyn Brady, and John Stuart Ingle, she is one of the artists most responsible for the revival of the medium and its adaptation to the large scale more typically associated with works on canvas. Like Carolyn Brady, Forrester relies on the transparency and viscosity of the medium, which is its traditional usage. But she is distinguished from the others in her insistence on working directly from nature; this is especially unusual considering that her major paintings are the size of a door, and the fact that she works six to eight hours a day. One of her solutions to this overriding problem is to paint the watercolors in panels (as Charles Burchfield did), as in the diptych *Moonlight Birches*.

Forrester's watercolors are "from the motif," she says, but regarding their correspondence to nature she writes:

I stare at trees and plants and they become overlaid with psychological events within myself. Therefore, the painting is not the relating of a scene, but an expression of an intensity of [my] response to it. I enjoy and exploit the physicality of watercolor as it swirls, reticulates, and dries in some approximation to what I am seeing and trying to make. . . . Of course this enjoyment is a consequence of Abstract Expressionist painting.

. . . . I tend to anthropomorphize the subject matter. I choose trees that have anatomical characteristics; they bulge, twist, [and] constrict with tension. Flowers bloom where they should not [such as the rose of Sharon in Moonlight Birches*], deliberately to reinforce that this is a landscape of my mind.*

Graham Nickson
Study for "Tracts," 1981
Charcoal on paper, 22 x 30 inches
Private collection
Courtesy of Hirschl & Adler Modern, New York

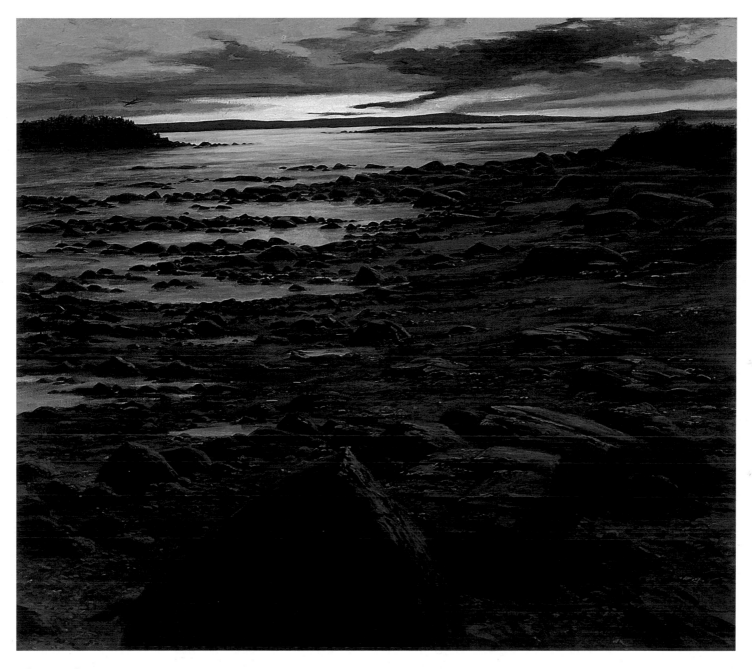

Robert Birmelin
Tidal Flats, Deer Isle, Sunset, 1978
Acrylic on canvas, 50 x 57½ inches
Courtesy of Sherry French Gallery, New York

Patricia Tobacco Forrester
Moonlight Birches, 1986
Watercolor on paper, 60 x 80 inches (diptych)
Courtesy of Fischbach Gallery, New York

Often the painting develops in a way I had not anticipated, and I either work at pulling the image back to the original plan, or amplify the tendencies that have emerged. I scrub out and overpaint if necessary. As the painting takes over, I often switch sites to find some subjects that will work with and support what is emerging. The process is always open-ended. The natural counterpart has been heightened, exaggerated, sometimes even rotated 90 degrees to fit the idea that develops.

Unlike most plein-air paintings, the landscapes of Patricia Tobacco Forrester are an interior, psychological vision, a parallel to what was found in nature during the act of painting.

The landscapes by Sylvia Plimack Mangold are also based on direct observation, and like Tobacco Forrester's, they are full of evidence of the hand. But while Forrester, who works in the Washington, D.C., area and, in the winter, in the tropics, ultimately produces images that are not topographically specific, Mangold concentrates on the familiar landscape near her upstate New York home, and her paintings are identifiable as specific views.

"The trees and hills are all familiar subjects. . . . I choose a subject I can return to over and over again so that the landscape is absorbed into a personal vocabulary. So that I can extend myself (my mood) into the mood of the space around me. . . . I put the configuration together . . . and take it apart as I work, until there is a resolution that feels right."

The works by Forrester and Mangold are extremely painterly, and both artists respond to the physical traits of their medium, but

Sylvia Plimack Mangold works in oil and reinforces the point that her images are painted through trompe-l'oeil devices. The conceptual decisions about the framing, cropping, and adjustments of the perimeters of the painted image, which many artists mark with masking tape, are represented in Mangold's paintings by extremely convincing illusions of taped edges, which include the tape's tactile and translucent characteristics, as in *Zodiacal Light*. In terms of this illusional aspect, Mangold acknowledges that her works can be interpreted as homages to the American masters William Harnett, John Haberle, and John F. Peto.

Ultimately, Mangold's paintings reflect the ambience of place as it combines with the mood of the painter; at the same time the works contain reminders of their conceptual basis and the fact that they are landscape illusions.

While the recent landscapes of Jon Imber are rooted in specific topographical facts, they are expressive translations of nature. Imber has painted numerous psychologically charged, enigmatic autobiographical allegories and remarkably penetrating portraits, and those emotional characteristics are carried over into the landscapes.

The large canvas *Upstate* is derived from a specific site in New York State, near Stockbridge, Massachusetts. The picturesque, rolling Berkshire Hills and narrow highway are viewed from a cornfield, but the pitch and sweep of the space are intensified and compressed, as though seen through a telephoto lens.

This somewhat claustrophobic, relieflike space and the muscular articulation of form reflect back to Marsden Hartley's *Dogtown*

paintings, while the color and light refer to the landscapes of Bonnard. But the painting's emotional and psychological edge is directly traceable to the late paintings of Philip Guston, with whom Imber studied. Guston's work has had a profound influence on many painters, particularly the Young Turks of Neo-Expressionism, but too often they have picked up on the look rather than the intensely personal and anguished substance, which was a gallows joke about human frailty and mortality. Jon Imber is one of the few who have grasped Guston's content, and he has turned its usable parts toward his own expressive ends.

April Gornik favors the more mysterious and primeval character of the landscape in her large paintings and drawings. Her expressive interpretations of deserts, seas, and mountain ranges are stirred from their quietude by the elemental forces of rain, tide, wind, and fire. She deals exclusively with nature, and has summed up her attraction to its broad themes by pointing out, "I dream in landscape images, so it seems to be an essential part of my subconscious vocabulary for emotional expression."

Her paintings and drawings are derived from photographs and slides, but the resultant images are landscapes remembered more than landscapes observed. Gornik's translation of a subject "varies from inexact to radically transformed" and reflects "more interest in personal-psychological expression than [in] recording the drama of nature."

Sylvia Plimack Mangold
Zodiacal Light, 1980
Oil on linen, 60 x 100 inches
© The Detroit Institute of Arts, Gift of Martin Bernstein

Jon Imber
Upstate, 1985
Oil on canvas, 80 x 90 inches
Collection of Metropolitan Life Insurance Co.
Courtesy of Victoria Munroe Gallery, New York

Usually she begins with a small drawing (6×8 inches) that is derived from a slide or photograph of a detail rather than the entire image. The small study is then transferred to the paper or canvas by the use of reference points, which is a two-dimensional variation of the traditional method of enlarging sculpture through "pointing." The scale of the large paintings and drawings is also a carefully considered factor.

The large charcoal and pastel drawing *Triple Smoke* is typical of Gornik's landscapes. It is a dramatic interpretation of a natural event rather than a representation of place, and is a description of mood rather than the visual specifics of the terrain. Like Leslie's wash drawings, *Triple Smoke* is an extravagant chiaroscuro composition, an image purged of all superfluous detail. The dark, undulating clouds of smoke billow upward, darkening the clear sky and dwarfing the mountains from which they ascend. The source and cause of this monumental triangulation of fires is not signified, and could be either a natural disturbance, such as a volcano or forest fire, or the destructive act of man. It is a mysterious and portentous event.

The young Texas artist David Bates considers himself first an outdoorsman, a hunter and a fisherman, and then a painter, and admits that when the fish start biting, "the sketchbook hits the bottom of the boat."

In 1977 he participated in the independent study program of the Whitney Museum of American Art (New York) and a decade later was included in the 1987 Whitney Biennial Exhibition. In fact, he is perhaps the most widely acclaimed of all the younger landscape artists, and has paintings in the Metropolitan Museum, the Hirshhorn Museum and Sculpture Garden (Washington, D.C.), the San Francisco Museum of Modern Art, and many other distinguished public and private collections. In part, his acceptance is due to the visual characteristics his work shares with the current vogue for Neo-Expressionism, but perhaps it has more to do with the deep sense of authenticity and authority conveyed through his images.

Bates acknowledges that his figurative inclinations found meager support when he was a student and that his paintings evoked little more than silence from visiting artists such as Frank Stella during his year in the Whitney program.

It was the hunting and fishing that first drew him to the Grassy Lake swamps off the Red River where Texas, Louisiana, and Arkansas connect; but he gradually became attracted to the area's strange natural beauty as a theme for his paintings. These dense everglades are most wisely entered with a seasoned guide familiar with their disorienting maze of lush vegetation, slow waters, and sly, prowling wildlife. Bates considers some of these guides to be geniuses in their ability to read the subtle signs and moods of the woods, and old guides, such as Ed Walker, posed with their favorite hounds or in canoes, have been the subjects of some of his finest paintings. Other works portray the restless, wary wildlife of the swamp as they stalk and eat their prey, cunning participants in an endless, symbiotic cycle of nature.

The anhinga, or snakebird, for example, is one of the most efficient hunters, and spends much of its time sunning with its wings half spread. A great swimmer, it can move through the water with only its head and neck above, and then quietly dive beneath the surface in pursuit of food. It is like a cormorant, but is much sleeker, and with a long neck and tail. In his grand obsession, *The Birds of America*, Audubon depicted an adult male anhinga and a young one, perched on a stump and silhouetted against the sky. He wrote, "Being a bird which . . . rarely fails to attract the notice of the most indifferent observer, it has received several names" (he called it a "water-turkey"), and noted on his original watercolor that the Creoles called the bird *Bec à Lancette*, "on account of its bill."[13]

In Bates's painting *Anhinga*, the snakebird is represented as a creature of the swamp. The shore's edge arcs in the background, and the still water reflects the distant trees and red-orange evening sky of late summer, which is filled with loaflike, ominous clouds. The surface of the water is scattered with lily pads and broken by the spiky protrusions of cypress knees. Perched on a low branch, the great water bird holds a fish in its stiletto beak, which he points skyward before devouring it. The sweltering climate of the region, its strange and profuse growth, and the underlying tension of its inhabitants are emphasized, and Bates's tableau is stripped to those essentials.

David Bates admires Audubon but acknowledges that his paintings are primarily influenced by twentieth-century American Expressionists such as Hartley, Burchfield, Dove, and Avery, by the primitive paintings of Salisbury Field and Ammi Phillips, and to a lesser extent by the work of Van Gogh. These painters show an expressive/reductive impulse that is succinctly described by Van Gogh in a letter to his brother Theo: "I am trying now to exaggerate the essential, and purposely leave the obvious things vague"[14] — an apt description of the spirit of Bates's work.

April Gornik
Triple Smoke, 1986
Charcoal and pastel on paper, 38 x 50 inches
Collection of Gloria Spivak
Courtesy of Edward Thorp Gallery, New York

David Bates
Anhinga, 1986
Oil on canvas, 96 x 78 inches
Courtesy of Charles Cowles Gallery, New York

David Bates
Sketches for Anhinga, n.d.
Pencil on paper, 8 x 11 inches each
Courtesy of the artist

Alexandre Hogue
Eroded Lava Badlands, 1982
Oil on canvas, 38 x 56 inches
Courtesy of Gerald Peters Gallery, Santa Fe, New Mexico, and Dallas, Texas

But unlike Hartley, whose inner turmoil was refracted in his landscapes, David Bates returns to a realm prescribed by the work of Charles Burchfield and the Orientals. Bates feels that it is paramount that the painter be deeply familiar with the land, and that each region has its own inherent mood. He describes the mountains of West Virginia as being "mournful," and the bayous of Louisiana as "spooky," and his paintings of the southern swamps are recollections of the quintessential spirit of place. In this regard, he and other landscape painters such as James Winn, Keith Jacobshagen, and Brooks Anderson clearly indicate a new commitment to regional painting. Their works differ from the Regionalism of the twenties and thirties, as did the paintings of Burchfield and Hopper at that time, in that they do not share the narrative or anecdotal impulse that is now regarded as a dominant trait of Regionalism. Nor do these painters subscribe to the antimodernist tendencies and cornpone rhetoric of the American Scene painters. Instead, they are very much aware of the diversity of today's art and express admiration for a broad range of contemporary work.

David Bates is one of the youngest of the contemporary landscape painters. Alexandre Hogue is in his nineties, the only surviving major Regionalist or American Scene painter. Hogue, like Bates, is originally from Texas; his most recent landscape paintings are also of Texas, and he shares the expressionist bent of the younger artist. Since 1970 he has channeled his energies into a series of paintings of the Big Bend area of Texas, a rugged desert country of a primeval beauty that is unlike any other region of North America. Hogue made sketch trips there as a young man in 1921 and had vowed for almost a half century to return. In 1965, while teaching a summer session at Sul Ross State College in Alpine, Texas, eighty miles from the Big Bend, he drove there in the afternoons, and over the summer produced a group of pastel sketches, which were later finished in his studio in Oklahoma. A decade later, Hogue began the large studio paintings, based on the pastels and his memory of the area.

Eroded Lava Badlands is one of the most powerful images from this series. The rugged, waterworn forms have an eerie beauty that is amplified by Hogue's abstraction of this strange, overwhelming landscape. Stylistically, it relates to his paintings from a half-century earlier, and like those works it has a passionate, feverish intensity. The light and color are saturated and verge on shrillness, but it is very much an evocation of place. The calligraphic brushstrokes and angular, crystal-like forms recall his paintings of the Dust Bowl, but where those paintings were ringing indictments of our ecological follies, the Big Bend paintings are paeans to the awesomeness of nature. These are among the wisest, most deeply felt, and intensely expressed visions of the American landscape in our time.

The haunting, mysterious landscapes by Tom Uttech mark another turning. Of these unique works, which refer to the northern area of the American and Canadian border called the Precambrian Shield, Uttech has written:

I don't want to paint pictures of how nature looks, but rather how it feels for me to be in it.

The physical parts of "my landscape" are the ancient, glaciated outcroppings of bedrock, which are exposed everywhere in the Precambrian Shield; they stimulate my imagination, they look like prehistory, like whales, like monsters, like angels. They crawl, thrust, hide, and scream or whisper in the woods. Also, the soft, fluffy feather moss which covers all of this bedrock and the defiant and deformed evergreen forest which scrabbles a living out of the moss and whatever cracks in the bedrock its roots manage to find.

And the light . . . the color of the light from the long, long days that occur so far north, which is especially magnified at my favorite time of the day . . . sunset-dusk.

. . . My paintings are highly formal in structure (this always takes precedence over description), and because of the expressive interest, this formality must be invisible. I don't want an art veil over the pictures.

Uttech's paintings are created in the studio. They are remembered responses to this continent's northern wilderness, and they correspond most closely to the temper of northern European painting. Mood, enigma, and lyrical light predominate. He has come of age as a painter in the eighties, and unlike the Realists of the seventies is more inclined to interpret and transpose, allowing experience and imagination to predominate over what has literally been seen. In these primordial forest dusks, we are offered a vignette of what has been remembered. They are filled with the lingering spirits of that vast, fecund, and extravagant territory.

Tom Uttech's paintings reflect his instinctive ability to conjure up these eloquent dramas of personal mythologies. Through these works, he brings back a sense of nature as regenerative and imbued with ancient magic, and restores through his images that quality so often lacking in Modernism, the capacity to awe and enchant.

Tom Uttech
Tree of Knowledge, 1987
Oil on canvas, 100 x 115 inches
Courtesy of Maxwell Davidson Gallery, New York

EPILOGUE

Give me health and a day, and I will make the pomp of emperors ridiculous. The dawn is my Assyria; the sun-set and moon-rise my Paphos, and unimaginable realms of faerie; broad noon shall be my England of the senses and the understanding; the night shall be my Germany of mystic philosophy and dreams.

Ralph Waldo Emerson
Nature[1]

Emerson's *Nature* is not a quaint and nostalgic relic of our past. The optimistic humanism that permeates his essay still persuades, the decency of his attitudes and poetry of his vision remain true, and his spiritual tone is still relevant to our time. Today, two and a half centuries after the publication of this discourse, there are flickering signals of a return to the values Emerson espoused, and, as in his day, they are perhaps most tangible in the arts.

To briefly review the evolution from abstraction to figuration in the art of our time, in landscape especially, we must look back to the early 1960s. The rapid proliferation of students, and the wide and unquestioned embrace of the avant-garde, along with the demise of a substantial knowledge of the past, led to a rapid deterioration of basic skills, a growing ignorance of the fundamentals of the

visual vocabulary, and a diminished sense of the communicative powers of the visual arts. As Robert Hughes pointed out in *The Shock of the New*, "By the end of the 1970s, the variety of gestures that could be called art had given the *coup de grace* to the idea of historical necessity on which the very conception of an *avant-garde* was based."[2]

This inane pedagogical hodgepodge and the lack of basic skills and knowledge have not been restricted to the arts. The teaching of history, geography, science, and literature has been drastically curtailed in many American high schools and colleges, and has contributed to our widespread cultural poverty. Without this background we are incapable of comprehending the complexities and subtleties of our culture, or the forces that have shaped it.[3]

Ultimately, this has resulted in the trivialization of the arts over the last two decades. Too little is asked for and too little is expected of artists, critics, and curators. This unfettered freedom of creative expression, set loose in a cultural vacuum and untempered by any substantial understanding or link with the past, has led to a diversity of formal expression that is consistently marred by the shallowness of its content and expectations. Divorced from tradition, the avant-garde, whether figurative or abstract, has wound up sharing the "what you see is what you get" superficiality of the amateur painters rather than extending the boundaries of art.

Yet from this same academic abyss of the late sixties and early seventies has emerged a diverse array of creative minds in every field of endeavor who share a concern for content, craft, and references to tradition. Aware of the inadequacies in their formal education, they have disciplined themselves in the skills needed to express their intentions, and have acquired the comprehension of the past that is so necessary to instilling their work with substance and resonance. The scope of their achievements cannot be overemphasized; that the struggle was won on many fronts, independently and often in solitude, is now apparent in the art they have produced.

Traditionally, the arts of almost every society have conveyed emotions, ideas, and attitudes (religious, social, allegorical, and political) through culturally associated images. Yet in our time, ironically, this comprehensible content has been in conflict with the notions propounded by many critics and historians of contemporary art. Even some of our best scholars of nineteenth-century American art have often failed to recognize characteristics they have praised in the art of the last century when similar traits appear in our time. Quite simply, they have failed to make obvious connections and have not been open to the full breadth of possibilities.

Perhaps the greatest loss in the visual arts as they were advocated by the art establishment in the sixties and seventies was a lack of humanism, of graciousness, eloquence, and delight, and a diminished capacity to awe and enchant.[4] And so, even as nonfiguration dominated painting and international modernism in architecture, there was a nagging sense that something was lacking in the art and architecture of the sixties. This was evidenced in the rapid spread of the architectural preservation movement, the renewed emphasis on figuration in the visual arts, a growing interest in photography, and the revival of the carefully crafted poem, novel, and film. This shift ushered in the *acceptance of pluralism* in the arts, rather than pluralism itself, which had existed for centuries.

As Witold Rybczynski pointed out in his extremely perceptive book *Home*:

Nostalgia for the past is often a sign of dissatisfaction with the present. I have called the modern interior "a rupture in the evolution of domestic comfort." It represents an attempt not so much to introduce a new style . . . as to change social habits, and even to alter the underlying cultural meaning of domestic comfort. Its denial of bourgeois traditions has caused it to question, and reject, not only luxury but also ease, not only clutter but also intimacy. Its emphasis on space has caused it to ignore privacy, just as its interest in industrial-looking materials and objects has led it away from domesticity. Austerity, both visual and tactile, has replaced delight. What

started as an endeavor to rationalize and simplify has become a wrong-headed crusade; not, as is often claimed, a response to a changing world, but an attempt to change the way we live. It is a rupture not because it does away with period styles . . . but because it attacks the very idea of comfort itself. That is why people look to the past. Their nostalgia is not the result of an interest in archaeology, like some Victorian revivals. . . . Nor is it a rejection of technology. . . . People turn to the past because they are looking for something that they do not find in the present — comfort and well-being.[5]

That sense of comfort and well-being is clearly expressed in landscape painting, which always refers back to the direct encounter with the physical extravagances and diversity of moods of the natural world, and to the emotional solace and replenishment that can only be provided by nature. When we bring these representations into the home, we are joining their flickering remembrances with our sense of shelter.

Even Van Gogh, that poor wretched saint of painting, with his bourgeois Dutch roots, thought of paintings as a part of the comfort and intimacy of the home, rather than of the public spaces of museums.

When I see a picture that interests me, I can never help asking myself, "In what house, room, corner of a room, in whose home would it do well, would it be in the right place?" . . . if an interior is not complete without a work of art, neither is a picture complete if it is not in harmony with surroundings originating in and resulting from the period in which it was produced. . . . In a word, are there minds and interiors of homes more important than anything that has been expressed by painting? I am inclined to think so.[6]

And these pictures on our walls are also windows onto the world, as it is seen, remembered, reconstructed, or imagined by the artists. The broad appeal of landscape painting to both the artist and viewer has been succinctly described by Robert Hughes:

One of the projects of art is to reconcile us with the world, not by protest, irony, or political metaphors, but by the ecstatic contemplation of pleasure in nature. Repeatedly, artists offer us a glimpse of a universe into which we can move without strain. It is not the world as it is, but as our starved senses desire it to be: neither hostile nor indifferent, but full of meaning — the terrestrial paradise whose gate was not opened by the mere fact of birth.[7]

A return to humanistic concerns and the regenerated spirits of romanticism and regionalism can be seen in certain revivals that have occurred in the arts over the past two decades, such as the recent emphasis on American art of the twenties and thirties, the renewed interest in the Arts and Crafts movement; the reappraisal of the work of Louis Comfort Tiffany; and the discovery that Frank Lloyd Wright was the great genius he had always proclaimed himself to be. Although this trend has not been widely recognized, many of the younger landscape painters share the same inclinations and traits, probe similar veins, and their work reflects a growing dissatisfaction with what is widely upheld as the "mainstream" in contemporary culture.

Also, there has been a rapid expansion of accessible information in every field over the last two decades. In the early sixties, a modestly priced book on Antonio Gaudi, Josef Hoffmann, Gustav Klimt, Egon Schiele, or Odilon Redon could only be found by diligent searching. Even Edvard Munch was a shadowy figure, as was the great German romantic Casper David Friedrich. Today, we are able to place Munch's haunted images within the context of Scandinavian painting (one of the great moments of enlightenment was the Northern Light exhibition curated by Kirk Varnedoe in 1982) and see the symbolic landscapes of Friedrich put in place as an integral part of nineteenth-century European art in Robert Rosenblum's *Modern Painting and the Northern Romantic Tradition*. Not only has the range of scholarly research and publication broadened over the last decade, but modern printing technology, especially in color reproduction, has brought us much closer to those once exotic originals. Our potential for more accurately grasping a sense of the past, and our familiarity with the breadth and diversity of the present are far greater than at any other point in history.

Wayne Thiebaud spoke of the influence of the Macchiaioli and Joaquin Sorolla y Bastida on his work at a time when most art historians ignored them. Tom Uttech's paintings are direct responses to nature, but they are also linked to the mysticism of German art and Canadian landscape painters from the turn of the century, while James Winn's romantic reconstructions of the landscape connect with Luminism, Northern, and Scandinavian painting. The dreamlike imagery of Juan Gonzalez is rooted in Catholicism, Latin poetry and literature, and the enigmatic constructions of Joseph Cornell. The art of these painters is all art with a past. For the contemporary painter, the range of resources has been greatly expanded by the exploration of many less familiar or poorly understood areas through recent exhibitions, books, and articles. The influences that shade their work are made more potent by the technological advances in communication in our time. For the artist who responds to tradition, the possibilities and combinations are endless.

But there has been a negative side to our achievements in technology. Whereas the mid-nineteenth century American painters encountered a vast, unknown wilderness of unlimited possibilities, and saw the spiritual manifested in the landscape, in less than a hundred years we have witnessed our great resources being exploited by technology. Today, our survival is threatened by the endangerment of wildlife and of forests, the contamination of the atmosphere, and the fouling of our waters. Corrective efforts have been achieved with reluctance and are woefully inadequate. Our governmental and corporate response has been shamefully lethargic, at best.

Such monumental and urgent ecological problems must haunt every contemporary landscape painter. Their images of the American landscape are not passive, for these works point toward a more positive side of life. Each is an open reminder of the eloquence and harmony of nature, and of our physical and emotional dependence on it.

This is not the time for the arts to be too self-absorbed, nor is it a time when a narrow, heavily biased interpretation of art history, past or recent, can be accepted. The past must be retold from a broader and more inclusive perspective. The artist must look beyond the tenets of Cézanne, Cubism, and the remnants of Modernism. And ultimately, we must allow room for images of reassurance, for an art that points away from itself and again focuses on the marvels and enigmas of both nature and the human situation, which will in turn open the way for new allegories and mythologies.

In the end we shall have had enough of cynicism and skepticism and humbug, and we shall want to live more musically. How will that come about, and what will we really find? It would be interesting to be able to prophesy, but it is even better to be able to feel that kind of foreshadowing, instead of seeing absolutely nothing in the future beyond the disasters that are all the same bound to strike the modern world and civilization like terrible lightning, through a revolution or a war, or the bankruptcy of worm-eaten states. If we study Japanese art, we see a man who is undoubtedly wise, philosophic and intelligent, who spends his time doing what? In studying the distance between the earth and the moon? No. In studying Bismarck's policy? No. He studies a single blade of grass.

Vincent Van Gogh[8]

CHAPTER NOTES

Unless otherwise attributed, all quotations of living artists are from unpublished correspondence or conversations with the author.

CHAPTER ONE
AMERICAN LIGHT:
The Shaping of a National Tradition

1. Ralph Waldo Emerson, *Nature*, Chandler Facsimile Editions in American Literature (San Francisco: Chandler, 1968), pp. 12–13.

2. Richard J. Boyle, *American Impressionism* (Boston: New York Graphic Society, 1974), p. 25.

3. John Arthur, *Realist Drawings & Watercolors: Contemporary American Works on Paper.* (Boston: New York Graphic Society, 1980), p. 51.

4. Quoted in *The Britannica Encyclopedia of American Art* (Chicago: Encyclopaedia Britannica Educational Corporation, 1973), p. 354.

5. Joseph S. Czestochowski, *The American Landscape Tradition: A Study and Gallery of Paintings* (New York: E. P. Dutton, 1982), p. 31.

6. Barbara Novak, *Nature and Culture: American Landscape and Painting, 1825–1875* (New York: Oxford University Press, 1980), p. 29.

7. *Ibid.*, pp. 28–29.

8. Louis Comfort Tiffany apprenticed to Inness for three years, although he was allowed to do little more than watch Inness paint. Later he would take Inness's dusky, glowing light, coupled with his own love of stained glass windows and Thomas Edison's incandescent bulb, and create his glorious lamps, which transformed the look and mood of interiors throughout this country and Europe.

9. Quoted in John K. Howat, et al., *American Paradise: The World of the Hudson River School* (New York: Metropolitan Museum of Art, 1987), p. 234.

10. Quoted in Nicolai Cikovsky, Jr., and Michael Quick, *George Inness*, exhibition catalogue, Los Angeles County Museum of Art, 1985, p. 205. The complete interview with Inness, which was originally published in *Harper's New Monthly Magazine* 56 (February 1878), is reproduced in the appendix of this catalogue.

11. Quoted in Lloyd Goodrich, *Albert P. Ryder* (New York: George Braziller, 1959), p. 20.

12. Sullivan used approximately thirty colors in the Transportation Building, which he compared to the naturalistic colors of landscape painting. His use of color was based on the theories of M. E. Chevreul and the writings of Ogden N. Rood, which were the same treatises that influenced the Impressionists and Post-Impressionists. In addition, Sullivan was familiar with the writings of John Ruskin and William Morris. His work was closely associated with the American Arts and Crafts movement, and he used furniture by Gustave Stickley and others in most of his buildings, including the small banks. For a thorough discussion, see Lauren S. Weingarden's *Louis H. Sullivan: The Banks* (Cambridge, Massachusetts: M.I.T. Press, 1987). In addition, Wendy Kaplan's *"The Art That is Life": The Arts & Crafts Movement in America, 1875–1920* (Boston: New York Graphic Society, 1987) is an indispensable source of information on the movement as a whole.

13. Quoted in Albert Bush-Brown, *Louis Sullivan*, Masters of World Architecture Series (New York: George Braziller, 1960), p. 21.

14. But whereas the Luminists and preceding American landscape painters focused with daguerreotype clarity on the spiritual, emotional, and physical side of nature, the French painters emphasized its sensuality, and rendered the retinal ghosts of their perceptions. American artists at the turn of the century, with their tradition tracing back to northern European painting, limners, and commercial printmaking, could not comfortably avoid the physical mass and perceptual space of the landscape, nor could they tilt the aesthetic balance toward the formal aspects of painting.

CHAPTER TWO
THE LANDSCAPE INTERPRETED

1. From a speech given in 1900, quoted in Peter Blake, *Frank Lloyd Wright: Architecture and Space* (New York: Penguin Books, 1965), p. 36.

2. Charles Burchfield, *The Drawings of Charles Burchfield* (New York: Frederick A. Praeger, in Association with The Drawing Society, 1968), p. 10. Most sources cite Chinese painting as an influence. Burchfield himself mentions the illustrators Edmund Dulac, Arthur Rackham, and Ivan Yakovlevich Bilibin, and Bakst's costumes. Then he states, "During my years in art school, I also became acquainted with Chinese painting and, to a greater degree, Japanese prints. Hiroshige and Hokusai were particular favorites."

Burchfield's use of color and pattern, and his way of abstracting nature, seem to come more from the illustrators and Japanese prints. In *Charles Burchfield* (New York: Macmillan, 1956), John I. H. Baur mentions that he received a copy of a Hiroshige book for Christmas in 1915 and mentions his interest in Hindu and Buddhist myths and their personification of nature, but he understates their significance, given Burchfield's pantheistic inclinations.

3. Quoted in Joseph S. Trovato, *Charles Burchfield* (Utica, New York: Museum of Art, Munson-Williams-Proctor Institute, 1970), p. 291.

4. Quoted in Eric Protter, ed., *Painters on Painting* (New York: Grossett & Dunlap, 1963), p. 227. This statement, which seems central to Burchfield's beliefs, has been omitted from most of the studies on him, including the major book by John Baur. I suspect that this is due to their discomfort with his strongly worded and unequivocal bias against abstract and nonobjective art, and their fear of Burchfield's appearing to be "reactionary."

5. Edward Hopper's *Sailing* sold from the Armory Show for $250; this was his first sale of a painting. In that watershed year in American art, Hopper moved to 3 Washington Square, where he lived for the rest of his life, except for summers, which were usually spent on Cape Cod.

6. Quoted in Lloyd Goodrich, *Edward Hopper* (New York: Harry N. Abrams, n.d.), p. 163.

7. *Ibid.*, p. 162.

8. Quoted in Gail Levin, *Edward Hopper: The Complete Prints* (New York: W. W. Norton in Association with the Whitney Museum of American Art, 1979), p. 8.

9. Coy Ludwig, *Maxfield Parrish* (New York: Watson-Guptill, 1973), p. 145.

10. *Ibid.*, p. 185.

11. Quoted in Barbara Haskell, *Marsden Hartley* (New York: Whitney Museum of American Art, 1980), p. 82.

12. Two years earlier, Hartley's friend Hart Crane, the poet, son of Clarence Crane, who commissioned Maxfield Parrish to do illustrations for his chocolate boxes, committed suicide by jumping from the steamship *Orizaba* on his return from Mexico, where he and Hartley had spent time together.

13. Carol Troyen and Erica E. Hirshler, *Charles Sheeler: Paintings and Drawings* (Boston: New York Graphic Society, 1987), p. 116.

14. Quoted in *ibid.*, p. 1.

15. This was the year after Wood's *American Gothic* and Hopper's *Early Sunday Morning*, two of the most widely known icons in American art.

16. Quoted in James T. Dennis, *Grant Wood: A Study in American Art and Culture* (New York: The Viking Press, 1975), p. 231.

17. Quoted in Lea Rosson DeLong, *Nature's Forms / Nature's Forces: The Art of Alexandre Hogue* (Tulsa: Philbrook Art Center and University of Oklahoma Press, 1984), p. 130.

18. Georgia O'Keeffe, *Georgia O'Keeffe*, A Studio Book (New York: Viking Press, 1976), no page numbers.

19. Quoted in Lloyd Goodrich and Doris Bry, *Georgia O'Keeffe*, exhibition catalogue, Whitney Museum of American Art, New York, 1970, p. 8.

20. Quoted in Adelyn D. Breeskin, *Milton Avery*, exhibition catalogue, National Collection of Fine Arts, Smithsonian Institution, Washington, D.C., 1970, no page numbers.

21. Quoted in Protter, ed., *Painters on Painting*, p. 223.

22. Klaus Kertess, "Entrancing Paint," *Edwin Dickinson, The Figure*, exhibition catalogue, Hirschl & Adler Modern, New York, 1986, no page numbers.

23. These aspects are at once apparent if *Ring Road* is compared to *Dawn, Nettleton Hollow* by Peter Poskas, *Scrub* by Catherine Murphy, or the painterly, impressionistic *Over Pemigewasset River* by George Nick.

24. Clement Greenberg, *Art and Culture* (Boston: Beacon Press, 1960), p. 157.

25. *Ibid.*, p. 135.

26. Ironically, the building is recognized as one of the greatest achievements in the long, illustrious career of Frank Lloyd Wright, who detested abstract and nonobjective painting. Hilla Rebay, the Guggenheim curator, wrote for an exhibition catalogue prior to the museum's 1939 opening in a rented space on East 54th Street that "non-objectivity is the religion of the future. . . . Non-objective paintings are prophets of spiritual life."

27. Blake, *Frank Lloyd Wright*, p. 83.

28. *Ibid.*, p. 26.

29. *Ibid.*, p. 9.

30. Peter Blake, *Mies van der Rohe: Architecture and Structure* (Baltimore: Penguin Books, 1960), p. 83.

31. *Ibid.*, p. 85.

32. Quoted in *ibid.*, p. 117.

33. Quoted in *ibid.*, p. 72.

34. Witold Rybczynski, *Home: A Short History of an Idea* (New York: Penguin Books, 1986), p. 202.

CHAPTER THREE
TOWARD A NEW REALISM

1. This widely quoted statement was originally written for an announcement for a lecture given by Leslie at the Quincy Art Club in Quincy, Illinois, in the spring of 1970. It has been modified and elaborated on by Leslie since then.

2. Rackstraw Downes, ed., *Fairfield Porter: Art in Its Own Terms—Selected Criticism 1935–1975* (New York: Taplinger, 1979), p. 72.

3. Elmer Bischoff, from his notes for a lecture, which he sent to the author.

4. Downes, ed., *Fairfield Porter*, pp. 235–236.

5. *Ibid.*, p. 70.

6. Jack Kroll, *Figures*, exhibition catalogue, Kornblee Gallery, New York, 1962, no page numbers.

7. Downes, ed., *Fairfield Porter*, p. 72.

8. *Ibid.*

9. *Ibid.*, pp. 232–233.

10. John Bernard Myers, "The Impact of Surrealism on the New York School," *Evergreen Review*, 4, no. 12 (March–April 1960), pp. 76–77.

11. *Ibid.*, pp. 77–85.

12. Robert Rosenblum, *Alfred Leslie*, exhibition catalogue, Museum of Fine Arts, Boston, 1976, no page numbers.

13. John Gruen, "Richard Diebenkorn: The Idea Is to Get Everything Right," *Art News* (November 1986), p. 85.

14. *Ibid.*, p. 82.

15. As art students in the early sixties, we were instructed to dislike these wonderful bourgeois interiors from the twenties and thirties, and other late paintings by Vuillard. In terms of the prevailing opinions on the merit of his art, Vuillard was treated as though he had died at the turn of the century rather than in 1940.

16. Quoted in Irving Sandler, *The New York School: The Painters and Sculptors of the Fifties* (New York: Harper & Row, 1978), p. 132.

17. *Ibid.*, p. 132.

18. Bischoff, lecture notes.

19. *Ibid.*

20. Peter Milton, *Peter Milton: Prints and Drawings*, exhibition catalogue, Hood Museum of Art, Dartmouth College, Hanover, New Hampshire, 1982, no page numbers.

21. Welliver's studio procedure is documented and discussed at length in this author's book *Realists at Work* (New York: Watson-Guptill, 1983), pp. 146–155.

CHAPTER FOUR
PAINTERLY REALISM

1. Robert Hughes, *Time*, November 29, 1976.

2. Heinrich Wölfflin, *Principles of Art History* (New York: Dover, n.d., p. 18; a reprint of the 1932 translation of the seventh German edition.

3. Diebenkorn and Bischoff have moved again into abstraction, but their paintings have retained their Bay Area markings and the lingering evidence of their search.

4. The other exceptions regarding the use of oils by Bay Area painters are Paul Wonner, who developed an allergy to oil, and Joan Brown.

5. Nick has done many interiors, portraits, and still lifes, which are rarely shown. Often, these are produced when the weather does not permit him to work outdoors.

6. Ralph Goings, John Baeder, and Robert Cottingham, for example, have used watercolor for their urban images. Carolyn Brady and John Stuart Ingle brought the larger scale of easel painting to their meticulous still life watercolors. Shatter was probably the first to use the medium for large-scale landscape paintings. More recently, James Winn has brought both delicacy and monumental size to watercolor through his impressive command of acrylic.

7. Teiji Itoh, *Space and Illusion in the Japanese Garden* (New York, Tokyo, and Kyoto: Weatherhill/Tankosha, 1973), p. 31.

CHAPTER FIVE
THE MIRROR OF NATURE

1. Henry David Thoreau, *A Week on the Concord and Merrimack Rivers* [*Thursday*], 1849 (Boston: Parnassus, 1987).

2. Rackstraw Downes, "The Meaning of Landscape," *Parenthese* (Spring 1975), p. 35.

3. For a discussion of Estes' studio procedure see the author's *Richard Estes: The Urban Landscape* (Boston: New York Graphic Society, 1978).

4. Wölfflin, *Principles of Art History*, p. 10.

5. Junichirō Tanizaki, *In Praise of Shadows* (New Haven, Connecticut: Leete's Island Books, 1977), p. 9. The author considers this essay by one of the greatest novelists of the twentieth century to be essential to his aesethetics.

6. For a detailed account of Beckman's studio procedure, particularly his use of oil, see *Realists at Work*, pp. 24–37.

7. Alexandra Anderson, *Altoon Sultan, Recent Work*, exhibition catalogue, Marlborough Gallery, New York, 1982, no page numbers.

8. Valerio's studio procedure is discussed in *Realists at Work*, pp. 130–143.

9. Daniel Chard, *Landscape Illusion: A Spatial Approach to Painting* (New York: Watson-Guptill, 1988). This book by the artist gives a thorough discussion of his composition and painting technique.

10. Quoted in Anderson, *Altoon Sultan, Recent Work*.

CHAPTER SIX
THE ROMANTIC LANDSCAPE

1. Quoted in Goodrich, *Edward Hopper*, p. 164.

2. Emerson, *Nature*, p. 62.

3. For example, see *Illyria*, illustrated on page 91 of this author's *Realist Drawings & Watercolors* (Boston: New York Graphic Society, 1980).

4. In spite of recent attempts to elevate Augustus Tack to a position of great influence, his name is seldom mentioned by contemporary landscape painters. Sorry, Professor Rosenblum.

5. Amy G. Poster and Henry D. Smith II, *Hiroshige, One Hundred Views of Edo* (New York: George Braziller, 1986), p. 30.

6. Emerson, *Nature*, p. 21.

7. The symbolic connotations of the lily (purity, peace, resurrection)—which is interchangeable with the lotus symbol in Eastern religions (sun and moon, birth and death, and the flower of light) — and of water (the source and grave of all things in the universe and the liquid counterpart of light) has not escaped Raffael.

8. Quoted in *Realists at Work*, p. 100, which also includes a discussion of his studio procedure.

9. Lafcadio Hearn, *Writings from Japan*, Penguin Travel Library (New York: Viking Penguin, 1984), p. 75.

CHAPTER SEVEN
THE EXPRESSIONIST LANDSCAPE

1. Cikovsky and Quick, *George Inness*, p. 205.

2. Robert Rosenblum, *Modern Painting and the Northern Romantic Tradition: Friedrich to Rothko* (New York: Harper & Row, 1975), p. 175.

3. *Ibid.*, p. 174.

4. *Ibid.*, p. 205.

5. Seldon Rodman, *Conversations with Artists* (New York: Capricorn Books, 1961), pp. 93–94.

6. Alfred Leslie, "Notes on the 100 Views," *Bimonthly Bulletin*, Philbrook Art Center, Tulsa, Oklahoma, July–August, 1985.

7. According to my friend Midori Shiraishi, "The characters for NOTAN mean 'dark-light.' We also use it for 'heavy-light' as in food taste, e.g., the preference of NOTAN in taste depends on the person. Also, for 'thick-light,' as in the ocean current which depends on the NOTAN of salinity. It's not particularly an art term [but] if you say put in the NOTAN, that would mean put in the shading."

8. Quoted in Martica Sawin, *Wolf Kahn: Landscape Painter* (New York: Taplinger, 1981), p. 9.

9. Quoted in *ibid.*, p. 18.

10. *Ibid.*, p. 43.

11. *Ibid.*, p. 29.

12. *Ibid.*, p. 12.

13. John J. Audubon, *Birds of America* (New York: American Heritage, 1966), plate 64.

EPILOGUE

1. Emerson, *Nature*.

2. Robert Hughes, *The Shock of the New* (New York: Alfred A. Knopf, 1980), p. 400.

3. See E. D. Hirsch, Jr., *Cultural Literacy: What Every American Needs to Know* (New York: Vintage Books, 1988).

4. The collision of these attitudes culminated in the public animosity displayed toward Richard Serra's *Tilted Arc* (commissioned by the U.S. General Services Administration's Art in Architecture program for the Federal Plaza in downtown Manhattan in 1979), not because his curved steel wall produced a "new shudder" in our culture, as did Auguste Rodin's revolutionary *Burghers of Calais* and monument to *Balzac*, but because it lacked a meaningful relationship to any comprehensible act, idea, or allegory, which is basic to the notion of public art. This failure on the part of the federal agency, its advisors (usually selected from the museum world by the National Endowment for the Arts) and the artist, culminated in a piece which was an aesthetic and humanistic disruption of the plaza. The results were simply more than the public could take. By comparison, the Vietnam Memorial in Washington, D.C. is as minimal and austere as the *Tilted Arc*, but it achieves great communicative power through its year-by-year list of the dead and lost. As in the past, the most significant art points away from itself and toward its symbolic meaning.

5. Witold Rybczynski, *Home: A Short History of an Idea* (New York: Penguin Books, 1986), p. 214–215.

6. Vincent Van Gogh, *The Complete Letters of Vincent Van Gogh*, Vol. III (Boston: New York Graphic Society, 2d ed., 1978), letter 542, to Theo, page 55.

7. Robert Hughes, *The Shock of the New*, p. 112.

8. Vincent Van Gogh, *The Complete Letters of Vincent Van Gogh*, Vol. III, letter 594, to Theo, p. 180.

SELECTED BIBLIOGRAPHY

Arthur, John, *American Realism: The Precise Image*. Tokyo: Brain Trust, Inc., 1985.

——, *Realists at Work*. New York: Watson-Guptill, 1983.

——, *Realist Drawings & Watercolors: Contemporary American Works on Paper*. Boston: New York Graphic Society, 1980.

Boyle, Richard J., *American Impressionism*. Boston: New York Graphic Society, 1974.

Clark, Kenneth, *Landscape into Art*. New York: Harper & Row, 1976.

Czestochowski, Joseph S., *The American Landscape Tradition: A Study and Gallery of Paintings*. New York: E. P. Dutton, 1982.

Downes, Rackstraw, ed., *Fairfield Porter: Art in Its Own Terms—Selected Criticism 1935–1975*. New York: Taplinger, 1979.

Foshay, Ella M., *Reflections of Nature: Flowers in American Art*. New York: Whitney Museum of American Art / Alfred A. Knopf, 1984.

Goodyear, Frank, *Contemporary American Realism Since 1960*. Boston: New York Graphic Society, 1981.

Hopkins, Henry T., et al., *Painting and Sculpture in California: The Modern Era*. San Francisco: San Francisco Museum of Modern Art, 1977.

Howat, John K., et al., *American Paradise: The World of the Hudson River School*. New York: Metropolitan Museum of Art, 1987.

Kaplan, Wendy, et al., *"The Art That Is Life": The Arts & Crafts Movement in America, 1875–1920*. Boston: New York Graphic Society, 1987.

Lears, Jackson, *No Place of Grace: Antimodernism and the Transformation of American Culture, 1880–1920*. New York: Pantheon Books, 1981.

Martin, Alvin, *American Realism: Twentieth-Century Drawings and Watercolors from the Glenn C. Janns Collection*. New York: San Francisco Museum of Modern Art / Harry N. Abrams, 1986.

Novak, Barbara, *Nature and Culture: American Landscape and Painting, 1825–1875*. New York: Oxford University Press, 1980.

Poster, Amy B., and Smith, Henry D., II, *Hiroshige, One Hundred Views of Edo*. New York: Brooklyn Museum / George Braziller, 1986.

Rosenblum, Robert, *Modern Painting and the Northern Romantic Tradition: Friedrich to Rothko*. New York: Harper & Row, 1975.

Sandler, Irving, *The New York School: The Painters & Sculptors of the Fifties*. New York: Harper & Row, 1978.

Schiff, Gert, and Waitzoldt, Stephan, *German Masters of the Nineteenth Century: Paintings and Drawings from the Federal Republic of Germany*. New York: Metropolitan Museum of Art, 1981.

Stebbins, Theodore E., et al., *A New World: Masterpieces of American Painting, 1760–1910*. Boston: Museum of Fine Arts, 1983.

Stein, Roger B., et al., *In Pursuit of Beauty: Americans and the Aesthetic Movement*. New York: Metropolitan Museum of Art / Rizzoli, 1987.

Steinberg, Leo, *Other Criteria: Confrontations with Twentieth-Century Art*. New York: Oxford University Press, 1972.

Strand, Mark, *Art of the Real*. New York: Clarkson N. Potter, 1983.

Varnedoe, Kirk, *Northern Light: Realism and Symbolism in Scandinavian Painting, 1880–1910*. New York: Brooklyn Museum, 1982.

Wichmann, Siegfried, *Japonisme: The Japanese Influence on Western Art in the 19th and 20th Centuries*. New York: Harmony Books, 1981.

Wilmerding, John, *American Light: The Luminist Movement, 1850–1875*. New York: Harper & Row, 1980.

PHOTO CREDITS

Photographs are credited either to the individuals, institutions, or firms owning the works that are
reproduced or to the galleries that represent the artists, with the following exceptions:

Eric Pollitzer	pp. 14, 69, 112, 128	Lee Fatherree	p. 53	Benjamin Fisher	p. 96
Geoffrey Clements	pp. 16, 72	Norman Fortier	p. 58	Winn Corp.	p. 111
Ed Owen	p. 19	Dana Salvo	pp. 59, 109, 149	E. A. Grenstead Commercial Photography	p. 114
Lee Boltin	p. 22	Ellen Page Wilson	p. 68		
G. R. Farley Photography	p. 26	Adam Reich	pp. 70, 91, 119	Steven Sloman	pp. 132, 133 (top left)
Joseph Szaszfai	p. 30	Michael Tropea	p. 74	Stephen Petegorshy	p. 133 (top right)
Charles Uht	p. 32	D. James Dee	pp. 80, 140	Otto Nelson	p. 136
Sarah Wells	pp. 39, 135	Earl Ripling	p. 89	David Caras	p. 130
Zindman/Fremont	pp. 48, 64, 82, 105, 147	eeva-inkeri	pp. 92, 113	Leslie Harris:	p. 141

Designed by Rick Horton

Editorial coordination by Dorothy Oehmler Williams

Production coordination by Christina Holz Eckerson

Composition in Janson by DEKR Corporation

Printed and bound in Italy by Arti Grafiche Amilcare Pizzi, S.p.A., Milan